unexpected afghans

INTERWEAVE.
interweave.com

EDITOR
Kim Werker

ART DIRECTOR
Liz Quan

COVER + INTERIOR DESIGNER
Pamela Norman

PHOTOGRAPHER
Joe Hancock

PRODUCTION DESIGNER
Katherine Jackson

TECHNICAL EDITOR + ILLUSTRATOR
Karen Manthey

Interweave Press LLC
201 East Fourth Street
Loveland, CO 80537
interweave.com

Printed in China by C&C Offset.

Library of Congress
Cataloging-in-Publication Data

Chachula, Robyn, 1978-
 Unexpected afghans : innovative crochet designs
with traditional techniques / Robyn Chachula.
 pages cm
 Includes bibliographical references and index.
 ISBN 978-1-59668-299-3 (pbk.)
1. Afghans (Coverlets) 2. Crocheting--Patterns. I.
Title.
 TT825.C3788 2012
 746.43'0437--dc23
 2012001563

10 9 8 7 6 5 4 3 2 1

This book is dedicated to my grandmother Rose, for inspiring all of her grandchildren, even many years after her time, to understand that crochet can be beautiful and simple, and it can wrap you with love.

acknowledgments

I am very thankful for this opportunity to work with such talented and creative designers. Their passion for crochet fueled my love of the simple, amazingly beautiful afghan. Thank you for making this book come alive with your brilliant projects.

All the yarns used in the book were donated graciously by the yarn companies. Thank you so much for your support and quick responses to all my requests. I truly appreciate all that you have given me. Those companies are Blue Sky Alpacas, Brown Sheep Company, Cascade Yarns, Tahki-Stacy Charles Inc., Classic Elite, Bijou Basin Ranch, Lion Brand, Caron International, Universal Yarn, Premier Yarns, and Coats and Clark.

Thank you to everyone at Interweave, especially Kim Werker and Karen Manthey, for making the ramblings of a sleep-deprived mom sound intelligent. I would also would like to thank Virginia Boundy for helping me crochet two of the pillows in the book so I could keep focused on writing and editing.

Most important, I would like to thank my friends and family for all their love and support in every crazy challenge I take on. I would especially like to thank my husband, Mark, for his un-wavering love. Without his encouragement and help, this book would not have been possible.

Last, I want to thank you, the readers. Thank you for enjoying what I love to do so much. Your enthusiasm for crochet is what keeps me energized to share my kooky designs!

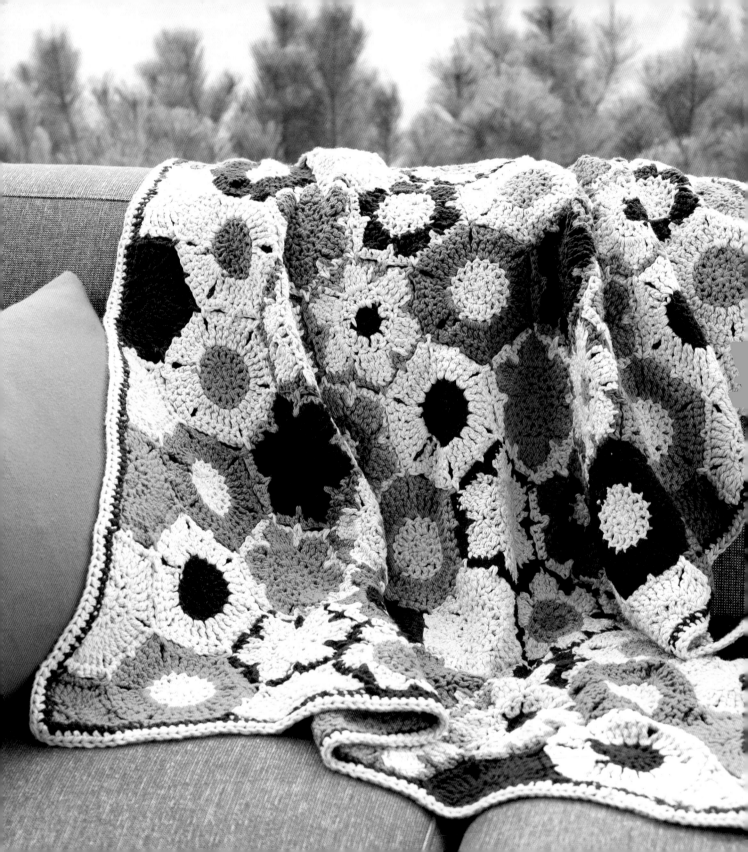

contents

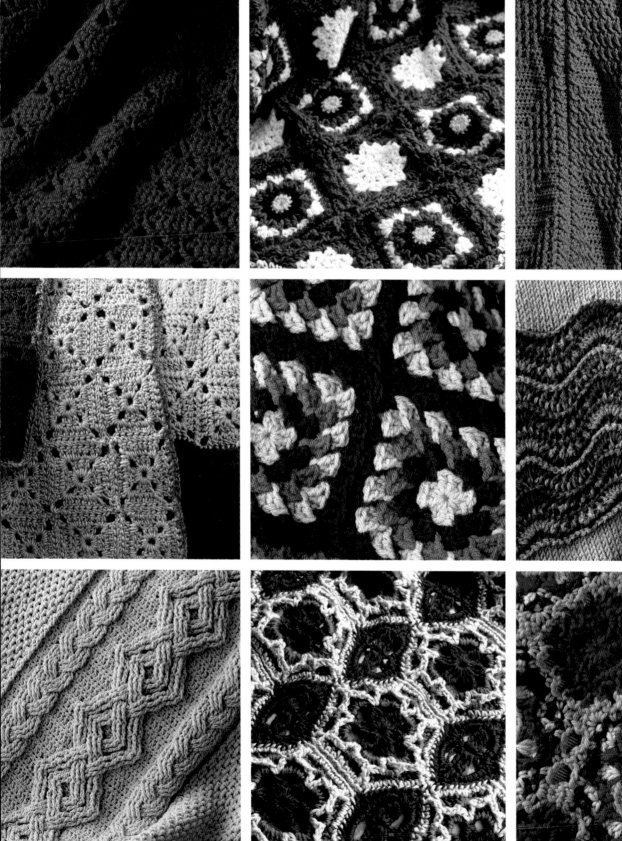

I have always been downright nosy about what other designers have in their homes.

I sometimes think I keep magazine sales afloat by myself. I always wonder how creative people design their homes to keep them inspired. For me, I try to live in a natural setting that has four distinct seasons, in a place that's centrally located enough that I am able to take a short walk to explore new exhibits at a museum. I then take pieces I find in my community and fill my home and studio with their colors, textures, and patterns. The subtle inspiration in my home has a direct effect on my crochet work.

My initial approach to this book was that pure sense of just being nosy—*what do other crochet designers have in their houses?* That then morphed into, *what would an afghan look like at Leigh Radford's house or in Drew Emborsky's studio? And finally, how amazing would it be to have all the masters work on one big canvas to showcase our craft so we all can decorate our homes?*

The results are astounding. I asked each crochet designer to use the afghan as a vehicle to showcase their favorite aspect of crochet. Some went colorful, some turned to granny motifs, and others came up with intricate stitch patterns. Each project highlights the beauty of crochet cables, colorwork, lace, granny motifs, or Tunisian crochet. Plus, every project has the intimate stamp of the designer's unique inspiration. The best part is that even though the projects in the book look amazing and maybe even slightly challenging, each one has tips and stitch diagrams to guide you along the way. Every chapter also begins with a small pillow project to ease you into the more involved afghans that follow.

So go ahead, jump on in. What would look good in your home? Could it be the masterpiece from Simona Merchant-Dest, or the modern take on granny motifs from Linda Permann, or the show-stopping exploded doily from Doris Chan? I know my hook is itching to start one for each room in my house.

first-time projects

Be honest—have you crocheted an afghan before? Of course you are not alone if you have. I am always amazed by how many crocheters' first projects are giant afghans. I can count myself among those numbers as well. My first afghan was a sampler with each block a different stitch pattern or granny square. I adored working on the project and learning a new stitch on each block. The pride I felt from finishing all the blocks and sewing them together is what has hooked me on all my projects since.

But maybe you've never crocheted an afghan. This book is a great place to get started. I truly believe that any kind of project can be someone's first project as long as it interests them enough to finish. If it is a boring project or stitch pattern, you are going to think crochet is boring. Why not start with something a bit more complex, as long as you are willing to learn how to make it? Even though all the designers in this book come from different

backgrounds, the one thing we have in common is that we finished our first project. Here are what some of our experts have done, in their own words:

DIANE HALPERN My first project was a 70" (178 cm) cluster stitch winter scarf that went great with maxi coats. It promptly stretched and became lethally long!

JILL WRIGHT I learned to crochet working granny squares, but I'm pretty sure my first actual project was a filet-crochet long-sleeve cardigan in a fine cotton yarn. I like to challenge myself!

DORA OHRENSTEIN My first crochet project was a cape that could also be worn as a skirt. This was back in the seventies when I was living on a houseboat in Amsterdam. It was in the days of wild colors, and it had lots of them. I had no idea what I was doing, but it came out very nice.

DORIS CHAN A blanket for my favorite toy horse, a palomino named, no surprise, Trigger.

DREW EMBORSKY I started crocheting when I was five years old, and if my memory serves me, my first project was a granny square pot holder.

EDIE ECKMAN I don't remember my very first project, but I suspect it was a little stuffed animal—I made dozens of them out of leftover yarn. I was making amigurumi WAY before it was "in."

ELLEN GORMLEY The first project I can remember was a crocheted Rubik's Cube made of solid-color granny squares sewn together into a 3-D cube shape. It was a little lopsided but I was ten and it was the 1980s. I wish I still had it.

KIMBERLY MCALINDIN My first crochet project was a baby blanket. It was the pattern on the back of a Red Heart Supersaver yarn label, and it took me two months to make and understand the pattern. I was determined though, and I figured it out . . . with a lot of ripping!

KRISTIN OMDAHL My first crochet project was a baby bootie in an intermediate stitch pattern. I struggled for quite a while with it, but once I got it right I figured if I can do this, I can do anything!

LINDA PERMANN My first real crochet project—after a series of foiled squares-turned-triangles and pancake-shaped hats—was a set of star ornaments made from crochet thread. I was so happy to have found a diagram for them in an old Irish Crochet book from the library—it was the first crochet diagram I had ever seen! I made lots of them for my holiday tree and still have them today.

MARTY MILLER The first project I really remember was squares for a granny square afghan in 8th grade. My teacher taught our class how to make granny squares so we could put them together in afghans for the veterans. I knew how to crochet already, but had never learned how to make a granny square. I picked it up quickly and was able to make one faster than the boy who was in the desk next to mine, who always finished our class assignments faster than I did. At last I was faster than he was! When I got home, I told my mother that I had learned how to make granny squares, figuring that she knew how. But she didn't and told me to sit down next to her and teach her. Which I did. My mom then started to make granny-square afghans for everyone in the family and friends and neighbors. When we all had one, she started on the second round of afghans. She was a real Queen of the Granny Squares. That's why I love to make granny squares.

MARY BETH TEMPLE A royal blue acrylic granny square when I was eleven. I got carried away with the corners, and it wound up being a sort of ruffled doily instead of a flat, tailored square, but I loved it anyway and displayed it in my room for a very long time.

SIMONA MERCHANT-DEST I believe that my first crochet project was when, in the 1980s, we had a scarf/small-shawl craze in the Czech Republic. Everyone had the same one using the same

stitch. A couple decades later, I saw a Czech woman wearing the exact same one here in the USA!

TAMMY HILDEBRAND My first crochet project was a floppy, purple hippie hat that I still have almost forty years later.

beginner tips

Whether you'll start your first project today or if you have been crocheting for years, I find that I learn a new tip every time I pick up my hook. Which means for you first timers, you really have nothing to worry about—we designers are still learning fun new tricks to make our projects look sensational. My main advice is to relax (it is supposed to be fun), ask for help when you need a hand (local yarn shops or the Internet are perfect for this), and make your first project something you want to use in the end (baby projects are perfect since babies will never complain about imperfection). You can learn all the basics, from what each stitch looks like to how to read a crochet diagram to what certain terms mean in the Glossary of this book (page 155). But don't just take my word for it, here is what my friends say, too.

ANNETTE PETAVY Use the best yarn you can afford and don't hesitate to play with colors!

ANNIE MODESITT Understand that holding the crochet hook WILL feel awkward. It just will. This feeling will go away, but it takes a certain number of hours to get beyond the "oddness" factor. Don't give up too easily, and know that every day you put time into the technique you'll feel the rewards down the line!

CAROL VENTURA It's not too difficult to design in tapestry crochet, so go ahead and personalize a project by substituting your own motif, once the basics are understood.

DIANE HALPERN Don't think that counting stitches is a bore; the correct count saves a lot of frogging.

DARLA FANTON Don't be afraid of the skill level designation in patterns. I find most crocheters tend to underestimate their capabilities.

JILL WRIGHT Don't be afraid to use a larger hook than is mentioned on the yarn ball band. Some yarns just look and feel better worked on a larger hook.

DREW EMBORSKY Always and under all circumstances work with yarn that you LOVE. If you love the yarn, your project will be amazing no matter what.

EDIE ECKMAN Relax! Breathe! Crocheting should be fun, not stressful. If you run into a technique you don't understand, don't give up. Look it up in a book or on the Internet or check with a more experienced friend or yarn-shop employee. You really can make anything!

ELLEN GORMLEY Don't sew your motifs together too tightly! Trust the yarn to hold the project together. When it is stitched too tightly, it tends to pucker.

KATHRYN MERRICK Don't be afraid to play with color! Make lots of swatches to see what you like and what works well.

LINDA PERMANN Block your work, even if it looks great right off the hook. Blocking will smooth any uneven stitches and can really give your work a professional finish.

MEGAN GRANHOLM It's okay if you don't follow the pattern to a T! Just make sure that as you experiment with stitches and shaping, you stay consistent throughout the entire piece, turn the same way, insert your hook into the stitches the same way, etc.

TAMMY HILDEBRAND If you find that you have made a mistake, take the time to go back and correct it. It will be worth the effort even if you think no one would ever notice it.

TRACIE BARRETT Be fearless! It's just yarn, you can always rip it back. No matter how complicated the finished lace looks, it's always done one stitch and one row at a time. If you truly love a project, go for it.

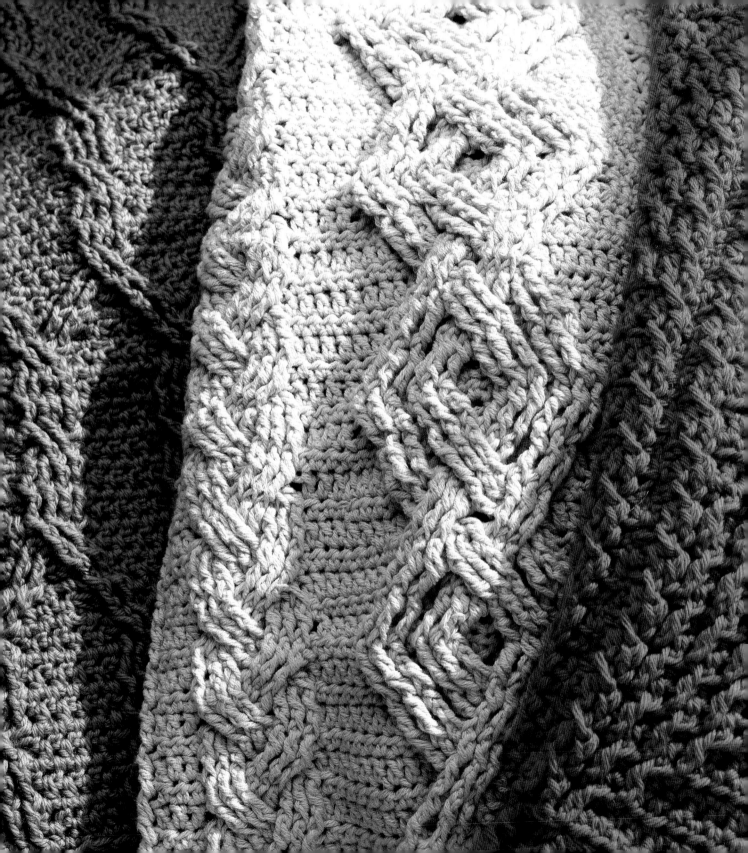

The one tip I tell students in all my classes is that they will almost always be sticking their hook under both of the top loops of a crochet stitch.

Cables, however, break this rule of thumb quite dramatically. Cables are nearly always created by going around the entire post of the stitch and not those two top loops (see the Glossary for instructions for how to work post stitches). Other than that, cables are just like any other stitch pattern, and you just need to keep track of where you are in the directions. An easy trick to help you keep track of where you are: when looking at a right-side row all your front post stitches will be popping out at you, and the back post stitches will be sitting behind the top loops of the stitches they're worked around. You can easily mark off in your pattern by looking at your row to double check that you have the right post stitches where they need to be.

Do not worry if your cables do not look perfect the first time around. Cables can take a bit of time to master. The key is simply practice.

Cabled stitch patterns are unique in their three-dimensional look, but different fiber contents in your yarn can produce wildly different results. Silk and bamboo have natural drape, and while they result in a flowing fabric, that drape may hide your stitch pattern unless you drop your hook size significantly. Cotton will have great stitch definition, and your cables will seem to jump off of your fabric as in Simona Merchant-Dest's Veledílo Cable Afghan (page 32), but be careful as cotton can also make a stiff fabric. Superwash wool has always been my favorite for both stitch definition and lightweight fabric. You can see the beauty of wool in Drew Emborsky's Artesia Zigzag Afghan (page 18) and Annie Modesitt's Croises Cable Afghan (page 22).

CABLE LOVE

Cables in crochet can get a bad name when done so tightly the fabric can stand up on its own. But when executed with the right yarn and hook size, cables can be just as stunning as their knitted counterparts. I, personally, love playing with color and cables. I think cables are so special that highlighting them in a different color makes them really pop, as you can see on the Tuxedo Pillow I designed (page 12). You will have to carry one color of yarn behind your work, but it is so worth it for the effect. I find that using cables on little projects such as purses or hats really does take the project to a whole other level of beauty.

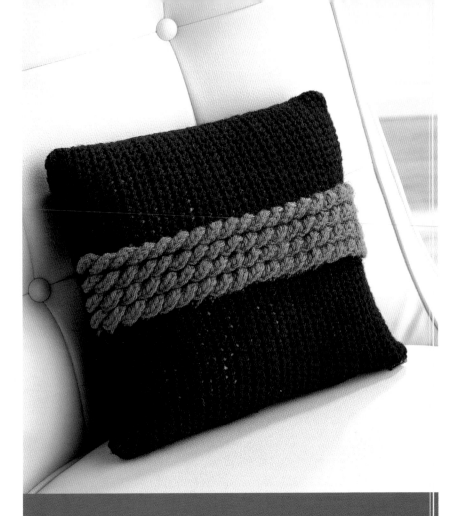

MATERIALS

Yarn Worsted weight (#4 Medium).
Shown Premier Yarns, Dream (100% acrylic; 224 yd [205 m]/3.5 oz [100 g]): #24–211 Garnet (MC), 2 balls; #24–206 Grenadine (CC), 1 ball.
Hook K/10.5 (6.5 mm) or size needed to obtain gauge.
Notions Yarn needle for weaving in ends, blocking pins and steam iron, 12" (30.5 cm) pillow form (cover optional), 12" (30.5 cm) matching zipper, sewing needle, and matching sewing thread.

GAUGE

13 sts and 14 rows = 4" x 4" (10 x 10 cm) in sc.

FINISHED SIZE

12" x 12" (30.5 x 30.5 cm).

NOTES

To change color, complete last st of first color with next color.

tuxedo pillow

If you're not quite feeling ready for the post stitches that make crochet cables possible, the stitch pattern in this pillow cover has you practice finding stitches to crochet around rows below the one you are working in. As an added bonus, you end up with a fancy tuxedo pattern just from making some chains and slip stitches. The ruffles pop off the fabric just like they do on fantastic retro tuxedo shirts.

pattern

FRONT

With MC, ch 39.

ROW 1 (WS): Sc in 2nd ch from hook and in each ch across, turn—38 sc.

ROWS 2–3: Ch 1, sc in each sc across, turn.

ROW 4: Ch 1, sc in next 15 sc, change to CC, *ch 4, sl st around post of next sc 3 rows below, turn, [sc, 4 hdc, sc] in ch-4 sp just made (ruffle made), turn, sk next sc on current row (behind ruffle), sc in next sc; rep from * 3 times, change to MC, sc in each rem sc to end, turn—30 sc + 4 ruffles.

ruffle detail

front panel

ROW 5: Ch 1, sc in next 16 sc, *sc in ch-sp of ruffle, sc in next sc; rep from * 3 times, sc in each sc to end, turn.

ROW 6: Ch 1, sc in next 15 sc, change to CC, *ch 4, sl st around post of next sc 3 rows below (behind ruffle), turn, [sc, 4 hdc, sc] in ch-4 sp just made, turn, sk next sc on current row (behind ruffle just made), sc in next sc; rep from * 3 times, change to MC, sc in each rem sc to end, turn—30 sc + 4 ruffles.

Rep Rows 5–6 seventeen more times, rep Row 5 once more, fasten off.

BACK
With MC, ch 39.

ROW 1 (WS): Sc in 2nd ch from hook and in each ch across, turn—38 sc.

ROW 2: Ch 1, sc in each sc across, turn.

Rep Row 2 thirty-nine more times, fasten off, and weave in loose ends.

finishing
BLOCKING AND SEAMING
Block front and back panels to 12" (30.5 cm) square, steam to set by keeping iron 1" (2.5 cm) above fabric at all times. With RS facing, using yarn needle and yarn, whipstitch 3 sides together. Turn cover right-side out. Pin zipper to open side of pillow cover. Whipstitch or backstitch zipper into opening using sewing needle and sewing thread. Insert pillow form and zip closed.

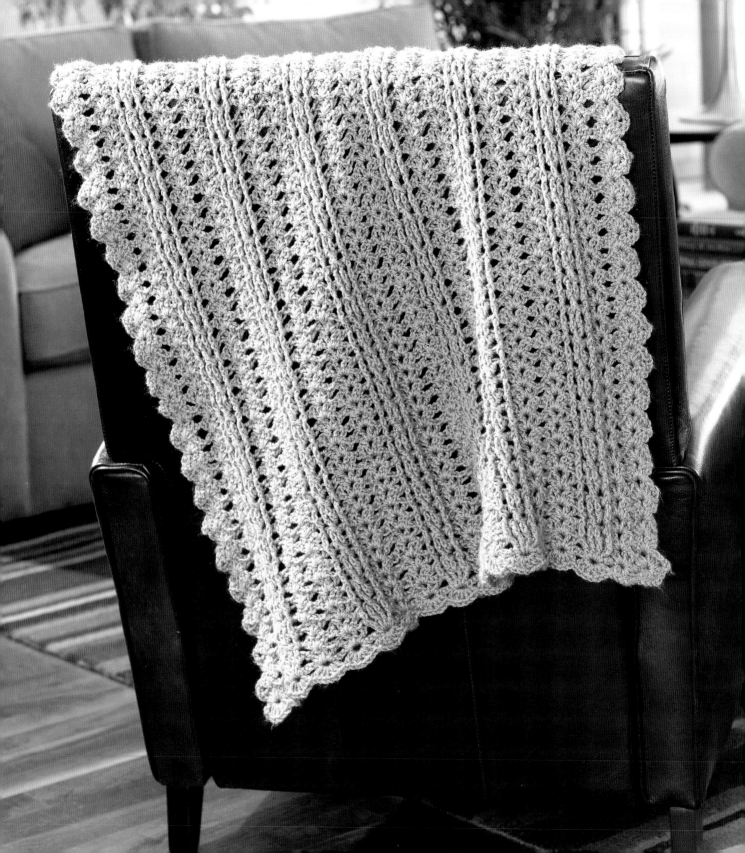

eloise baby blanket

Cables, lacy shells, and dc eyelets—some of my favorite stitch patterns to use. And they're all in this baby afghan, which is one of my "go-to" baby afghans for all my new great-nieces and great-nephews! It's easy to make it wider and longer, so I can even make it for their older brothers and sisters. Once you crochet one, I know you will quickly add it to your "go-to" patterns, also! ● BY MARTY MILLER

MATERIALS

Yarn Worsted weight (#4 Medium).

Shown Red Heart, Eco-Ways (70% acrylic, 30% recycled polyester; 186 yd [170 m]/4 oz [113 g]): #3522 Fern, 6 skeins.

Hook J/10 (6.00 mm) or size needed to obtain gauge.

Notions Tapestry needle for weaving in ends, spray bottle with water and straight pins for blocking, large towel for blocking.

GAUGE

1 pattern repeat (2 shells, 1 crossed-cable pattern) = 5" (12.5 cm).
7 rows in pattern = 5" (12.5 cm).

FINISHED SIZE

33" x 48" (84 x 122 cm).

NOTES

Begin by working a foundation row of dc eyelets, then work the bottom border into the eyelets, on the RS. Work the first row of the afghan into the opposite side of the eyelets, still on the RS. The rest of the afghan is worked in rows, and the upper border is added at the end. The side borders are formed as you crochet the body of the afghan.

Make the afghan wider or narrower by adding or subtracting dc eyelets at the beginning. Work more rows to make the afghan longer, fewer rows to make it shorter.

SPECIAL STITCHES

Shell (sh) (3 dc, ch 1, 3 dc) in sp or st indicated.

Lacy shell (l-sh) (Dc, [ch 1, dc] 3 times) in sp or st indicated.

Dc eyelet (dc eyelet) Ch 3, dc in 3rd ch from hook, *ch 7, dc in 3rd ch from hook; rep from *.

pattern

Work 20 dc eyelets (see Special Stitches), ch 3, do not turn.

BOTTOM BORDER

Working back along the dc eyelets, over the post of each dc, sh (see Special Stitches) in each dc eyelet, do not turn, rotate piece so you are now working over the chs of the eyelet spaces.

AFGHAN

ROW 1 (RS): Ch 3, working over ch-3 of each dc eyelet, sh in first dc eyelet, l-sh (see Special Stitches) in next dc eyelet, 4 dc in next dc eyelet, *l-sh in each of next 2 dc eyelets, 4 dc in next dc eyelet; rep from * to last 2 dc eyelets, l-sh in next dc eyelet, sh in last dc eyelet, turn—6 groups of 4 dc.

ROW 2: Ch 3, sh in ch-1 sp of first sh, l-sh in center ch-1 sp of next l-sh, *fpdc

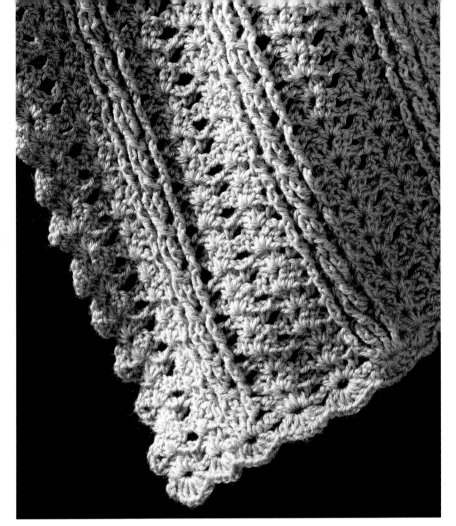

tip Pay attention to your crocheting. Don't let your mind wander too much, because you will inevitably miss a stitch or do the wrong one, and then you'll have to rip out a row or two. I keep myself focused by counting stitches, making sure I come up with the same number at the end of each row. —MARTY MILLER

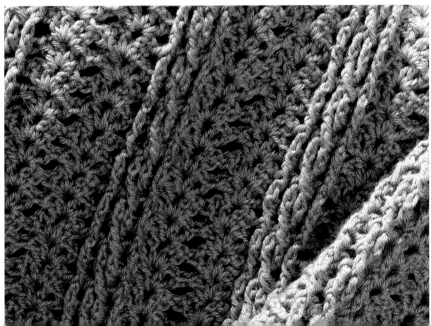

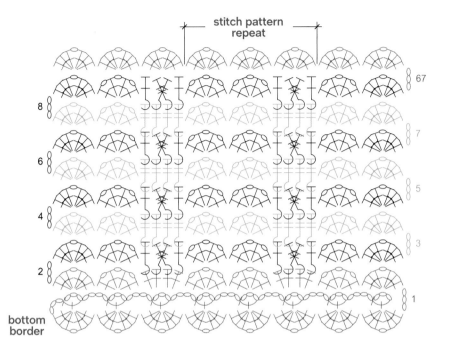

stitch pattern repeat

bottom border

around next st, sk next st, fptr around next st, fptr around last skipped st, fpdc around next st, sk next ch-1 sp**, [l-sh in center ch-1 sp of next l-sh] 2 times; rep from * across, ending last rep at **, l-sh in center ch-1 sp of next l-sh, sh in ch-1 sp of last sh, turn.

ROW 3: Ch 3, sh in ch-1 sp of first sh, l-sh in center ch-1 sp of next l-sh, *bptr around each of next 4 post sts, [l-sh in center ch-1 sp of next l-sh] 2 times; rep from * across, ending with bptr around each of next 4 post sts, l-sh in center ch-1 sp of next l-sh, sh in ch-1 sp of last sh, turn.

ROWS 4–65: Rep Rows 2 and 3 thirty-one times.

ROW 66: Rep Row 2.

TOP BORDER

Ch 3, sh in ch-1 sp of first sh, sh in center ch-1 sp of next l-sh, *sh in sp bet 2nd and 3rd post sts, sh in center ch-1 sp of each of next 2 l-sh; rep from * across, ending with sh in sp between 2nd and 3rd post sts, sh in center ch-1 sp of next l-sh, sh in ch-1 sp of last sh. Fasten off.

finishing

Weave in loose ends.

BLOCKING

Lay afghan on flat surface with towel(s) underneath. Gently straighten out edges and pin in place. Spray edges lightly with cold water. Let dry.

" I love cabling in crochet because it adds another dimension and depth to the fabric." —SIMONA MERCHANT-DEST

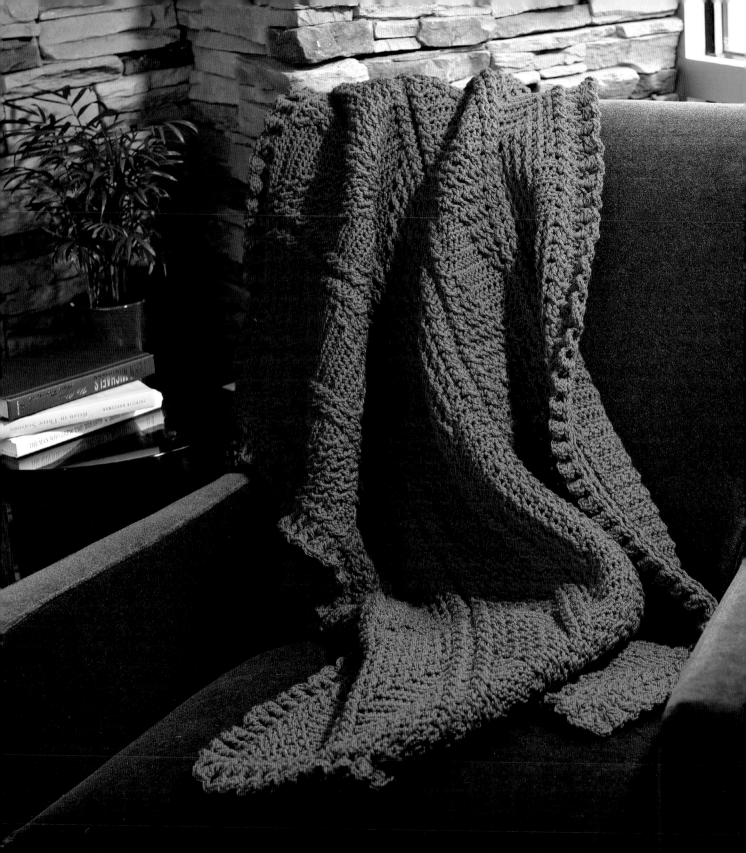

artesia zigzag afghan

What I love most about crochet is the possibility to fool the eye through clever stitch combinations. The cables in this afghan not only create amazing texture, but also a faux ripple effect. Worked in strips and assembled later, it's a great portable project. ● BY DREW EMBORSKY

MATERIALS
Yarn Worsted weight (#4 Medium).

Shown Cascade Yarns, Cascade 220 (100% Peruvian Highland Wool; 220 yd [200 m]/3.5 oz [100 g]): #7824, 9 hanks.

Hook J/10 (6.0 mm) or size needed to obtain gauge.

Notions Tapestry needle for weaving in ends; split stitch marker (sm).

GAUGE
14 hdc and 10 rows = 4" x 4" (10 x 10 cm) in stitch pattern.

FINISHED SIZE
32" x 48" (81 x 122 cm).

NOTES
Afghan is composed of three strips, seamed together lengthwise, then edged.

SPECIAL STITCHES
Cable A (cbl-a) Sk 2 sts, fpdc around next st, bpdc around 2nd skipped st, fpdc around first skipped st working in front of post st just made.

Cable B (cbl-b) Sk 1 st, fpdc around next st, hdc in skipped st working in back of post st just made.

Cable C (cbl-c) Sk 1 st, fpdc around next st, fpdc around skipped st working in front of post st just made.

Cable D (cbl-d) Sk 1 st, hdc in next st, fpdc around skipped st working in front of hdc just made.

pattern

STRIP (make 3)

Ch 38.

ROW 1: Dc in 4th ch from hook and in each ch across, turn—36 dc.

ROW 2 (RS): Ch 2 (counts as first st here and throughout patt), cbl-a (see Special Stitches for this and all cables), cbl-b 6 times, cbl-c 2 times, cbl-d 6 times, cbl-a, hdc in last st, turn.

ROW 3 AND ALL ODD NUMBERED ROWS OF STRIP: Ch 2, as you work across row fpdc around all post sts facing you, bpdc around all post sts away from you, and hdc in all hdc; hdc in last st, turn.

ROW 4: Ch 2, cbl-a, cbl-b 5 times, hdc in next 2 sts, cbl-c 2 times, hdc in next 2 sts, cbl-d 5 times, cbl-a, hdc in last st, turn.

ROW 6: Ch 2, cbl-a, cbl-b 4 times, hdc in next 4 sts, cbl-c 2 times, hdc in next 4 sts, cbl-d 4 times, cbl-a, hdc in last st, turn.

ROW 8: Ch 2, cbl-a, cbl-b 3 times, hdc in next 6 sts, cbl-c 2 times, hdc in next 6 sts, cbl-d 3 times, cbl-a, hdc in last st, turn.

ROW 10: Ch 2, cbl-a, cbl-b 2 times, hdc in next 8 sts, cbl-c 2 times, hdc in next 8 sts, cbl-d 2 times, cbl-a, hdc in last st, turn.

ROW 12: Ch 2, cbl-a, cbl-b, hdc in next 8 sts, cbl-b, cbl-c 2 times, cbl-d, hdc in next 8 sts, cbl-d, cbl-a, hdc in last st, turn.

ROW 14: Ch 2, cbl-a, hdc in next 8 sts, cbl-b 2 times, cbl-c 2 times, cbl-d 2 times, hdc in next 8 sts, cbl-a, hdc in last st, turn.

ROW 16: Ch 2, cbl-a, hdc in next 6 sts, cbl-b 3 times, cbl-c 2 times, cbl-d 3 times, hdc

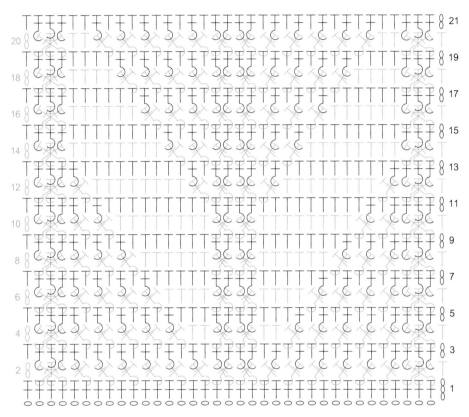

in next 6 sts, cbl-a, hdc in last st, turn.

ROW 18: Ch 2, cbl-a, hdc in next 4 sts, cbl-b 4 times, cbl-c 2 times, cbl-d 4 times, hdc in next 4 sts, cbl-a, hdc in last st, turn.

ROW 20: Ch 2, cbl-a, hdc in next 2 sts, cbl-b 5 times, cbl-c 2 times, cbl-d 5 times, hdc in next 2 sts, cbl-a, hdc in last st, turn.

Rep Rows 2–21 four more times.

Rep Rows 2–13 once more. Fasten off.

finishing

SEAMING

With RS facing, whipstitch first strip to second strip lengthwise being sure to carefully match up rows. Seam third strip to second strip in same fashion.

EDGING

RND 1: Attach yarn with sl st to last st of top edge of project, ch 3 (counts as first dc), 2 dc in same st; working down side of project into ends of rows, 3 dc in end

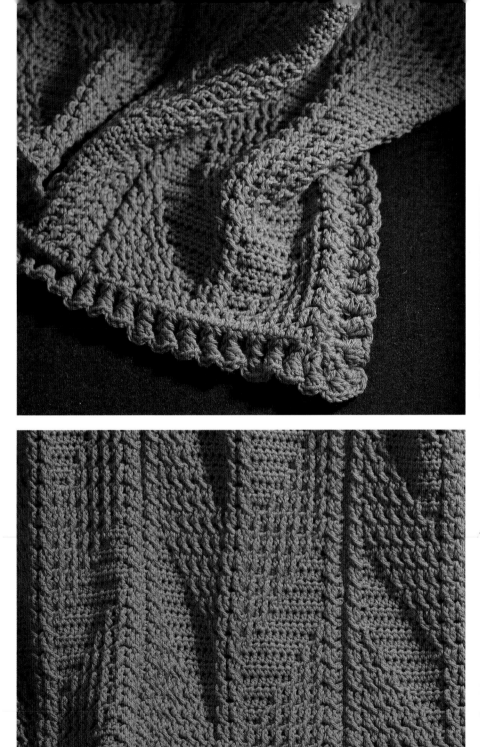

of first row, [sk 1 row, 3 dc in end of next row] across, 6 dc in base of first st of foundation ch, [sk 2 sts, 3 dc in next st] across, 6 dc in last st of foundation ch; working up side of project into ends of rows, 3 dc in end of first row, [sk 1 row, 3 dc in end of next row] across, 6 dc in top of first st of last row, [sk 2 sts, 3 dc in next st] across, work 3 more dc in same st as beg 3 dc, do not join, use sm to indicate last st of each rnd—564 dc.

RND 2: 3 fpdc around center st of each 3-st group around—564 fpdc.

RND 3: 5 fpdc around center st of each 3-st group around, sl st in beg dc to join—940 fpdc.

Fasten off and weave in loose ends.

Spray or wet-block (see Glossary).

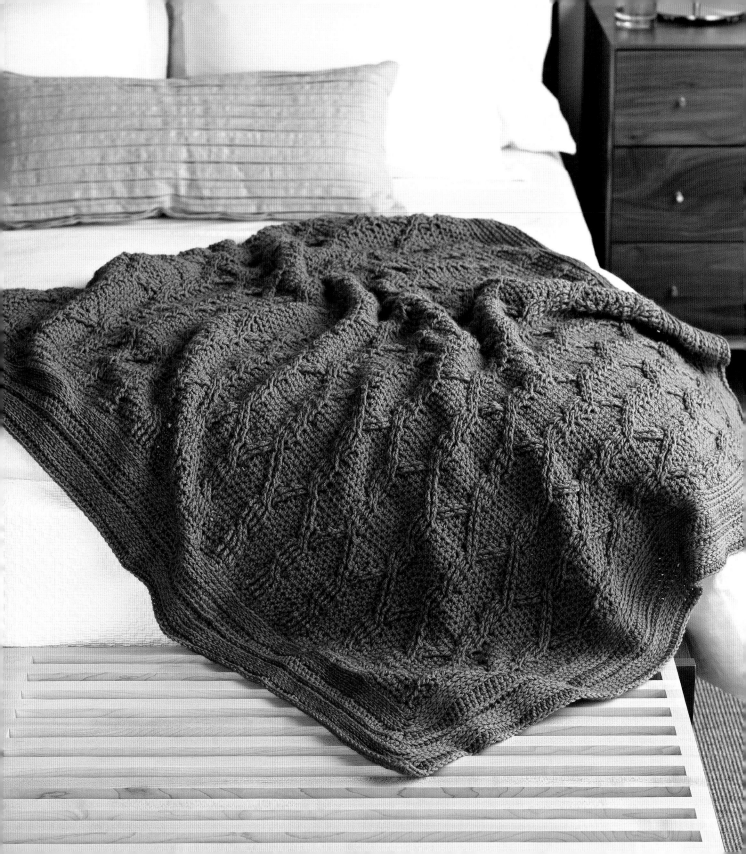

croises cable afghan

Knitting is where my heart lies, but my soul is consumed with crochet. I find the dimensional aspect of crochet so intriguing that it constantly inspires me. In the case of this afghan, the inspiration was a knitted piece, but I find the crocheted cables more fun to work than knitted ones—they're relatively simple and very engaging. This is a great chance to perfect your crocheted cable technique before you move on to a more complex fitted shape. ● BY ANNIE MODESITT

MATERIALS

Yarn Sportweight (#3 Light).

Shown Brown Sheep Company, Lamb's Pride Superwash Sport (100% washable wool; 180 yd [165 m]/ 1.75 oz [50 g]): #SW16 Sea Foam, 19 balls.

Hooks G/6 (4 mm) and H/8 (5 mm) or hooks needed to obtain gauge.

Notions Tapestry needle for weaving in ends.

GAUGE

With larger hook, 12 sts and 12 rows = 4" x 4" (10 x 10 cm) in stitch pattern.

FINISHED SIZE

50" x 48" (127 x 122 cm).

NOTE

Skip one st behind each post st worked unless directed otherwise.

SPECIAL STITCHES

C2L Sk next st, fptr around next st 2 rows below, fptr around skipped st 2 rows below.

C4L Sk next 2 sts, fptr around next 2 sts 2 rows below, fptr around 2 skipped sts 2 rows below.

pattern

With larger hook, ch 126.

ROW 1 (RS): Hdc in 3rd ch from hook (2 skipped chs count as hdc) and in each ch across, turn—125 hdc.

ROW 2: Ch 2, hdc in each hdc across, turn.

ROW 3: Ch 3, hdc in next 3 hdc, *fptr around next 4 post sts 2 rows below, hdc in next 4 sts in current row; rep from * across, turn.

ROW 4: Ch 2, hdc in each st across, turn.

ROWS 5–6: Rep Rows 3–4.

ROW 7: Ch 2, hdc in next 3 sts, *C4L (see Special Stitches) over next 4 sts, hdc in next 4 sts; rep from * across, turn.

ROW 8: Rep Row 4.

ROWS 9–14: Rep Rows 3–8.

ROW 15: Ch 2, hdc in next 2 hdc, *fptr around next 2 post sts 2 rows below, sk 2 hdc, hdc in next 2 hdc; rep from * across to t-ch, hdc in top of t-ch, turn.

ROW 16: Rep Row 4.

ROW 17: Ch 2, hdc in next hdc, *fptr around next 2 fptr 2 rows below, sk 2 hdc, hdc in next 4 hdc, fptr around next 2 fptr 2 rows below; rep from * across, hdc in last 2 sts, turn.

ROW 18: Rep Row 4.

ROW 19: Ch 2, hdc in next hdc, C2L (see Special Stitches) over next 2 sts, *hdc in next 4 hdc, C4L over next 4 sts; rep from * to last 8 sts, hdc in next 4 hdc, C2L over next 2 sts, hdc in last 2 sts, turn.

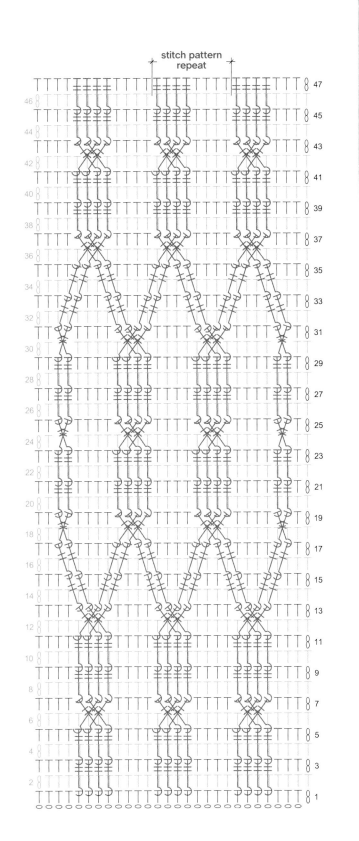

stitch pattern repeat

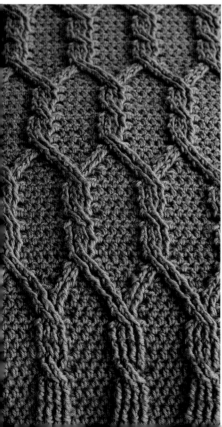

ROW 20: Rep Row 4.

ROW 21: Ch 2, hdc in next hdc, fptr around next 2 post sts 2 rows below, *hdc in next 4 hdc, fptr around next 4 post sts 2 rows below; rep from * to last 8 sts, hdc in next 4 hdc, fptr around next 2 post sts 2 rows below, hdc in last 2 sts, turn.

ROW 22: Rep Row 4.

ROWS 23–24: Rep Rows 21–22.

ROWS 25–26: Rep Rows 19–20.

ROWS 27–32 Rep Rows 21–26.

ROWS 33–34: Rep Rows 15–16.

ROW 35: Ch 2, hdc in next 3 hdc, *fptr in next 4 tr 2 rows below, sk 4 hdc behind post sts just made, hdc in next 4 hdc, rep from * across, turn.

ROW 36: Rep Row 4.

ROWS 37–38: Rep Rows 7–8.

Rep Rows 3–38 two more times, rep Rows 3–12 once more, change to smaller hook.

finishing
EDGING

RND 1: With smaller hook, ch 2 (counts as hdc here and throughout), *hdc in each st across to next corner, (hdc, ch 3, hdc) in corner st, hdc in each row-end st to next corner, (hdc, ch 3, hdc) in corner st, rep from * once, sl st in top of beg ch-2 to join—494 hdc, four ch-3 lps.

RND 2: NOTE: Backmost lps are located directly under the top 2 lps of the st, on the side of the work facing away from you. This is not the same as the back loop of the st. Ch 2, working in backmost lps of sts, *hdc of each hdc around, working 3 hdc in each corner ch-3 sp, sl st in top of beg ch-2 to join—506 hdc.

RNDS 3–5: Ch 2, working in backmost lps of sts, *hdc in each hdc around, working 3 hdc in each corner hdc, sl st in top of beg ch-2 to join.

RNDS 6–7: Ch 2, working in top 2 lps of sts, *hdc in each hdc around, working 3 hdc in each corner hdc, sl st in top of beg ch-2 to join.

RND 8: Rep Rnd 2.

RND 9: Ch 2, working in front lps of sts, *hdc in each hdc around, working 3 hdc in each corner hdc, sl st in top of beg ch-2 to join.

RNDS 10–13: Rep Rnd 2.

RND 14: Rep Rnd 6—602 hdc.

Block as desired. Weave in loose ends.

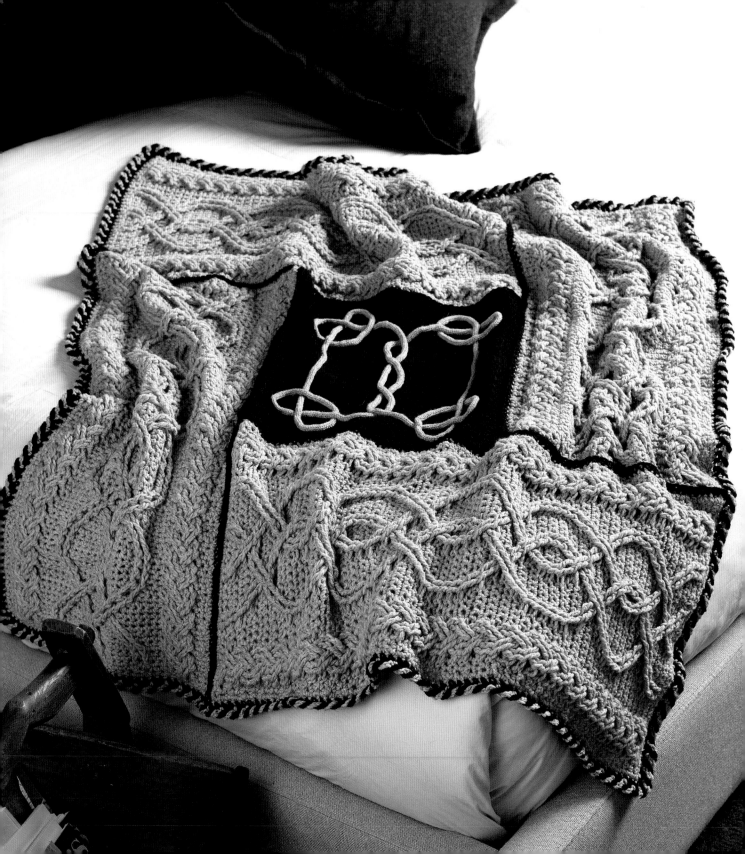

vika

Cables and Celtic history fascinate me, so these had to be the inspiration for my Vika Afghan. Pronounced "Vee-kah," the Celtic meaning is "from the creek," which is fitting because I live near a creek. The log cabin construction of this afghan provides an unusual twist, and the central Celtic-style knot in applied I-cord adds further interest and is a another fun technique to add to your repertoire. ● BY JILL WRIGHT

MATERIALS

Yarn Worsted weight (#4 Medium).

Shown Brown Sheep Company, Nature Spun Worsted (100% wool; 245 yd [224 m]/3.5 oz [100 g]): #720W Ash (MC), 12 balls; #111W Plumberry (CC), 3 balls.

Hooks J/10 (6.00 mm), N (9.00 mm), or sizes needed to obtain gauge.

Notions Tapestry needle, straight pins for blocking.

GAUGE

12 sts and 10 rows = 4" x 4" (10 x 10 cm) in dc/sc patt.

10 sts and 13 rows = 4" x 4" (10 x 10 cm) in sc.

FINISHED SIZE

50" x 50" (127 x 127 cm).

Center panel 16" x 16" (40.5 x 40.5 cm).

Outer panels 16" x 32" (40.5 x 81.5 cm) each.

NOTES

Turn after each row unless otherwise indicated.

Skip one st behind each post st worked unless directed otherwise.

SPECIAL STITCHES

Cable 4 Front (C4F) Sk next 2 sts, fptr around next 2 sts, working in front of 2 previous fptr, fptr around 2 skipped post sts.

Cable 4 Back (C4B) Sk next 2 sts, fptr around next 2 sts, working in back of 2 previous fptr, fptr around 2 skipped post sts.

Twist 3 Left (T3L) Sc in next st in current row, fpdc around next 2 post sts 2 rows below.

Twist 3 Right (T3R) Fpdc around next 2 post sts 2 rows below, sc in next st in current row.

Twist 4 Left (T4L) Sc in next 2 sts in current row, fptr around next 2 post sts 2 rows below.

Twist 4 Right (T4R) Fptr around 2 post sts 2 rows below, sc in next 2 sts in current row.

Braided Cable
Worked over 10 sts.

Row 1 (RS) (BC1) Ch 1 (does not count as st here and throughout), sc in next 2 sts, C4F, fpdc around next 2 sts, sc in next 2 sts.

Row 2 (and all WS rows) Ch 1, sc in next 2 sc, hdc in next 6 hdc 2 rows below, sc in next 2 sc in current row.

Row 3 (BC3) Ch 1, sc in next 2 sts, fpdc around next 2 sts, C4B, sc in next 2 sts.

Row 4 Rep Row 2.

Rep Rows 1–4 for patt.

pattern

CENTER PANEL

With CC and smaller hook, ch 49.

ROW 1 (RS): Sc in 2nd ch from hook, dc in next ch, *sc in next ch, dc in next ch, rep from * across, turn—48 sts.

ROW 2: Ch 1, *sc in next dc, dc in next sc, rep from * across, turn.

Rep Row 2 until work measures 16" (40.5 cm) from beg.

Without breaking yarn and with RS facing, change to larger hook, ch 1, 2 sc in first st, sc in next 38 sts, 3 sc in last st for corner, rotate work 90 degrees, work 38 sc evenly across, 3 sc in last row end for corner, rotate work, work 38 sc across foundation row, 3 sc in last st for corner, work 38 sc evenly across, sc in same st as beg 2 sc, sl st in beg ch-1 to join, fasten off.

CABLE PANELS
(make 4)

With MC and larger hook, ch 41.

SET UP ROW (WS): Sc in 2nd ch from hook, sc in next ch, hdc in next 6 ch, sc in next 2 ch, hdc in next 2 ch, *sc in next 4 ch, hdc in next 2 ch, rep from * twice, sc in next 2 ch, hdc in next 6 ch, sc in last 2 ch, turn—40 sts.

ROW 1 (RS): BC1 (see Special Stitches), fpdc around next 2 sts, *sc in next 4 sts, fpdc around next 2 sts, rep from * twice, BC1.

ROW 2 (AND ALL WS ROWS): Ch 1, leaving all post sts unworked, sc in first 2 sc in current row, hdc in next 6 hdc

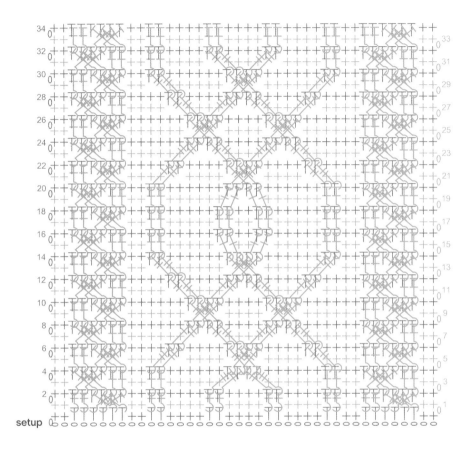

setup

When you're working the post stitches *behind* stitches already worked, you may find your stitches get caught on another stitch. Here's how to avoid that problem: Once you have the yarn hooked around the post and brought back to the front (3 lps on hook), before you complete the stitch try to raise the whole stitch area up above the already formed stitches so you can see the rest of your dc forming. Once the stitch is complete you can pop it back in place. —**JILL WRIGHT**

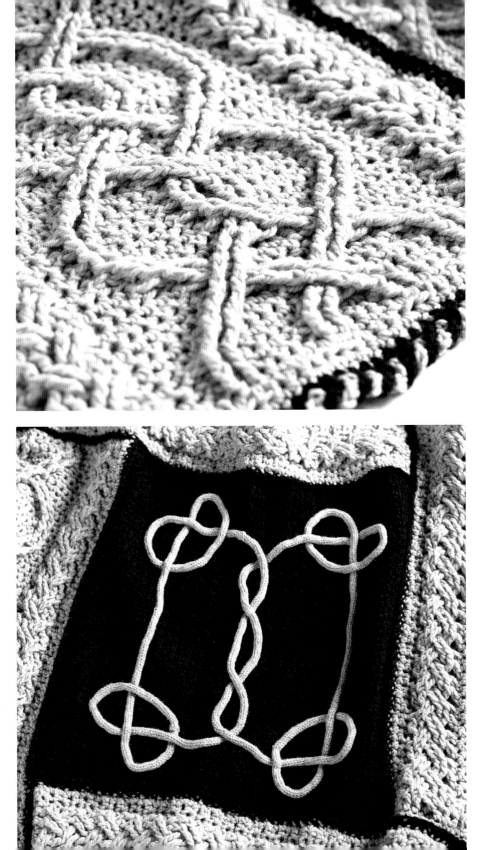

2 rows below, sc in next 2 sc in current row, [hdc in next 2 hdc 2 rows below, sc in next 4 sc in current row] 3 times, hdc in next 2 hdc 2 rows below, sc in next 2 sc in current row, hdc in next 6 hdc 2 rows below, sc in next 2 sc in current row, turn.

ROW 3: BC3 (see Special Stitches), fpdc around next 2 sts, sc in next 4 sts, T4L (see Special Stitches),T4R (see Special Stitches), sc in next 4 sts, fpdc around next 2 sts, BC3, turn.

ROW 5: BC1, T4L, sc in next 4 sts, C4F (see Special Stitches), sc in next 4 sts, T4R, BC1, turn.

ROW 7: BC3, sc in next 4 sts, T4L, T4R, sc in next 4 sts, T4L, T4R, sc in next 2 sts, BC3, turn.

ROW 9: BC1, sc in next 4 sts, C4B (see Special Stitches), sc in next 4 sts, C4B, sc in next 4 sts, BC1.

ROW 11: BC3, sc in next 2 sts, T4R, T4L, T4R, T4L, sc in next 2 sts, BC3, turn.

ROW 13: BC1, T4R, sc in next 4 sts, C4F, sc in next 6 sts, T4L, BC1, turn.

ROW 15: BC3, fpdc in next 2 sts, sc in next 5 sts, T3R, T3L, sc in next 5 sts, fpdc in next 2 sts, BC3, turn.

ROW 17: BC1, fpdc in next 2 sts, sc in next 5 sts, fpdc in next 2 sts, sc in next 2 sts, fpdc in next 2 sts, sc in next 5 sts, fpdc in next 2 sts, BC1, turn.

ROW 19: BC3, fpdc in next 2 sts, sc in next 5 sts, T3L, T3R, sc in next 5 sts, fpdc in next 2 sts, BC3, turn.

ROWS 21–30: Rep Rows 5–14.

ROW 31: BC3, fpdc in next 2 sts, sc in next 4 sts, T4R, T4L, sc in next 4 sts, fpdc in next 2 sts, BC3, turn.

ROW 33: Rep Row 1.

Rep Rows 1–33 twice more, then rep Row 1.

ROW 104: Ch 1, sc in first 2 sc in current row, working through double thickness, hdc in next 6 hdc 2 rows below and in corresponding post sts in current row (joining cable and background together), sc in next 2 sc in current row, [working through double thickness, hdc in next 2 hdc 2 rows below and in corresponding post sts in current row, sc in next 4 sc in current row] 3 times, working through double thickness, hdc in next 2 hdc 2 rows below and in corresponding post sts in current row, sc in next 2 sc in current row, working through double thickness, hdc in next 6 hdc 2 rows below and in corresponding post sts in current row, sc in next 2 sc in current row, turn.

Without breaking yarn and with RS facing, work 1 sc rnd as foll: ch 1, 2 sc in first st, sc in next 38 sts, 3 sc in last st for corner, work 78 sc evenly across long edge, 3 sc in last st for corner, sc in 38 sts across foundation row, 3 sc in last st for corner, work 78 sc evenly across long edge, sc in same st as beg 2 sc, sl st in beg ch-1 to join, fasten off.

I-CORD
(make 2)
Using MC and smaller hook ch 4.

RND 1: Insert hook in 2nd ch from hook and pull up lp, keeping all lps on

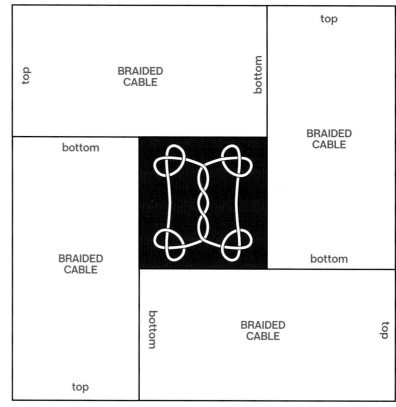

assembly diagram

hook, [insert hook in next ch, pull up lp] twice (4 lps on hook).

RND 2: Pinch work, slip last 3 sts from hook, ch 1 in rem lp, again keeping all lps on hook [sl next st back onto hook, ch 1 in this lp] 3 times (4 lps on hook).

Rep Rnd 2 until I-cord is 60" (152.5 cm) long, fasten off, using tapestry needle pull yarn end through all 4 lps on hook and secure.

finishing
BLOCKING AND SEAMING
Block each piece separately as foll: soak in cold water, roll piece in dry towel to squeeze out excess moisture, block to size. Block I-cord as foll: repeat as for panels, but tug gently after removing moisture, allow to dry. Seam pieces together using sc with CC and larger hook, beginning at center panel and working toward outside

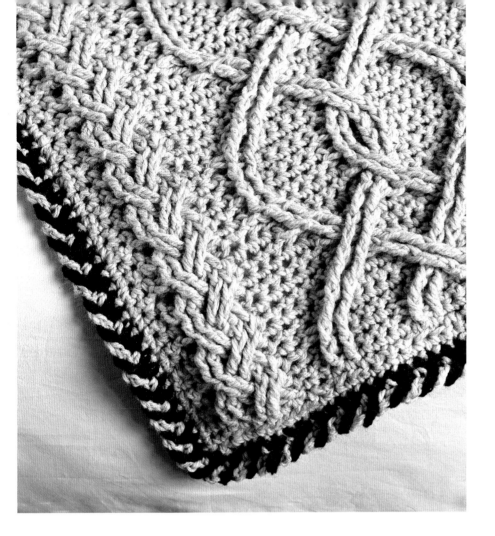

edge, matching sts as you go (see assembly diagram for placement).

CENTER PANEL KNOT
Follow assembly diagram for I-cord placement in center panel.

NOTE: Corner knots should be angled across corners. Knots can be started anywhere, but preferably where the ends can be stitched together underneath a crossing point.

BARBER POLE EDGING
RND 1: With smaller hook, join CC with sl st in any corner st, ch 1, 2 sc in corner st, sc around whole afghan working 3 sc in each corner st, do not join.

RND 2: Ch 4, drop lp from hook, join MC with sl st in next st, ch 4, drop lp from hook, *bring CC over top of MC, slip CC lp back on hook, sc in next st, ch 3, slip lp off hook, bring MC over top of CC, slip MC lp back on hook, sc in next st, ch 3, slip lp off hook, rep from * around, sc in final st using CC, fasten off CC, slip hook back in last MC lp, working in front of first CC ch, sc in same sp where MC joined, fasten off MC. Weave in loose ends.

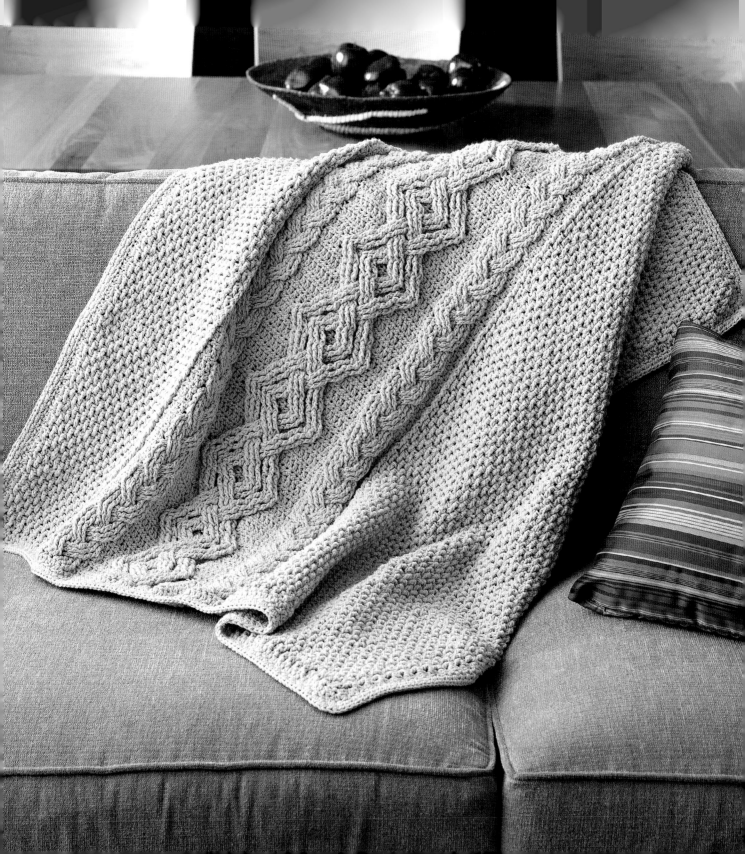

veledílo cable afghan

Veledílo means "masterpiece" in Czech. Inspired by a stunning knitted pillow project, the focal point of this afghan is a double cable forming diamonds, enclosed by a braid on each side. Laid against a basketweave stitch pattern, it's a celebration of texture and elegance, resulting in an heirloom-quality blanket to be handed down through generations. ● BY SIMONA MERCHANT-DEST

MATERIALS

Yarn Worsted weight (#4 Medium).

Shown Lion Brand Yarn Cotton Ease (50% cotton, 50% acrylic; 207 yd [188 m]/3.5 oz [100 g]): #186 Maize, 11 (14) balls.

Hook G/6 (4 mm) or size needed to obtain gauge.

Notions Removable stitch markers, tapestry needle, spray bottle with water, and straight pins for blocking.

GAUGE

16 sts and 10 rows = 4" x 4" (10 x 10 cm) in alternating fpdc, bpdc.

14 sts and 10 rows = 4" x 4" (10 x 10 cm) in alternating dc and hdc rows.

FINISHED SIZE

Size Small (large).

36" x 41" (44" x 49") (91.5 x 104 cm [112 x 124.5 cm]). Shown in small size.

NOTES

Afghan is worked from lower edge up. Starting with foundation single crochet (fsc) at the lower edge, alternating fpdc and bpdc is worked on either side of the double diamond cable pattern. After afghan is finished, a decorative edging is worked in the round.

tip When working long patterned rows, as with this afghan, check your work often to avoid mistakes. To help with counting stitches, mark every 20th or 50th fsc with a removable stitch marker.
—SIMONA MERCHANT-DEST

pattern

Fsc 144 (176).

ROW 1 (WS): *Ch 3 (counts as dc here and throughout), dc in next fsc and in each fsc to end, placing markers in 28th and 84th st, turn—144 (176) dc.

ROW 2 (CABLE CROSS ROW): Ch 3, [fpdc in next dc, bpdc in next dc] 29 (37) times, fpdc in next 2 dc, dc in next 3 dc, *fpdc in next 3 dc, sk next 3 dc, fptr in next 3 dc, working in front of sts just made fptr in last 3 skipped sts (braid started)*, dc in next 10 dc, [sk next 3 dc, fptr in next 3 dc, working in back of sts just made fptr in last 3 skipped sts] 2 times (center cable started), dc in next 10 dc; rep from * to * once, dc in next 3 dc, fpdc in next dc, [fpdc in next st, bpdc in next st] 12 (20) times, fpdc in next dc, dc in last dc, turn.

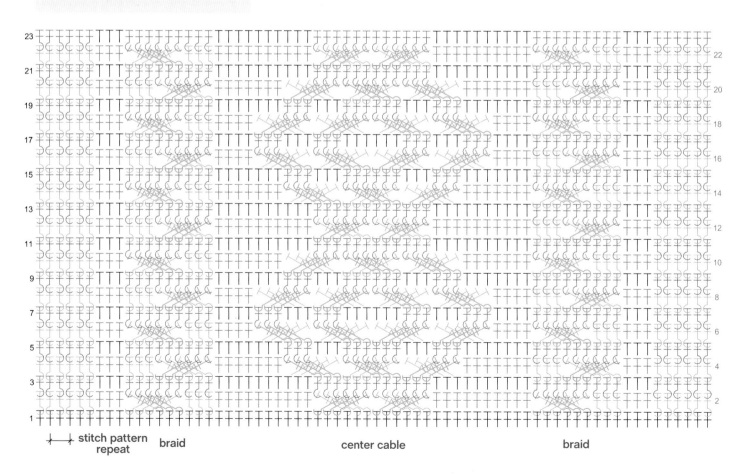

stitch pattern repeat braid center cable braid

partial stitch diagram

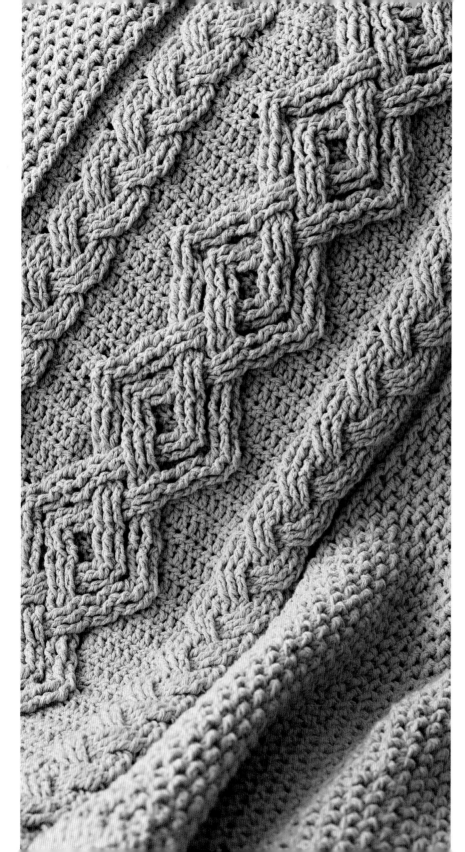

ROW 3: Ch 2 (counts as hdc here and throughout), [fpdc in next st, bpdc in next st] 13 (21) times, hdc in next 3 sts, bpdc in next 9 sts, hdc in next 10 sts, bpdc in next 12 sts, hdc in next 10 sts, bpdc in next 9 sts , hdc in next 3 sts, bpdc in next st, [fpdc in next st, bpdc in next st] 29 (37) times, fpdc in next dc, hdc in last st, turn.

ROW 4 (CABLE CROSS ROW): Ch 3, [fpdc in next st, bpdc in next st] 29 (37) times, fpdc in next 2 sts, dc in next 3 sts, *sk next 3 sts, fptr in next 3 sts, working in back of sts just made, fptr in last 3 skipped sts, fpdc in next 3 sts*, dc in next 7 sts, sk next 3 sts, fptr in next 3 sts, working in back of sts just made, dc in last 3 skipped sts, sk next 3 sts, fptr in next 3 sts, working in front of sts just made, fptr in last 3 skipped sts, sk next 3 sts, dc in next 3 sts, working in front of sts just made, fptr in last 3 skipped sts, dc in next 7 sts, rep from * to * once, dc in next 3 sts, fpdc in next st, [fpdc in next st, bpdc in next st] 12 (20) times, fpdc in next dc, dc in last st, turn.

ROW 5: Ch 2, [fpdc in next st, bpdc in next st] 13 (21) times, hdc in next 3 sts, bpdc in next 9 sts, hdc in next 7 sts, [bpdc in next 3 sts, hdc in next 3 sts, bpdc in next 3 sts] 2 times, hdc in next 7 sts, bpdc in next 9 sts, hdc in next 3 sts, bpdc in next st, [fpdc in next st, bpdc in next st] 29 (37) times, fpdc in next dc, hdc in last st, turn.

ROW 6 (CABLE CROSS ROW): Ch 3, [fpdc in next st, bpdc in next st] 29 (37) times, fpdc in next 2 sts, dc in next 3 sts, *fpdc in next 3 dc, sk next 3 dc, fptr

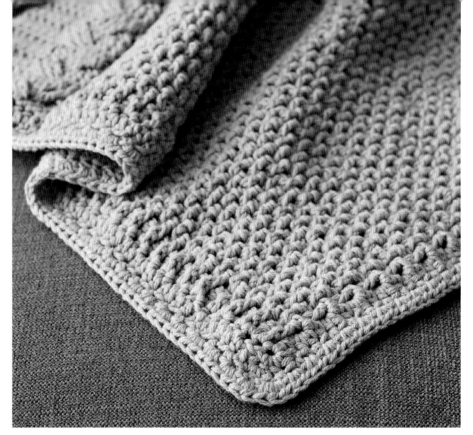

in next 3 dc, working in front of sts just made, fptr in last 3 skipped sts*, dc in next 4 sts, [sk next 3 sts, fptr in next 3 sts, working in back of sts just made, dc in last 3 skipped sts] 2 times, [sk next 3 sts, dc in next 3 sts, working in front of sts just made, fptr in last 3 skipped sts] 2 times, dc in next 4 sts, rep from * to * once, dc in next 3 sts, fpdc in next st, [fpdc in next st, bpdc in next st] 12 (20) times, fpdc in next dc, dc in last st, turn.

ROW 7: Ch 2, [fpdc in next st, bpdc in next st] 13 (21) times, hdc in next 3 sts, bpdc in next 9 sts, hdc in next 4 sts, *bpdc in next 3 sts, hdc in next 3 sts, bpdc in next 3 sts*, hdc in next 6 sts, rep from * to *once, hdc in next 4 sts, bpdc in next 9 sts, hdc in next 3 sts, bpdc in next st, [fpdc in next st, bpdc in next st] 29 (37) times, fpdc in next dc, hdc in last st, turn.

ROW 8 (CABLE CROSS ROW): Ch 3, [fpdc in next st, bpdc in next st] 29 (37) times, fpdc in next 2 sts, dc in next 3 sts, *sk next 3 sts, fptr in next 3 sts, working in back of sts just made fptr in last 3 skipped sts, fpdc in next 3 sts*, dc in next 4 sts, [sk next 3 sts, dc in next 3 sts, working in front of sts just made fptr in last 3 skipped sts] 2 times, [sk next 3 sts, fptr in next 3 sts, working in back of sts just made dc in last 3 skipped sts] 2 times, dc in next 4 sts, rep from * to * once, dc in next 3 sts, fpdc in next st, [fpdc in next st, bpdc in next st] 12 (20) times, fpdc in next dc, dc in last st, turn.

ROW 9: Rep Row 5.

ROW 10 (CABLE CROSS ROW): Ch 3, [fpdc in next st, bpdc in next st] 29 (37) times, fpdc in next 2 sts, dc in next 3 sts, *fpdc in next 3 dc, sk next 3 dc, fptr in next 3 dc, working in front of sts just made fptr in last 3 skipped sts*, dc in next 7 sts, [sk next 3 sts, dc in next 3 sts, working in front of sts just made fptr in last 3 skipped sts, sk next 3 sts, fptr in next 3 sts, working in front of sts just made fptr in last 3 skipped sts, sk next 3 sts, fptr in next 3 sts, working in back of sts just made dc in last 3 skipped sts, dc in next 7 sts, rep from * to * once, dc in next 3 sts, fpdc in next st, [fpdc in next st, bpdc in next st] 12 (20) times, fpdc in next dc, dc in last st, turn.

ROW 11: Rep Row 3.

ROW 12 (CABLE CROSS ROW): Ch 3, [fpdc in next dc, bpdc in next dc] 29 (37) times, fpdc in next 2 sts, dc in next 3 sts, *sk next 3 sts, fptr in next 3 sts, working in back of sts just made fptr in last 3 skipped sts, fpdc in next 3 sts*, dc

tip The use of cabling in crochet adds a great dimension to the fabric but can be a bit daunting for a beginner. To keep track of whether to work front- or back-post stitches, check the right side of the blanket if you feel you are getting lost, and follow the braid.
—SIMONA MERCHANT-DEST

in next 10 dc, [sk next 3 dc, fptr in next 3 dc, working in back of sts just made, fptr in last 3 skipped sts] 2 times, dc in next 10 dc, rep from * to * once, dc in next 3 sts, fpdc in next st, [fpdc in next st, bpdc in next st] 12 (20) times, fpdc in next dc, dc in last dc, turn.

ROW 13: Rep Row 3.

ROW 14 (CABLE CROSS ROW): Ch 3, [fpdc in next st, bpdc in next st] 29 (37) times, fpdc in next 2 sts, dc in next 3 sts, *fpdc in next 3 dc, sk next 3 dc, fptr in next 3 dc, working in front of sts just made, fptr in last 3 skipped sts*, dc in next 7 sts, sk next 3 sts, fptr in next 3 sts, working in back of sts just made dc in last 3 skipped sts, sk next 3 sts, fptr in next 3 sts, working in front of sts just made fptr in last 3 skipped sts, sk next 3 sts, dc in next 3 sts, working in front of sts just made fptr in last 3 skipped sts, dc in next 7 sts, rep from * to * once, dc in next 3 sts, fpdc in next st, [fpdc in next st, bpdc in next st] 12 (20) times, fpdc in next dc, dc in last st, turn.

ROW 15: Rep Row 5.

ROW 16 (CABLE CROSS ROW): Ch 3, [fpdc in next st, bpdc in next st] 29 (37) times, fpdc in next 2 sts, dc in next 3 sts, *sk next 3 sts, fptr in next 3 sts, working in back of sts just made fptr in last 3 skipped sts, fpdc in next 3 sts*, dc in next 4 sts, [sk next 3 sts, fptr in next 3 sts, working in back of sts just made dc in last 3 skipped sts] 2 times, [sk next 3 sts, dc in next 3 sts, working in front of sts just made fptr in last 3 skipped sts] 2 times, dc in next 4 sts,

rep from * to * once, dc in next 3 sts, fpdc in next st, [fpdc in next st, bpdc in next st] 12 (20) times, fpdc in next dc, dc in last st, turn.

ROW 17: Rep Row 7.

ROW 18 (CABLE CROSS ROW): Ch 3, [fpdc in next st, bpdc in next st] 29 (37) times, fpdc in next 2 sts, dc in next 3 sts, *fpdc in next 3 dc, sk next 3 dc, fptr in next 3 dc, working in front of sts just made fptr in last 3 skipped sts*, dc in next 4 sts, [sk next 3 sts, dc in next 3 sts, working in front of sts just made fptr in last 3 skipped sts] 2 times, [sk next 3 sts, fptr in next 3 sts, working in back of sts just made dc in last 3 skipped sts] 2 times, dc in next 4 sts, rep from * to * once, dc in next 3 sts, fpdc in next st, [fpdc in next st, bpdc in next st] 12 (20) times, fpdc in next dc, dc in last st, turn.

ROW 19: Rep Row 5.

ROW 20 (CABLE CROSS ROW): Ch 3, [fpdc in next st, bpdc in next st] 29 (37) times, fpdc in next 2 sts, dc in next 3 sts, *sk next 3 sts, fptr in next 3 sts, working in back of sts just made fptr in last 3 skipped sts*, dc in next 7 sts, sk next 3 sts, dc in next 3 sts, working in front of sts just made fptr in last 3 skipped sts, sk next 3 sts, fptr in next 3 sts, working in front of sts just made, fptr in last 3 skipped sts, sk next 3 sts, fptr in next 3 sts, working in back of sts just made dc in last 3 skipped sts, dc in next 7 sts, rep from * to * once, dc in next 3 sts, fpdc in next st, [fpdc in next st, bpdc in next st] 12 (20) times, fpdc in next dc, dc in last st, turn.

ROW 21: Rep Row 3.

Rep Rows 2–21 four (five) more times.

Rep Rows 2–3 once more. Do not fasten off.

BORDER

RND 1 (RS): Ch 2, hdc evenly around afghan, working 2 hdc in each dc row-end, 1 hdc in each hdc row-end, and 3 hdc in each corner, sl st in beg hdc to join, do not turn.

RND 2: Ch 1, sc in first st, ch 1, *[sk next st, sc in next st, ch 1] to corner st, (sc, ch 1, sc) in corner st; rep from * around, sl st in first sc to join, turn.

RND 3: (Sl st, ch 2, hdc) in first ch-1 sp, *3 hdc in corner st, 2 hdc in each ch-1 sp to corner st; rep from * around, sl st in first st to join.

Fasten off and weave in loose ends.

finishing

Pin to measurements. Spritz with water and allow to dry.

granny motifs

When people hear mention of crochet, many think of some sort of granny square and for good reason.

Most of us have something made from granny squares somewhere in our house. They also make for great first projects. You get to practice crocheting by making all the squares, and most of the time you are not crocheting into a stitch (which can be hard for first timers to get their hook into) but into a large chain space.

Joining granny motifs can be as much fun as making all the pieces. You can sew them together as in Annette Petavy's Cabine de Dentelle Afghan (page 56), crochet them together with a single crochet stitch, join them as you crochet the last round of the block as in Edie Eckman's Mod Retro Afghan (page 52), or even join them with an entirely different motif in the corners as in Ellen Gormley's Peacock Afghan (page 48). The last is often used with hexagon motifs.

As seen in the Peacock Afghan, not all granny motifs are squares. Whether you are handsewing or crocheting hexagon motifs

together, you have a great opportunity to play with their geometry for your benefit. For a ceramic tile look, match tiles together on their sides so that they nestle into the adjoining ones as seen in Linda Permann's Dots and Poppies Afghan (page 42). By joining hexagons in columns and then joining the columns at the corners while keeping the motifs in line with adjoining ones, you will create a void between the motifs as shown in Tammy Hildebrand's Kaleidoscope afghan (page 60).

GRANNY MOTIF LOVE

I have been a fan of granny squares since the moment I picked up my first crochet hook. They are easy to whip up, and it gives you the best sense of accomplishment to see that pile of motifs grow. Plus, when you have all those blocks made, there are so many fun ways you can join them together.

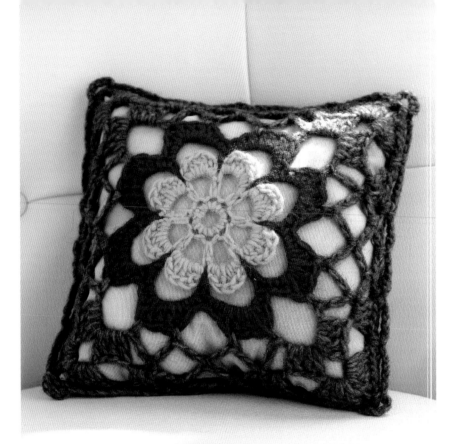

hatsukoi pillow

Granny squares make great pillow covers, whether as one huge motif as with this pillow or as multiple squares sewn together. If you're still new to motifs and granny squares, consider experimenting by making a few that inspire you and, instead of just keeping all those swatches, whip them up into a fun pillow. I hope that after you make your first few you will love motifs as much as I do.

MATERIALS

Yarn Chunky weight (#5 Bulky).

Shown Blue Sky Alpacas Techno (68% baby alpaca, 10% extrafine merino, 22% silk; 120 yd [109 m]/ 1.75 oz [50 g]): #1973 Rogue (MC), 1 hank; #1976 Cha-cha Red (CC1), 1 hank; #1979 Tonic Orange (CC2), 1 hank.

Hook K/10.5 (6.5 mm) or size needed to obtain gauge.

Notions Tapestry needle for weaving in ends, spray bottle with water and straight pins for blocking, 10" (25.5 cm) pillow form, two 11" (28 cm) square pieces of fabric, sewing needle and matching sewing thread.

GAUGE

First 3 rnds of motif = 4" (10 cm) in diameter; 1 motif = 10" x 10" (25.5 x 25.5 cm).

FINISHED SIZE

11" x 11" (28 x 28 cm).

pattern
(make 2)

With CC1, ch 5, sl st in first ch to form a ring.

RND 1 (RS) Ch 1, 8 sc in ring, sl st in first sc to join, do not turn—8 sc.

RND 2 Ch 1, (sc, ch 4) in each sc around, sl st in first sc to join, do not turn—8 sc.

RND 3 Ch 1, (sc, hdc, 3 dc, hdc, sc) in each ch-4 sp around, sl st in first sc to join, fasten off CC1, do not turn—8 petals.

RND 4 Join CC2 to sl st, ch 1, *sc bet next 2 sc, ch 6; rep from * around, sl st in first sc to join, do not turn—8 ch-sps.

RND 5 Ch 1, (sc, hdc, 5 dc, hdc, sc) in each ch-6 sp around, sl st in first sc to join, fasten off.

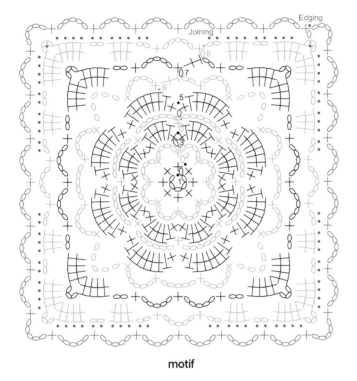

motif

RND 6 Join MC with sl st bet first 2 dc on next petal, sc in same sp, *ch 5, sc bet 4th and 5th dc on petal, ch 5, sc bet first and 2nd dc on next petal; rep from * to last petal, ch 5, sc bet 4th and 5th dc on last petal, ch 2, dc in first sc to join, do not turn—16 ch-sp.

RND 7 Ch 1, sc around post of dc, *ch 5, sc in next ch-5 sp, (ch 2, 4 dc, ch 3, 4 dc, ch 2) in next ch-5 sp, sc in next ch-5 sp, ch 5**, sc in next ch-5 sp; rep from * around, ending last rep at **, ch 2, dc in first sc to join, do not turn—20 ch-sps.

RND 8 Ch 1, sc around post of dc, *ch 5, sc in next ch-5 sp, ch 2, 3 dc in next ch-2 sp, ch 2, (4 dc, ch 3, 4 dc) in next ch-3 sp, ch 2, 3 dc in next ch-2 sp, ch 2, sc in next ch-5 sp; rep from * around, omitting last sc, sl st in first sc to join, fasten off, weave in loose ends.

finishing

Pin motifs to size and spray with water. While motifs are drying, create pillow form cover as foll: with RS tog and leaving a ¼" (6 mm) seam allowance, use sewing thread and needle to sew edges tog with straight stitches, leaving a 5" (12.5 cm) opening unsewn; turn right-side out, stuff pillow through opening, then sew opening closed.

Once dry, seam pillow motifs by pinning motifs to pillow. With MC, sl st corners tog as foll:

JOINING ROW Working though double thickness of front and back, join MC in ch-2 sp to the left of any center ch-5 sp on Rnd 8, sl st in each st to corner ch-3 sp, sl st in corner ch-3 sp, sl st in each st to second ch-2 sp on next side, fasten off. Rep joining row for each corner of pillow.

EDGING Working through double thickness, in the ch-sps in Rnd 8 of pillow, join MC in any corner ch-3 sp, ch 1, sc in same corner ch-3 sp, ** *ch 5, sc in next ch-sp; rep from * to corner **, (sc, ch 5, sc) in corner; rep from ** to ** around, sc in first corner ch-3 sp, ch 5, sl st in first sc to join, fasten off.

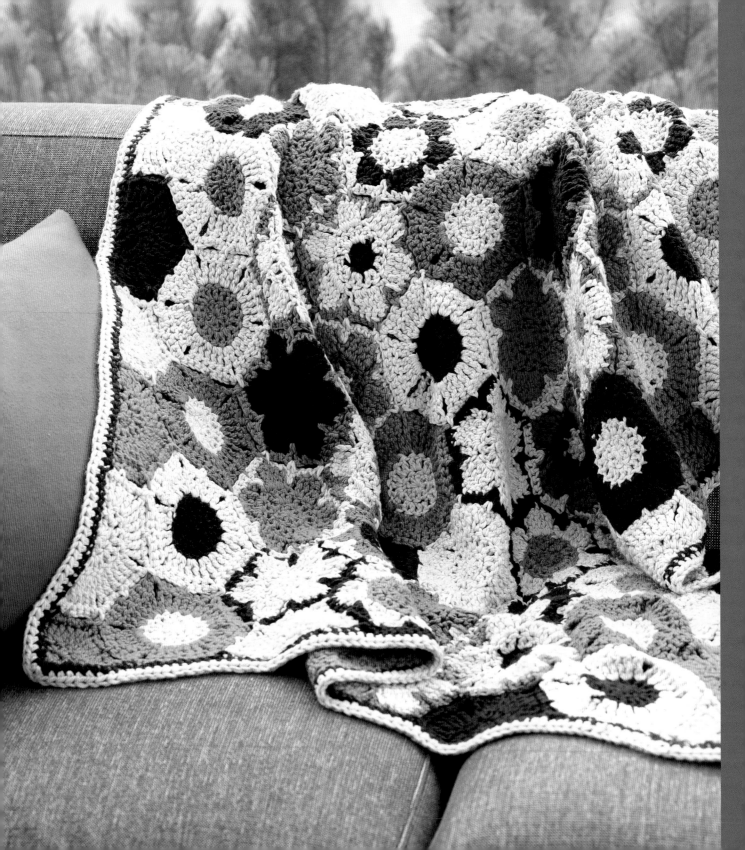

dots + poppies baby blanket

For me, color changes keep a basic shape interesting even as I crochet it again and again. I designed this blanket with the color lover in mind—pick a handful of colors and have fun placing the hexagons. If you'd like to lay out your motifs before joining them, leave the last round of each motif until the very end—that way you can still join them as you go but with a better idea of how your final layout will look. ● BY LINDA PERMANN

MATERIALS

Yarn Worsted weight (#4 Medium). **Note** Featured yarn is quite lofty; if using a lighter weight yarn, you may need to adjust your hook size accordingly.

Shown Blue Sky Alpacas Worsted Cotton (100% organically grown cotton; 150 yd [137 m]/3.5 oz [100 g]): 2 balls each in #606 Shell (A), #601 Poppy (B), #604 Aloe (C), #633 Pickle (D), #607 Lemongrass (E), and #623 Toffee (F).

Hook J/10 (6 mm) or size needed to obtain gauge.

Notions Tapestry needle for weaving in ends, spray bottle with water, and straight pins for blocking.

GAUGE

One completed Dot Motif (blocked) = 5" (12.5 cm) from flat side to flat side; 6" (15 cm) from point to point.

FINISHED SIZE

37" x 48" (94 x 122 cm). Size is modular—add or subtract motifs to alter final size.

NOTES

Color Keys are provided for motifs where color changes constitute the variation between motifs. Change colors as indicated in key. For best results, change colors on the last yarn over of the last stitch of the round before the new color is needed. Fasten off the old color at the end of color-change rounds, leaving a long tail for weaving in.

SPECIAL STITCHES

Motif join (MJ) With lp of working motif on hook, insert hook in corresponding ch-1 sp of joining motif (see diagram on page 45), sl st, cont along working motif.

pattern

Make motifs as instructed below, joining them tog as you go. Refer to diagram at right for motif placement. Beg with the starred Dot Motif, then work left to right along the row, joining each motif along 1 side, replacing ch-1 sp at corner and between sets of 3 dc with MJ (see Special Stitches). Cont to make and join full motifs (Solid and Multicolor Poppy Motif rows), working from the bottom up according to layout, joining each along three sides (total of four corners joined). When finished with all full motifs, make and join half and quarter motifs. In last round of each full motif, replace necessary ch-1 sps of working motifs with MJ instead, slip-stitching in ch-1 sps of corresponding hexagons to join. Further join the half-hexagons along the edge using decreases as directed along the first round of blanket edging.

DOT MOTIF [DM]
(Make 1, join 25 according to Color Key on page 45)
With first color, make an adjustable ring.

RND 1: Ch 3 (counts as dc here and throughout), 8 dc in ring, sl st in beg ch-3 to join—9 dc.

RND 2: Ch 3, dc in same st as join, 2 dc in each dc around, change to second color in last yarn over of last dc (see Notes), sl st in beg ch-3 to join—18 dc, fasten off first color.

RND 3: Join second color with sl st in same st as join, ch 6 (counts as tr, ch 2), tr in same st as join, 2 tr in each of next 2 sts, *(tr, ch 2, tr) in next st, 2 tr in each

of next 2 sts; rep from * around, sl st in 4th ch of beg ch-6 to join—36 tr, 6 ch-2 sps. Fasten off second color.

RND 4: Ch 1, sc in same st as join, *(sc, ch 1, sc) in next ch-2 sp, sc in next 3 sts, ch 1, sc in next 3 sts; rep from * 4 times more, replacing ch-1 sp with MJ (see Special Stitches) as necessary when joining to other hexagons, (sc, ch 1, sc) in next ch-2 sp, sc in next 3 sts, ch 1, sc in last 2 sts, sl st in first sc to join—48 sc, 6 ch-1 sps.

Fasten off.

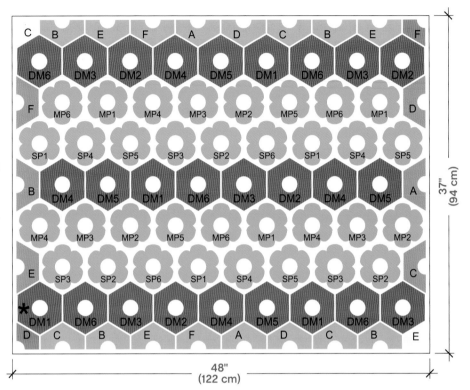

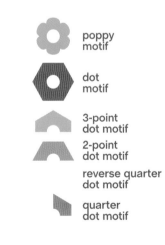

poppy motif

dot motif

3-point dot motif

2-point dot motif

reverse quarter dot motif

quarter dot motif

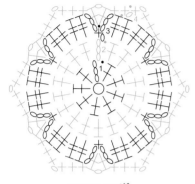

poppy motif

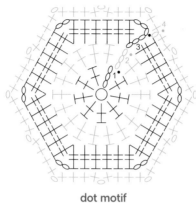

dot motif

POPPY MOTIF

(Join 17 each of 2 variations in 6 colorways according to Color Keys)
With first color, make an adjustable ring.

RND 1: Ch 3 (counts as dc here and throughout), 8 dc in ring, sl st in beg ch-3 to join—9 dc.

RND 2: Ch 3, dc in same st as join, 2 dc in each dc around, sl st in beg ch-3 to join—18 sc.

RND 3: Ch 1, sc in same st as join, ch 3, 2 tr in each of next 2 dc, *(ch 3, sc, ch 3) in next dc, 2 tr in each of next 2 dc; rep from * 4 times, ch 3, sl st in first sc to join—24 tr, 12 ch-3 sps. Fasten off.

RND 4: With RS facing, join final color in any tr just before ch-3 sp, ch 1, sc in tr,

Solid Poppy [SP] Color Key

	RNDS 1–3	RND 4	# MOTIFS
SP1	A	D	3
SP2	B	E	3
SP3	C	F	3
SP4	D	A	3
SP5	E	C	3
SP6	F	B	2

Dot Motif [DM] Color Key

	RNDS 1–2	RNDS 3–4	# MOTIFS
DM1	A	B	4
DM2	B	C	4
DM3	C	D	5
DM4	D	E	4
DM5	E	F	4
DM6	F	A	5

Multicolor Poppy [MP] Color Key

	RND 1	RND 2	RND 3	RND 4	# MOTIFS
MP1	A	C	F	E	3
MP2	B	E	A	D	3
MP3	C	F	D	A	3
MP4	D	B	C	F	3
MP5	E	D	B	C	2
MP6	F	A	E	B	3

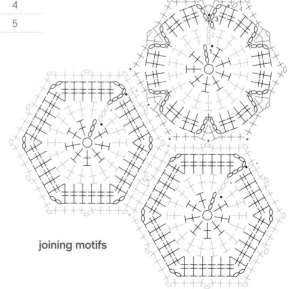

joining motifs

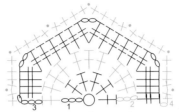

3-point dot motif

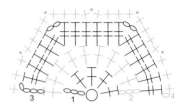

2-point dot motif

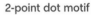

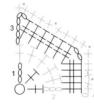

quarter-dot motif

reverse quarter-dot motif

sc in top ch of ch-3, (dc, ch 1, dc) in sc, sc in top of next ch-3, sc in next 2 sts, ch 1 (corner made), *counting top ch of each ch-3 sp as a st, sc in next 3 sts, (dc, ch 1, dc) in next sc, sc in next 3 sts, ch 1 (corner made); rep from * 4 times, replacing ch-1 sp with MJ as necessary when joining to other hexagons, sc in last sc, sl st in first sc to join —12 tr, 36 sc, 6 ch-1 sps, fasten off.

3-POINT DOT MOTIFS
(Join 2 in A, 4 in B, 3 in C, 2 in D, 3 in E and 2 in F)
Make an adjustable ring.

ROW 1 (WS): Ch 3 (counts as dc here and throughout), 5 dc in ring, turn—6 dc.

ROW 2 (RS): Ch 3, turn, 2 dc in each dc across, turn—11 dc.

ROW 3 (WS): Ch 4 (counts as tr), tr in first st, 2 tr in next st, *(tr, ch 2, tr) in next

st, 2 tr in each of next 2 sts; rep from * 2 times, turn—22 tr, 3 ch-2 sps.

ROW 4 (RS): Ch 1, sc in first 2 tr, MJ, sc in next 3 tr, *(sc, MJ, sc) in ch-2 sp, sc in next 3 sts, MJ, sc in next 3 sts; rep from * once, (sc, MJ, sc) in ch-2 sp, sc in next 3 sts, MJ, sc in last 2 sts—28 sc, 7 MJ, fasten off.

2-POINT DOT MOTIFS
(Join 1 in each color)
Make an adjustable ring.

ROW 1 (WS): Ch 3 (counts as dc here and throughout), 4 dc in ring, turn—5 dc.

ROW 2 (RS): Ch 3, dc in first st, 2 dc in each rem dc, turn—10 dc.

ROW 3 (WS): Ch 4 (counts as tr), * 2 tr in each of next 2 sts, (tr, ch 2, tr) in next

st; rep from * once, 2 tr in each of next 2 sts, tr in last st, turn—18 tr, 2 ch-2 sps.

RND 4 (RS): Ch 1, *sc in next 3 sc, MJ, in next 3 sc, (sc, MJ, sc) in next ch-2 sp; rep from * once, sc in next 3 sc, MJ, sc in last 3 sc—22 sc, 5 MJ, fasten off.

QUARTER (¼) DOT MOTIF
(Join 1 each in D and F)
Make an adjustable ring.

ROW 1 (WS): Ch 3 (counts as dc here and throughout), 2 dc in ring, turn—3 dc.

ROW 2 (RS): Ch 3, dc in first st, 2 dc in each dc across, turn—6 dc.

ROW 3 (WS): Ch 6, tr in first st, 2 tr in each of next 2 sts, (tr, ch 2, tr) in next st, 2 tr in each of of last 2 dc, turn—12 tr, 2 ch-2 sps.

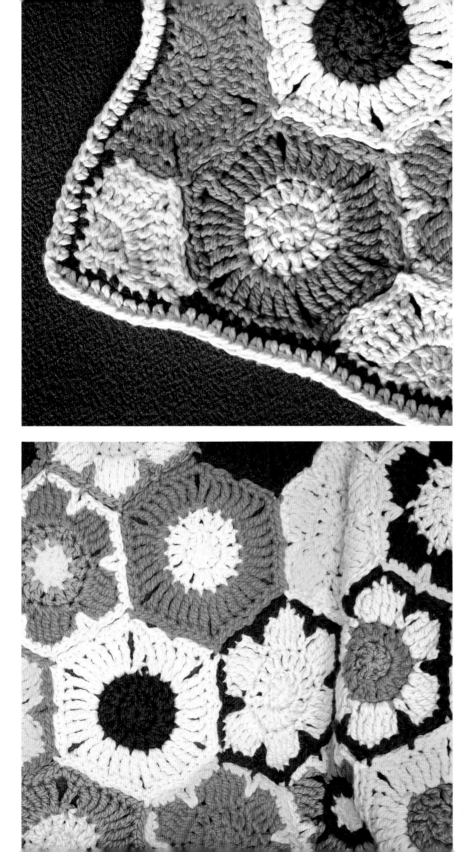

ROW 4 (RS): Ch 1, sc in first 2 sts, MJ, sc in next 3 sc, (sc, MJ, sc) in ch-2 sp, sc in next 3 sts, MJ, sc in next 3 sts, (sc, MJ, sc) in last ch-2 sp—15 sc, 4 MJ, fasten off.

REVERSE QUARTER (¼) DOT MOTIF
(Join 1 each in C and E)

Work same as Quarter-Dot Motif through Row 2.

ROW 3 (WS): Ch 4, tr in first st, 2 tr in next dc, (tr, ch 2, tr) in next dc, 2 tr in each of next 2 sts, (tr, ch 2, tr) in last dc, turn—12 tr, 2 ch-2 sps.

ROW 4 (RS): Sl st in first ch-2 sp, (sc, MJ, sc) in next ch-2 sp, sc in next 3 sts, MJ, sc in next 3 sts, (sc, MJ, sc) in next ch-1 sp, sc in next 3 sts, MJ, sc in last 2 sts—15 sc, 4 MJ, fasten off.

EDGING

RND 1: Join F with sl st in any st on edge of blanket, ch 1, sc evenly around entire outer edge of blanket, working (sc, ch 1, sc) in each corner, working sc2tog over last st of ending motif and first st of next motif at each junction bet motifs, sl st in first sc to join, fasten off.

RND 2: With RS facing, join C with sl st in any st, ch 2 (counts as hdc), hdc in each sc around, working (hdc, ch 1, hdc) in each corner ch-1 sp, fasten off.

finishing

Weave in loose ends. Soak blanket in cool water and spin dry in washing machine. Pin blanket to finished dimensions on blocking surface and allow to dry overnight.

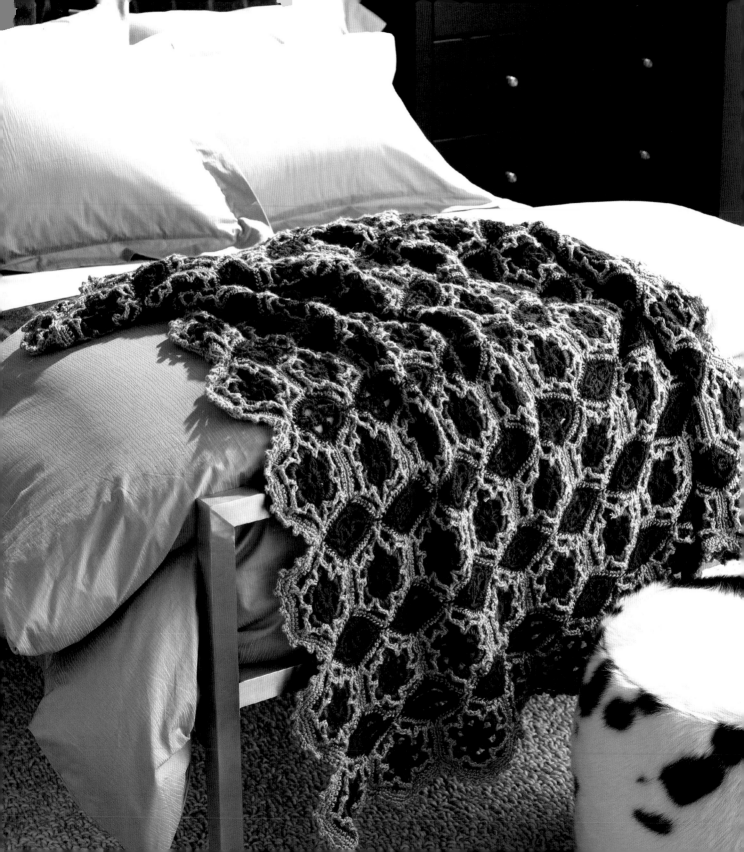

peacock afghan

Inspired by the colors of water and the depths of the ocean, I strived to show a foreground, middle ground, and background. Hexagons are very popular, but I wanted to use them with a twist. By orienting them point to point instead of interlocking them like a tile floor, negative space is created and then filled by the navy diamonds. The overlay picot round, the teal middle ground, and the dark diamonds make an interesting layering effect for this flat blanket. ● BY ELLEN GORMLEY

MATERIALS
Yarn Worsted weight (#4 Medium).

Shown Caron Yarn Simply Soft (100% acrylic; 315 yd [288 m]/6 oz [170 g]): #9711 dk country blue (MC), 3 balls; #9709 lt country blue (CC1), 6 balls; #0014 pagoda (CC2), 3 balls.

Hook K/10.5 (6.5 mm) or size needed to obtain gauge.

Notions Locking stitch markers, tapestry needle for assembly and weaving in ends.

GAUGE
Hexagon motif = 3" (7.5 cm) on each side; 6" (15 cm) from point to point; 5" (12.5 cm) from flat side to flat side.

FINISHED SIZE
51" x 51" (129.5 x 129.5 cm)

NOTES
All rounds are worked on the right side and are joined without turning.

SPECIAL STITCHES
3 Treble Cluster (3 tr-cl)
*Yo twice, insert hook in sp, yo and pull up a lp, (yo and draw through 2 lps on hook) 2 times; rep from * 2 times in same sp; yo and draw through all 4 lps on hook.

Beg tr cluster (beg tr-cl)
Ch 3; *yo twice, insert hook in sp, yo and pull up a lp, (yo and draw through 2 lps on hook) twice; rep from * once more in same sp, yo and draw through all 3 lps on hook.

Picot Sl st in 3rd ch from hook.

V-st (Dc, ch 2, dc) in same st.

pattern

HEXAGON MOTIF
(make 90)

With MC, ch 5, sl st in first ch to form a ring.

RND 1: Beg tr-cl (see Special Stitches) in ring, [ch 4, 3 tr-cl (see Special Stitches) in ring] 5 times, ch 4, sl st in top of beg cl to join, fasten off—6 tr-cl, 6 ch-4 sps.

RND 2: With RS facing, join CC1 with sl st in any tr-cl, ch 5 (counts as first dc, ch 2), dc in same st (first V-st made), *sk next ch-4 sp, ch 5, picot (see Special Stitches), ch 2**, V-st (see Special Stitches) in next tr-cl; rep from * 4 times; rep from * to ** once, sl st in 3rd ch of beg ch-5 to join, fasten off —12 ch-3 sps, 6 picots, 6 V-sts.

RND 3: With RS facing, join CC2 with sc in ch-2 sp of any V-st, sc in same sp; *working behind Rnd 2, 3 tr in next ch-4 sp of Rnd 1, sc in corresponding picot of Rnd 2, 3 tr in same ch-4 sp of Rnd 1**, 2 sc in ch-2 sp of next V-st; rep from * 4 times; rep from * to ** once, sl st in first sc to join, fasten off—36 tr, 18 sc.

RND 4: With RS facing, join CC1 with sc in first sc in Rnd 3; *sc in next 4 sts, fpdc around next sc, sc in top of same sc, fpdc around same sc**, sc in next 4 sts; rep from * 4 more times; rep from * to ** once, sc in last 3 sts, sl st in first sc to join, fasten off—12 fpdc, 54 sc.

DIAMOND MOTIF
(make 72)

With MC, ch 5, sl st in first ch to form a ring.

RND 1 Beg tr-cl in ring, ch 5, sc in ring, ch 5, 3 tr-cl in ring, ch 5, sc in ring,

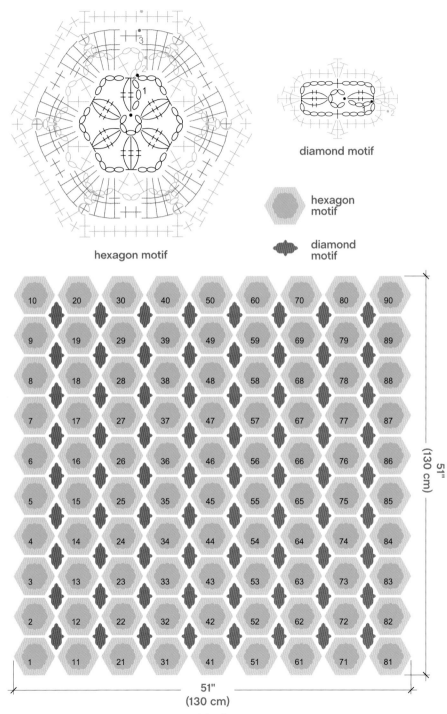

diamond motif

hexagon motif

hexagon motif

diamond motif

assembly diagram

51"
(130 cm)

51"
(130 cm)

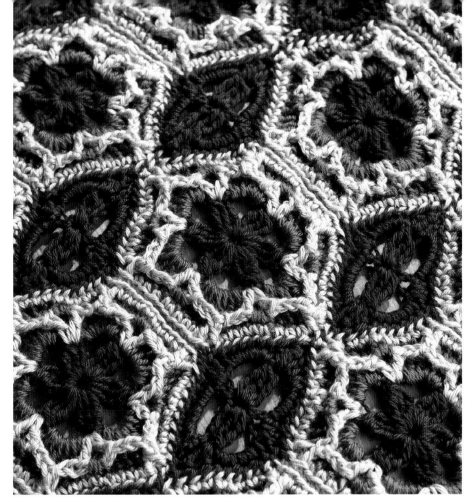

tip To keep count of numerous granny squares, I batch them in stacks of 10 or 20 in resealable plastic bags. —ELLEN GORMLEY

ch 5; sl st in top of beg tr-cl to join, do not fasten off—2 sc, 2 tr-cl, 4 ch-5 sps.

RND 2: Ch 3 (counts as dc), (tr, dc) in same st as join, 6 sc in next ch-5 sp, (hdc, dc, hdc) in next sc, 6 sc in next ch-5 sp, (dc, tr, dc) in next tr-cl, 6 sc in next ch-5 sp, (hdc, dc, hdc) in next sc, 6 sc in last

ch-5 sp; sl st in top of beg ch-3 to join, fasten off—2 tr, 8 dc, 8 hdc, 20 sc.

assembly

BLOCKING AND SEAMING

Spray block all motifs.

According to Assembly Diagram at left, arrange hexagons in 9 strips of 10 motifs each. With RS facing and CC2, working through both motifs at the same time, sl st motifs tog through the flp of the motif closest to you and blp of the motif farthest from you (the outermost lps when holding the motifs tog). After assembling all 9 strips, whipstitch diamonds to the first strip using yarn

needle and CC1. Use locking stitch markers to line up and secure diamonds to hexagons. Add a strip of hexagons to the opposite side of diamonds. Cont building side to side across the blanket, ending with a strip of hexagons.

EDGING

RND 1: With RS facing, join CC1 with sc in bottom-right corner of assembled blanket, sc in each st around, working 3 sc in middle st of 3-st corners of hexagons, sc2tog in joins (the middle st of 1 corner with the middle st of the next motif corner); sl st in first sc to join, do not fasten off.

RND 2: *Sc, ch 4, picot, ch 1, sk 3 sts; rep from * around; sl st in first sc to join, fasten off.

Weave in loose ends.

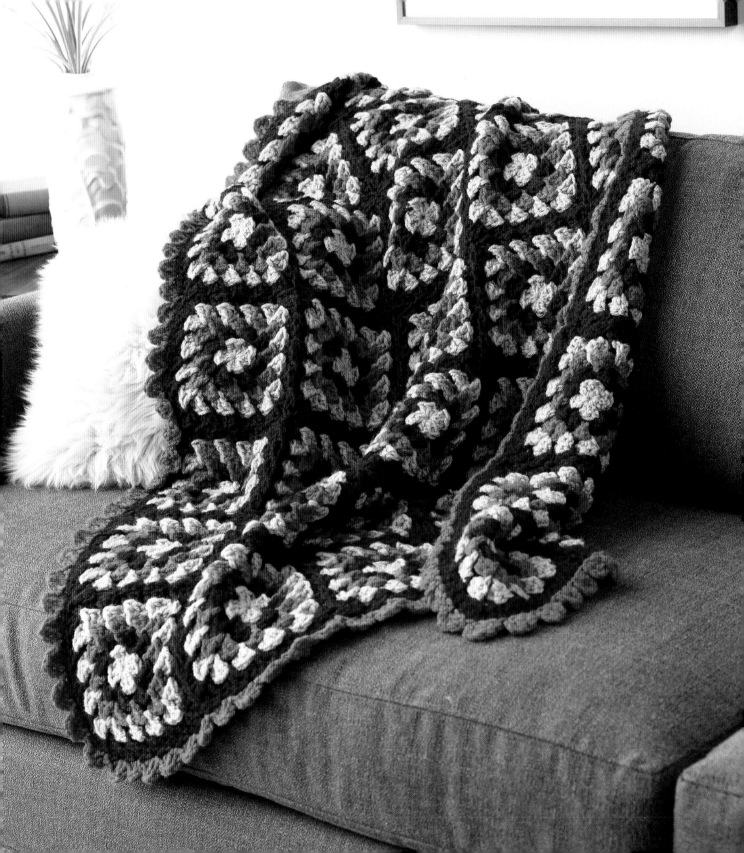

mod retro afghan

This fun afghan offers a twist on the traditional granny square. The clusters of extended double crochet and double crochet stitches add dimensionality and suggest movement. Don't worry about a slight biasing of the fabric—that's part of the charm! Joining as you go means there's no tedious sewing to do when you're finished. To customize the look, choose colors to suit your décor, or add additional squares for a larger afghan. ● BY EDIE ECKMAN

MATERIALS
Yarn Worsted weight (#4 Medium).

Shown Lion Brand Vanna's Choice (100% acrylic; 170 yd [156 m]/3.5 oz [100 g]): #140 Dusty Rose (A), 3 balls; #141 Wild Berry (B), 4 balls; #134 Terra Cotta (C), 3 balls.

Hook L/11 (8 mm) or size needed to obtain gauge.

Notions 4 stitch markers, tapestry needle for weaving in ends.

GAUGE
Rnds 1–5 of motif = 6½" x 6½" (16.5 x 16.5 cm).

FINISHED SIZE
35" x 48" (89 x 122 cm).

SPECIAL STITCHES
Extended Double Crochet (edc) Yo, insert hook in next st, yo and pull up a lp, yo and draw through 1 lp on hook, (yo and draw through 2 lps on hook) 2 times.

Partial Leaning Tower St Edc (see above), dc into base of edc just made as foll: yo, insert hook under both strands that form base of previous edc, yo and pull up a lp, (yo and draw through 2 lps) 2 times.

Leaning Tower St Edc, 2 dc into base of edc just made as foll: *yo, insert hook under both strands that form base of previous edc, yo and pull up a lp, (yo and draw through 2 lps) 2 times; rep from * once more.

Tower Stitch Motif (See stitch diagram on page 54.) With A, make an adjustable ring.

RND 1 (RS) Ch 3 (counts as dc), 11 dc in ring, sl st in top of beg ch-3 to join—12 dc. Fasten off.

RND 2 With RS facing, join B in any sp bet 2 dc, ch 3, leaning tower st (see above) in same sp, *sk 2 dc, 2 leaning tower sts in sp bet next 2 dc; rep from * 2 times, sk 3 dc, partial leaning tower st (see above) in beg sp, sl st in top of beg ch-3 to join. Fasten off.

RND 3 With RS facing, join C in any corner sp bet 2 tower sts, ch 3, leaning tower st in same sp, *leaning tower st

tower stitch motif

in sp bet next 2 tower sts, 2 leaning tower sts in sp bet next 2 tower sts; rep from * 2 times, leaning tower st in sp bet next 2 tower sts, partial leaning tower st in beg sp, sl st in top of beg ch-3 to join. Fasten off.

RND 4 With RS facing, join A in any corner sp bet 2 tower sts, ch 3, leaning tower st in same sp, *[leaning tower st in sp bet next 2 tower sts] 2 times**, 2 leaning tower sts in sp bet next 2 tower sts; rep from * around, ending last rep at **, partial tower st in beg sp, sl st in top of beg ch-3 to join. Fasten off.

RND 5 With RS facing, join B in corner sp bet 2 tower sts, ch 3, leaning tower st in same sp, *[leaning tower st in sp bet next 2 tower sts] 3 times**, 2 leaning tower sts in sp bet next 2 tower sts; rep from * around, ending last rep at **, partial tower st in beg sp, sl st in top of beg ch-3 to join. Fasten off.

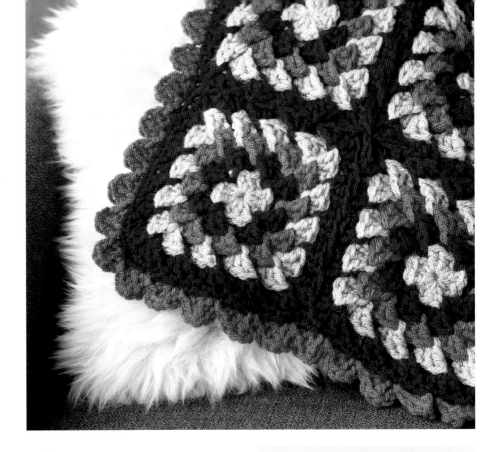

pattern

FIRST MOTIF

Make 1 tower stitch Motif (see Special Stitches).

SECOND AND ALL SUBSEQUENT MOTIFS

Make Tower Stitch Motif through Rnd 4. On Rnd 5, join to previous motif along 1 edge as foll: at corner, complete 1 leaning tower st, drop lp from hook and insert hook from front to back through adjacent sp on previous motif then into dropped lp; draw lp through; cont joining to previous motif along adjacent edge, after each tower st to next corner, then complete Rnd 5 of motif.

Make 33 additional motifs, joining to previous motifs along 1 or 2 edges as needed to create a rectangle 7 squares by 5 squares—35 motifs total.

tip Joining as you go saves a lot of tedious sewing, but it can be less portable than making individual motifs. To get the best of both worlds, make all the motifs up to but not including the last round, then work the final round on each motif while you join them together.
—EDIE ECKMAN

joining + edging diagram

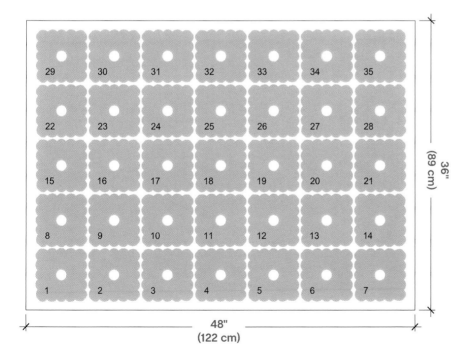

36"
(89 cm)

48"
(122 cm)

EDGING

RND 1: With RS facing, join B with sl st in any dc, ch 1, sc in each dc around, placing 1 sc in join bet squares and 1 sc in each corner (bet corner tower sts), sl st in first sc to join—384 sc. Fasten off. Place marker in each corner sc.

RND 2: With RS facing, join C with sl st in any corner sc, *sk 2 sc, leaning tower st in next sc, ch 3, sl st in same st; rep from * around, ending with (leaning tower st, ch 3, sl st) in beg corner st. Fasten off.

finishing

Block lightly. Weave in loose ends.

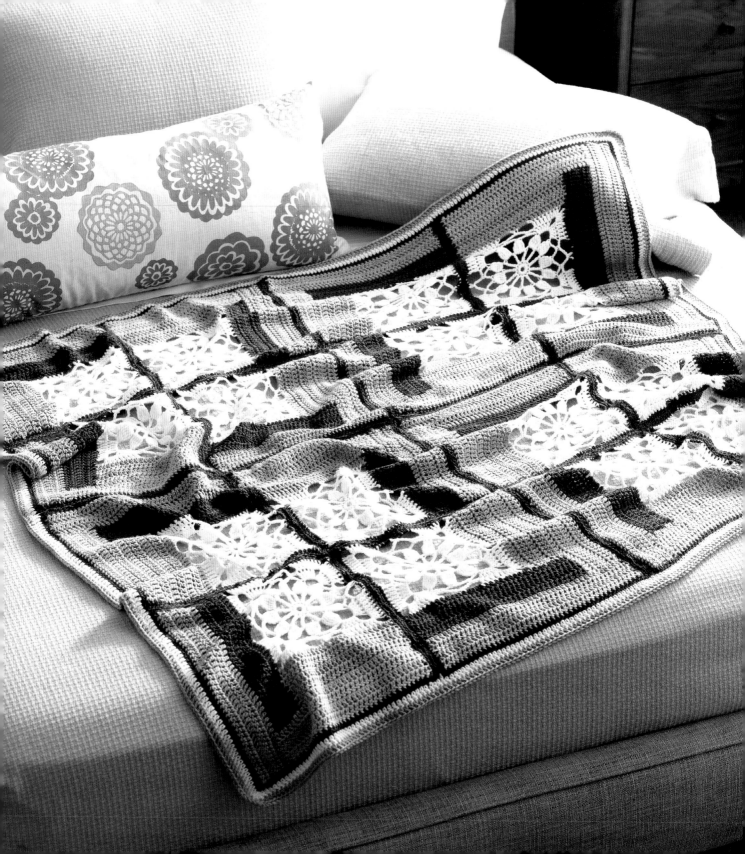

cabine de dentelle afghan

I've always been fascinated by the log-cabin motif and how its simplicity can be used as a backdrop for sophisticated compositions. The lacy flower is, in a way, the essence of crochet to me. In this afghan, I tried to put them together, to see how it turned out. In my opinion, it worked! ● BY ANNETTE PETAVY

MATERIALS
Yarn DK weight (#3 Light).

Shown Filatura di Crosa Zara (100% merino superwash; 137 yd [125 m]/ 1.75 oz [50 g]): 4 balls #1396 off white (MC), 4 balls #1494 light grey (CC1), 4 balls #1468 charcoal grey (CC2), 1 ball #1451 oatmeal (CC3).

Hook 7 (4.5 mm) or size needed to obtain gauge.

Notions Tapestry needle, straight pins for blocking.

GAUGE
15 dc and 8 rows = 4" (10 cm) in dc. Square = 7" x 7" (18 x 18 cm).

FINISHED SIZE
49" x 49" (124.5 x 124.5 cm).

NOTES
This design relies on the contrast between the solid dc "logs"—inspired by the traditional log cabin quilt design—and the airy flower motif. To achieve this contrast, the flower needs to be quite heavily blocked. I recommend pinning out the finished squares to measurements and ironing them (with a light hand) on the wrong side of the fabric.

SPECIAL STITCHES
4 Treble Crochet Cluster (4tr-cl) *Yo twice, insert hook in indicated sp, yo and pull up lp, [yo and draw through 2 lps on hook] 2 times; rep from * 3 times in same sp, yo and pull through rem 5 lps on hook.

5 Treble Crochet Cluster (5tr-cl) *Yo, insert hook in indicated sp, yo and pull up lp, [yo and draw through 2 lps on hook] 2 times; rep from * 4 times in same sp, yo and pull through rem 6 lps on hook.

pattern

SQUARE
(make 16)

With MC, ch 5, sl st in first ch to form a ring.

RND 1 (RS): Ch 1 (does not count as a st), 12 sc in ring, sl st in first sc to join—12 sc.

RND 2: Ch 7 (counts as tr, 3 ch), [tr in next sc, ch 3] 11 times, sl st in 4th ch of beg ch-7 to join—12 tr, 12 ch-3 sps.

RND 3: Sl st in ch-3 sp, ch 4 (counts as tr), 4tr-cl (see Special Stitches) in same ch-3 sp, [ch 6, 5tr-cl (see Special Stitches) in next ch-3 sp] 11 times, ch 3, dc in 4tr-cl at beg of rnd to join—12 tr clusters, 12 ch-6 sps.

RND 4: Ch 8 (counts as dc, ch 5), 5 dc around dc at end of previous round, *ch 2, sc in ch-6 sp, ch 7, sc in next ch-6 sp, ch 2, (5 dc, ch 5, 5 dc) in next ch-6 sp; rep from * 2 times, ch 2, sc in next ch-6 sp, ch 7, sc in next ch-6 sp, ch 2, 4 dc in next ch-6 sp, sl st in 3rd ch of beg ch-8 to join—4 "corners" with (5 dc, ch 5, 5 dc), 4 sides with (2-ch sp, sc, 7-ch sp, sc, 2-ch sp).

RND 5: Ch 3 (counts as dc), (3 dc, ch 5, 3 dc) in ch-5 sp, dc in each of next 5 dc, *ch 5, sc in ch-7 sp, ch 5, dc in next 5 dc, (3 dc, ch 5, 3 dc) in ch-5 sp, dc in next 5 dc; rep from * 2 times, ch 5, sc in next ch-7 sp, ch 5, dc in next 4 dc, sl st in 3rd ch of beg ch-8 to join. Fasten off.

LOG 1

ROW 1: With RS facing, join CC1 with sl st in any corner ch-5 sp, ch 3 (counts as dc), dc in same sp, dc in next 8 dc, 4 dc in next ch-5 sp, dc in next sc, 4 dc

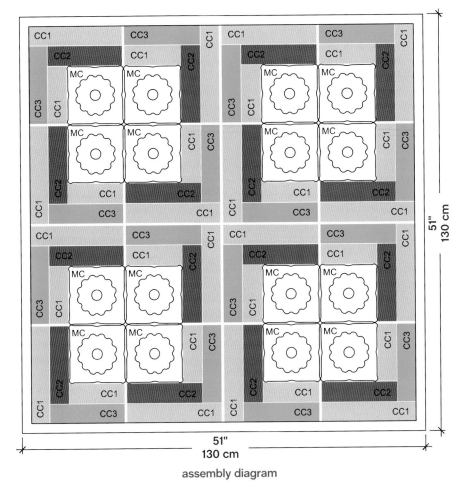

assembly diagram

in next ch-5 sp, dc in next 8 dc, 2 dc in next corner ch-5 sp, turn—29 dc.

ROWS 2–4: Ch 2 (does not count as a st), dc in each dc across, turn.

Fasten off.

LOG 2
Turn square 90 degrees counterclockwise, so Log 1 is on left side of square.

ROW 1: With RS facing, join CC2 with sl st in right-hand corner ch-5 sp, ch 3 (counts as dc), dc in same sp, dc in next

8 dc, 4 dc in ch-5 sp, dc in next sc, 4 dc in next ch-sp, dc in next 8 dc, 2 dc in next corner ch-5 sp, 2 dc around each row-end dc of Log 1, turn—37 dc.

ROWS 2–4: Ch 2 (does not count as a st), dc in first dc and in each dc across, turn.

Fasten off.

LOG 3
Turn square 90 degrees clockwise so Log 2 is on right side of square.

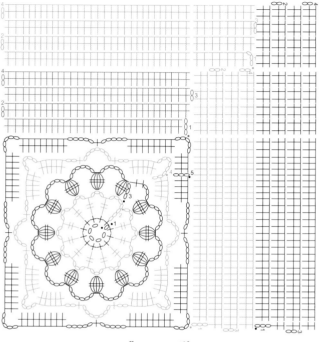

flower motif

ROW 1: With RS facing, join CC3 with sl st in top right-hand corner (row-end st of Row 4 of Log 2), ch 3 (counts as dc), dc in same row-end st, work 2 dc around each row-end dc of Log 2, then dc in each dc of Log 1, turn—37 dc.

ROWS 2–4: Ch 2 (does not count as a st), dc in first dc and in each dc across, turn.

Fasten off.

LOG 4

Turn square 90 degrees counterclockwise, so Log 3 is on left side of square.

ROW 1: With RS facing, join CC1 with sl st in top right-hand corner (last dc of row 4 of Log 2), ch 3 (counts as dc), dc in

each dc of Log 2, 2 dc around each row-end dc of Log 3 turn—45 dc.

ROWS 2–4: Ch 2 (does not count as a st), dc in first dc and in each dc across, turn.

Fasten off.

SQUARE EDGING

RND 1: With RS facing, join CC2 in any corner of square, ch 1, sc evenly around, working 1 sc in each dc, 2 sc in each row-end dc on edges of logs, and 1 sc in each corner st, sl st in first sc of edging to join—184 sts.

RND 2: Ch 1, sc in each sc around, working 3 sc in each corner st—192 sts.

finishing

BLOCKING AND SEAMING

Block the squares severely to stretch out the flower motif (see Notes). Pin them out to measurements, WS up, and iron lightly but thoroughly (preferably with a steam iron—if you don't have one, spray your square with water first). Let dry completely before removing pins.

Sew together 4 large squares as indicated in Assembly Diagram. Sew these 4 large squares together to form the square-shaped afghan.

BORDER

RND 1: With MC, dc around, working 3 dc in each of the 4 corners, sl st in first dc to join.

RND 2: With CC1, rep Rnd 1.

Fasten off. Weave in loose ends.

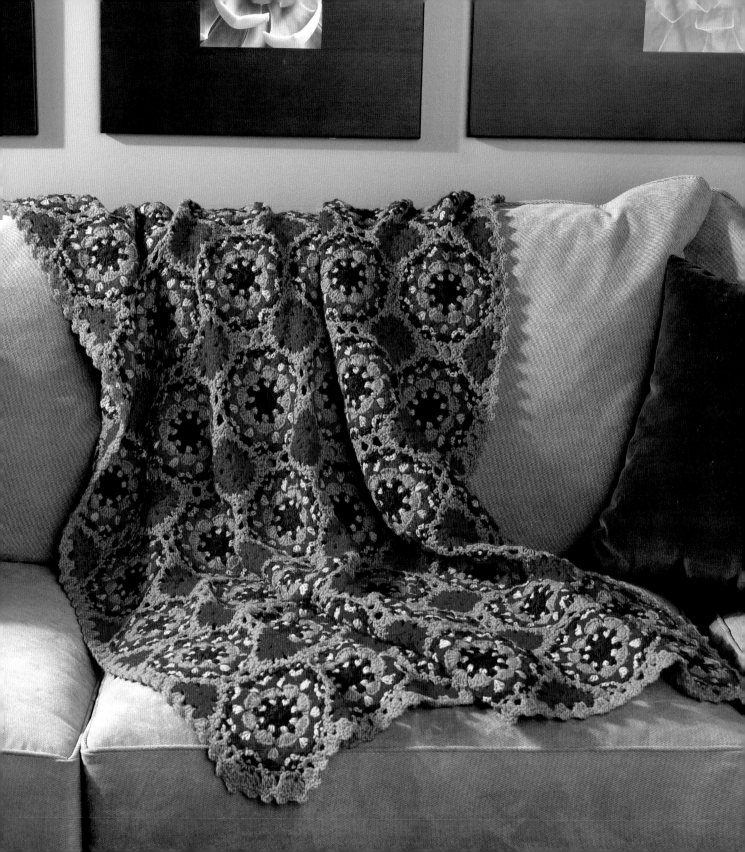

kaleidoscope

As a child, I was fascinated looking into my toy kaleidoscope, watching the ever-changing designs appear. That memory was the inspiration behind the Kaleidoscope afghan. Designing each motif, I imagined lying in the grass on a summer day, twisting the end of the kaleidoscope to come up with a beautiful new design. ● BY TAMMY HILDEBRAND

MATERIALS

Yarn Worsted weight (#4 Medium).

Shown Universal Yarn Deluxe Worsted 100% Wool (100% wool; 220 yd [200 m] 3.5 oz [100 g]): #91475 Sangria (A), 3 hanks; #12174 Ginseng (B), 3 hanks; #41795 Nectarine (C) 4 hanks; #3691 Christmas Red (D) 3 hanks.

Hook I/9 (5.5 mm) or size needed to obtain gauge.

Notions

Tapestry needle for weaving in ends, spray bottle with water, and straight pins for blocking.

GAUGE

Motif = 7" (18 cm) from flat side to flat side.

Filler = 3" x 3" (7.5 x 7.5 cm).

FINISHED SIZE

43" x 57" (109 x 145 cm).

NOTES

Do not turn at end of rnds unless otherwise instructed. Join each new color with RS facing.

SPECIAL STITCHES

Shell (sh) 3 dc in same sp or st.

Large Shell (lg-sh) 5 dc in same sp or st.

Ch-3 join Ch 1, drop lp from hook, insert hook in corresponding ch-3 sp on other motif, pick up dropped lp and draw through, ch 1.

Ch-5 join Ch 2, drop lp from hook, insert hook in corresponding ch-3 sp on other motif, pick up dropped lp and draw through, ch 2.

pattern

MOTIF
(make 48)

With A, ch 3, sl st in first ch to form a ring.

RND 1 (RS): Ch 3 (counts as dc), 15 dc in ring, sl st in top of beg ch to join—16 dc.

RND 2: Ch 1, sc in first st, ch 3, sk next st, *sc in next st, ch 3, sk next st; rep from * around, sl st in first sc to join, fasten off—8 sc, 8 ch-3 sps.

RND 3: Working behind ch-3 sps of previous rnd, join B with sl st in any skipped st, ch 3 (counts as dc), 2 dc in same st, ch 1, *sh (see Special Stitches) in next skipped st, ch 1; rep from * around, sl st in top of beg ch to join, fasten off—8 sh, 8 ch-1 sps.

RND 4: Join C with sc in any ch-1 sp, working in ch-3 sp of Rnd 2 and center st of sh on Rnd 3 at the same time, lg-sh (see Special Stitches) in next ch-3 sp and center st of next sh, *sc in next ch-1 sp, lg-sh in next ch-3 sp and center st of next sh; rep from * around, sl st in first sc to join, fasten off—8 lg-sh, 8 sc.

RND 5: Join D with sc in blo of center st of any lg-sh, (ch 3, sc) in blo of same st, (dc, ch 5, dc) in both lps of next sc, *(sc, ch 3, sc) in blo of center st of next lg-sh, (dc, ch 5, dc) in both lps of next sc; rep from * around, sl st in first sc to join, fasten off—8 ch-5 sp, 8 ch-3 sps.

RND 6: Join B with sc in any ch-3 sp, (ch 3, sc) in same sp, ch 1, working behind ch-5 sp between dc of Rnd 5, in same sc of Rnd 4, sh in next sc, ch 1, *(sc, ch 3, sc) in next ch-3 sp, ch 1, sh in next sc of

Rnd 4, ch 1; rep from * around, sl st in first sc to join, fasten off—8 ch-3 sps, 8 sh.

RND 7: Join A with sc in any ch-3 sp, (ch 3, sc in same sp), ch 1, working in ch-5 sp of Rnd 5 and center st of sh on Rnd 6 at the same time, 5 sc in next sp and center st of next sh, ch 1, *(sc, ch 3, sc) in next ch-3 sp, ch 1, 5 sc in next sp and center st of next sh, ch 1; rep from * around, sl st in first sc to join, fasten off—8 ch-3 sps, 48 sc.

First Strip
FIRST MOTIF ONLY

RND 8: Join C with sc in any ch-3 sp, (ch 3, sc) 3 times in same sp, sc in next ch-1 sp, sk next 2 sc, (sc, ch 3, sc) in blo of next sc, sc in next ch-1 sp, *(sc, [ch 3,

sc] 3 times) in next ch-3 sp, sc in next ch-1 sp, sk next 2 sc, (sc, ch 3, sc) in blo of next sc, sc in next ch-1 sp; rep from * around, sl st in first sc to join, fasten off—64 sc, 32 ch-3 sps.

MOTIFS 2–8

RND 8: Join C with sc in any ch-3 sp, (ch 3, sc, [ch-3 join {see Special Stitches}, sc] 2 times) in same sp, sc in next ch-1 sp, sk next 2 sc, (sc, ch-3 join, sc) in blo of next

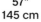

motif

filler motif

half motif

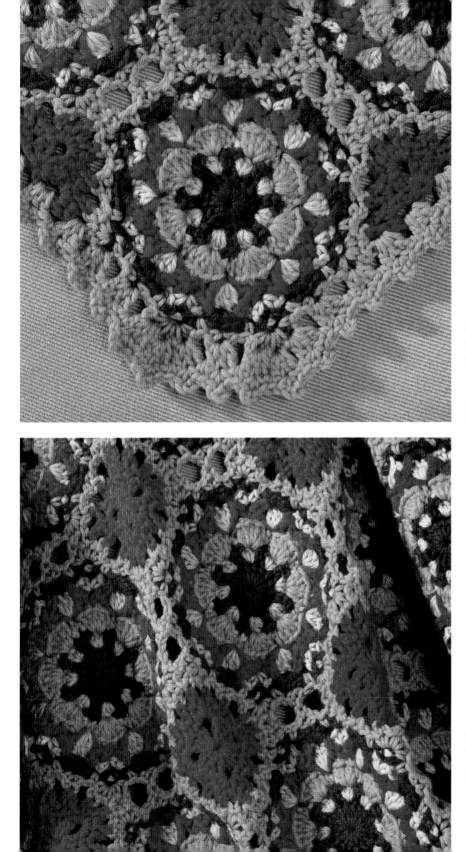

sc, sc in next ch-1 sp, ([sc, ch-3 join, sc] 2 times, ch 3, sc) in next ch-3 sp, sc in next ch-1 sp, sk next 2 sc, (sc, ch 3, sc) in blo of next sc, sc in next ch-1 sp, *(sc, [ch 3, sc] 3 times) in next ch-3 sp, sc in next ch-1 sp, sk next 2 sc, (sc, ch 3, sc) in blo of next sc, sc in next ch-1 sp; rep from * around, sl st in first sc to join, fasten off.

Strips 2–6
FIRST MOTIF ONLY
RND 8: Rep Rnd 8 as for motifs 2–8, joining to side of first strip.

MOTIFS 2–8
RND 8: Join C with sc in any ch-3 sp, (ch 3, sc, [ch-3 join, sc] 2 times) in same sp, sc in next ch-1 sp, sk next 2 sc, (sc, ch-3 join, sc) in blo of next sc, sc in next ch-1 sp, ([sc, ch-3 join, sc] 2 times, ch 3, sc) in next ch-3 sp, sc in next ch-1 sp, sk next 2 sc, (sc, ch 3, sc) in blo of next sc, sc in next ch-1 sp, (sc, ch 3, [sc, ch-3 join, sc] 2 times) in next ch-3 sp, sc in next ch-1 sp, sk next 2 sc, (sc, ch-3 join, sc) in blo of next sc, sc in next ch-1 sp, ([sc, ch-3 join, sc] 2 times, ch 3, sc) in next ch-3 sp, sc in next ch-1 sp, sk next 2 sc, (sc, ch 3, sc) in blo of next sc, sc in next ch-1 sp, * (sc, [ch 3, sc] 3 times) in next ch-3 sp, sc in next ch-1 sp, sk next 2 sc, (sc, ch 3, sc) in blo of next sc, sc in next ch-1 sp; rep from * around, sl st in first sc to join, fasten off.

FILLER MOTIF
With D, ch 3, sl st in first ch to form ring.

RND 1: Ch 3 (counts as dc), 2 dc in ring,

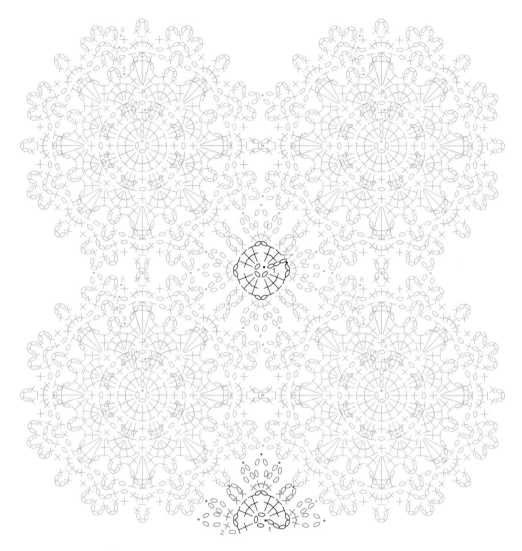

joining and filler motif

ch 2, *3 dc in ring, ch 2; rep from * 3 more times, sl st in top of beg ch-3 to join, 12 dc, 4 ch-2 sps.

RND 2: Ch 1, sl st in next st, ch 1, *sc in center st, working in opening bet motifs and joining to chs, ch-5 join (see Special Stitches) attaching to side of motif, sc in same sc on filler, sc in next ch-2 sp, ch-5 join in next ch on motif, sc in same sp on filler, ch-5 join in center of motif joining, sc in same sp on filler, ch-5 join in next ch on motif, sc in same sp on filler; rep from * around, sl st in first sc to join, fasten off—24 sc, 16 ch-5 joins.

> "There are many advantages to granny squares. When they are squares, they can be added up in different configurations to make all types of garments or home decor items. Everything from pot holders to sweaters and skirts can be made of squares. Because granny squares are usually symmetrical, it's easy to memorize one side of the instructions, then repeat it for the total number of sides." —ELLEN GORMLEY

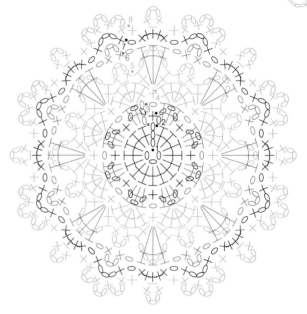

kaleidoscope motif

HALF FILLER MOTIF

With D, ch 3, sl st in first ch to form ring.

RND 1: Ch 5 (counts as dc, ch 2), [3 dc in ring, ch 2] 2 times, dc in ring, turn—8 dc, 3 ch-2 sps.

RND 2: Ch 1, sc in first st, working around outside of afghan in sp bet motifs, ch-5 join in corner ch-3, sc in ch-2 sp on filler, ch-5 join in next ch-3 on motif, sc in same ch-2 sp on filler, sk next st, (sc, ch-5 join, sc) in next st, sc in next ch-2 sp, ch-5 join in next ch on motif, sc in same sp on filler, ch-5 join in center of motif joining, sc in same sp on filler, ch-5 join in next ch on motif, sc in same sp on filler, sk next st, (sc, ch-5 join, sc) in next st, sc in next ch-2 sp, ch-5 join in next ch on motif, sc in same ch-2 sp, ch-5 join in next ch on motif, sc in 3rd ch of turning ch, fasten off.

BORDER

RND 1: With RS facing, join C with sl st in any ch-3 sp on outer edge of afghan, ch 3, (counts as dc), 2 dc in same sp, *sh in each ch-3 sp to next filler, 3 dc in center of joining, sh over post of st at each end of Row 1, 3 dc in center of joining; rep from * around, sl st in top of beg ch-3 to join.

RND 2: Ch 1, sc in same sp as join, (sc, ch 3, sc) in center st of next sh, *sc in sp before next sh, (sc, ch 3, sc) in center of next sh; rep from * around, sl st in first sc to join, fasten off.

finishing

Weave in loose ends. Spread afghan flat on soft surface such as folded blankets or a bare mattress. Using spray bottle, mist entire afghan. Place pins around edges to hold in place. Allow to dry completely before removing pins.

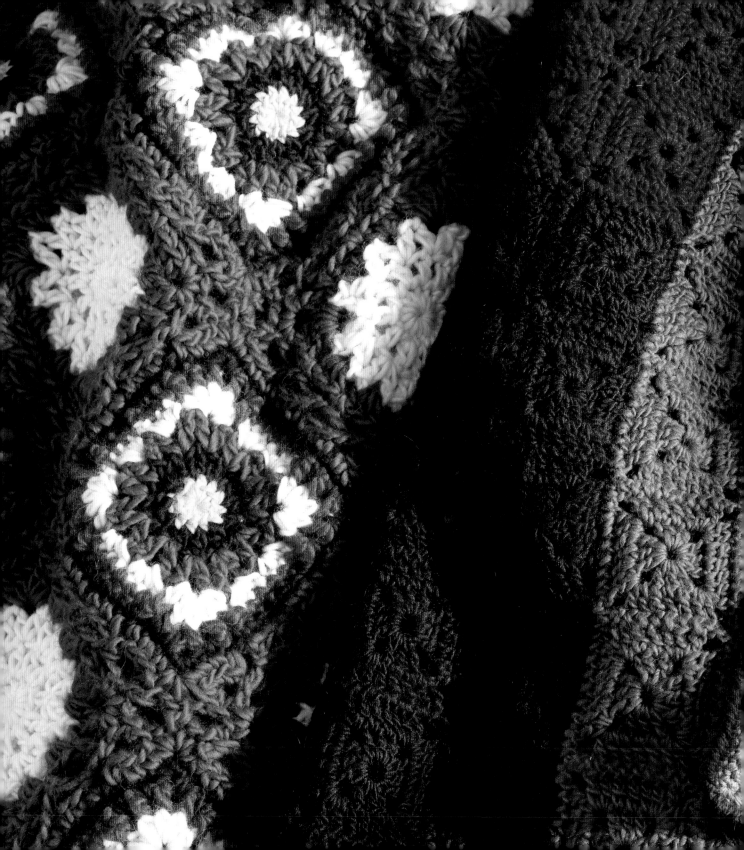

"Colorwork" in crochet means anything to do with using multiple colors.

It can be stripes (as in the Elan Waves Pillow on page 68), it can be solid blocks of color joined together (as in the Peerie Baby Blanket on page 70 or Behrens Color Block Afghan on page 74), and it can be a charted design (as in the Desert Sunrise afghan on page 78). In most cases, adding additional colors to your project does not make it more difficult, it just requires the skill to combine colors into a pleasing palette. Take a look at Linda Permann's Dots and Poppies Baby Blanket (page 42). She makes combining all those colors look like child's play. For me, the color novice, I use cheat sheets. I will look for photos of nature or tiles or anything that pops for me, then go and match the colors in the photo with yarn. I know they will look okay together, because I have the cheat sheet.

Once you get over the initial hurdle of choosing colors to combine, the technique to change yarn color is quite simple. You crochet normally to the stitch before you want a color change, finish that stitch until there are only two loops left on the hook, wrap the new yarn around your hook (as if doing a yarn over) and complete the stitch. You will have added that new color and finished the old color in one fell swoop.

All that's left is deciding what to do with that old color. Do you want to carry it up the side or across the back of the work until you use it again? Do you want to crochet over that strand until you will use it again (as in tapestry crochet)? Or will you just cut that strand and rejoin the color when you need it next?

There are benefits to either technique of carrying your unused yarn—crocheting around it (tapestry crochet) or stranding it behind your work (stranded colorwork). When using tapestry crochet and crocheting around the unused yarn, you get a nearly reversible fabric that can make projects with no distinct right side (like afghans) really special. Stranding unused yarn results in a less dense fabric. For me it comes down to numbers—if I'm only using two colors in my project, I use tapestry crochet; if there are more colors, I will strand or cut and rejoin.

My favorite colorwork trick is for making stripes. If you use an odd number of colors, changing color at the end of each row, you will never have to weave in ends. Whenever you get to the end of the row, the color you need will be waiting for you at the end. It is like magic and only works with an odd number of colors.

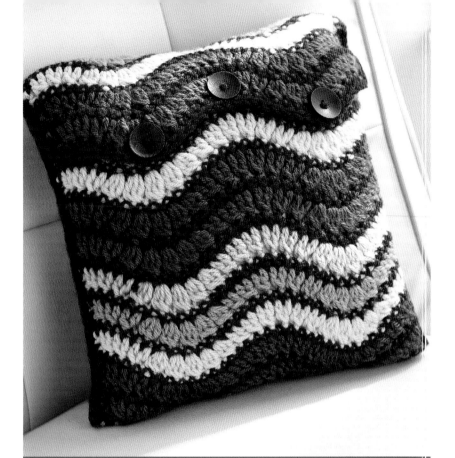

elan waves pillow

Working with multiple colors does not need to be a big hurdle as you develop your crochet skills. Think of it as simply enjoying the colors you have in your yarn stash. Use this pillow pattern to test color combinations that inspire you, such as fall leaves, sunsets, or Turkish tile. Experiment with different combinations and let your imagination run wild.

MATERIALS

Yarn Worsted weight (#4 Medium).

Shown Lion Brand Vanna's Choice (100% acrylic; 170 yd [156 m]/3.5 oz [100 g]): #144 Magenta (MC), 1 ball; #99 Linen (CC1); #171 Fern (CC2); #194 Lime (CC3); #146 Dusty Purple (CC4); #125 Taupe (CC5), 50 yd each.

Hook J/10 (6 mm) or size needed to obtain gauge.

Notions: Tapestry needle for weaving in ends; four ¾" (2 cm) buttons; spray bottle with water and straight pins for blocking; 12" (30.5 cm) square pillow form.

GAUGE

17 sts and 10 rows = 6" x 6" (15 x 15 cm) in pattern.

FINISHED SIZE

Finished pillow cover is 12" x 26" (30.5 x 66 cm) size before seaming. Pillow is 12" x 12" (30.5 x 30.5 cm).

SPECIAL STITCHES

Dc2tog Yo, insert hook in next indicated st, yo and draw up a lp, yo and pull yarn through 2 loops, yo, insert hook in next indicated st and draw up a lp, yo and pull yarn through 2 lps, yo and pull yarn through remaining 3 loops on hook— 1 decrease made.

3dc-cl [Yo, insert hook in indicated st, yo and draw up lp, yo and pull through 2 lps on hook] 3 times, yo and pull through rem 4 lps on hook.

NOTES

To change color Work last st of first color until 2 lps rem on hook, yo with the new color, and pull it through both lps.

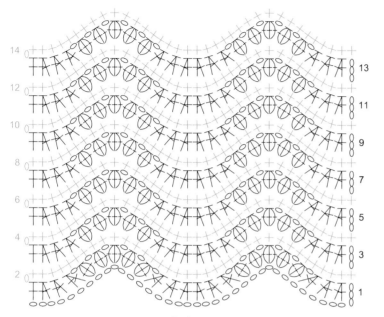

stitch diagram

pattern

NOTE: Change colors on all odd-numbered rows in the following color sequence: *CC1, CC2, CC3, CC4, CC5; rep from * 4 times. Use MC on all even-numbered rows.

With CC1, ch 38.

ROW 1 (RS): Dc2tog over 4th and 5th ch from hook, *[dc2tog over next 2 ch] twice, [ch 1, 3 dc-cl in next ch] 5 times, ch 1*, [dc2tog over next 2 ch] 4 times; rep from * to * once, [dc2tog over next 2 ch] 2 times, dc in last ch, change to MC (see Note), turn—2 waves; 36 sts.

ROW 2: With MC, ch 1, sc in each st across, change to CC2, turn—36 sc.

ROW 3: With CC2, ch 3 (counts as dc),

*[dc2tog over next 2 sc] 3 times, [ch 1, 3 dc-cl in next sc] 5 times, ch 1, [dc2tog over next 2 sc] 3 times; rep from * to last sc, dc in last ch, change to MC, turn.

Maintaining color sequence as est, rep rows 2–3 twenty-three times.

EDGING RND: With MC, ch 1, sc in each st to last sc, 3 sc in last sc for corner, turn work 90 degrees, sc evenly down side edge of pillow (in ends of rows) to foundation ch, 3 sc in corner ch, turn work 90 degrees, working across opposite side of foundation ch, sc in each ch across, 3 sc in last ch for corner, turn work 90 degrees, sc evenly up side edge of pillow, 2 sc in first sc of prev row, join with sl st in first sc, fasten off.

finishing

BLOCKING AND SEAMING

Pin pillow cover to finished size and spray block. With WS tog, fold cover in half by overlapping last 4 rows over first 4 rows.

SIDE EDGING: With WS facing, join MC at bottom of fold on side edge, working through double thickness of front and back, sl st across side, fasten off. Rep side edging across other side edge. Using spaces in row 49 at two peaks and at center valley of flap for buttonholes, sew one button to front, opposite buttonholes. Place pillow form in cover.

peerie baby blanket

In Fair Isle knitting patterns, *peerie* means "small"—peerie patterns are made up of repeats of just a few stitches and rows. I wanted this baby blanket to look like expanded peerie patterns. Instead of each square on the diagram representing a single stitch, each square stands for a little crocheted square. This results in a simple, pixelated colorwork pattern. ● BY KATHRYN MERRICK

MATERIALS

Yarn DK weight (#3 Light).

Shown Cascade Yarns Cascade 220 Superwash Sport (100% superwash wool; 136 yd [125 m]/ 1¾oz [50 g]: #878 pale yellow (MC), 4 balls; #845 blue (A), #803 purple (B), #864 bright green (C), #811 teal (D), #827 coral (E), #807 fuchsia (F), 1 ball each.

Hook 7 (4.5 mm) or size needed to obtain gauge.

GAUGE

7 hdc and 5 rows = 1½" (4 cm).

FINISHED SIZE

30" x 30" (75 x 75 cm).

NOTES

New squares are worked onto old squares and joined to an adjacent square while working.

Begin blanket with the center square and work out by adding squares in counterclockwise rounds.

Rotate work 90 degrees to work each new square, following the Assembly Diagram (page 73) for color changes.

Work over tails as much as possible to save time in finishing.

pattern

SQUARE 1

With A, ch 7.

ROW 1 (RS): Hdc in 3rd ch from hook (skipped chs count as hdc) and in each ch to end, turn—6 hdc.

ROW 2: Ch 2 (counts as hdc), hdc in each hdc across, turn.

Rep Row 2 three more times, fasten off.

SQUARE 2

Join MC to top left corner of Square 1 with sl st.

ROW 1 (RS): Ch 2 (counts as hdc), work 5 hdc evenly spaced across row ends of Square 1, turn—6 hdc.

ROW 2: Ch 2 (counts as hdc), hdc in each hdc across, turn.

Rep Row 2 three more times, fasten off.

SQUARE 3

Join MC to top left-hand corner of Square 2 with sl st. Rep as for Square 2.

SQUARE 4

Using Assembly Diagram as a guide, use color indicated, cont with current color or join yarn to top left corner of prev square with sl st.

ROW 1 (RS): Ch 2 (counts as hdc), work 4 hdc evenly across row ends of prev square, yo, insert hook through next sp on prev square and first hdc of bottom of adjoining square, yo, pull through both sts on hook, yo, pull through rem lps, do not turn—6 hdc.

ROW 2: Ch 1, sl st to adjoining square, turn, hdc in each hdc across, turn.

square 1

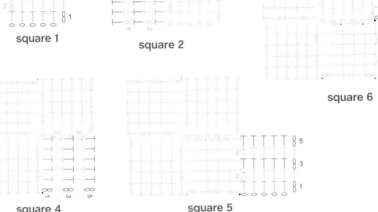

square 2

square 6

square 4

square 5

ROW 3: Ch 2 (counts as hdc), hdc in next 4 hdc, hdc in sl st, do not turn.

Rep Rows 2–3 once more, fasten off.

SQUARE 5

Using Assembly Diagram as a guide, use color indicated, join yarn to top right corner of prev square with sl st.

ROW 1 (RS): Ch 7, hdc in 3rd ch from hook (skipped chs count as hdc) and in each of next 4 chs, yo, insert hook through next sp on prev square and first hdc of bottom of adjoining square, yo, pull through both sts on hook, yo, pull through rem lps, do not turn—6 hdc.

ROW 2: Ch 1, sl st to adjoining square, turn, hdc in each hdc across, turn.

ROW 3: Ch 2 (counts as hdc), hdc in next 4 hdc, hdc in sl st, do not turn.

Rep Rows 2–3 once more, fasten off.

SQUARE 6

Using Assembly Diagram as a guide, use color indicated, cont with current color or join yarn to top left corner of prev square with sl st.

ROW 1 (RS): Ch 1, sl st to adjacent square on right, work 5 hdc evenly spaced across row ends of prev square below, turn—6 hdc.

ROW 2: Ch 2 (counts as hdc), hdc in next 4 hdc, hdc in sl st, do not turn.

ROW 3: Ch 1, sl st to adjoining square, turn, hdc in each hdc across, turn.

Rep Rows 2–3 once more, fasten off.

SQUARE 7

With MC, work as for Square 2.

SQUARE 8

With MC, work as for Square 4.

color key

MC
A
B
C
D
E
F

assembly diagram

tip Always change colors by making the last step of the final old-color stitch with the new color.
—KATHRYN MERRICK

30"
(76 cm)

30"
(76 cm)

SQUARE 9
With MC, work as for Square 6.

SQUARES 10–361
Cont working squares in numerical order, using Assembly Diagram as a guide for order, direction of work and color. Each square will be a repeat of squares 2, 4, 5 or 6, depending on position and direction of square.

finishing
BORDER
RND 1: With RS facing, join A in any corner of afghan, ch 1, *(sc, ch 1) twice in corner st, [sc, ch 1, sk 1 st or row-end st] across to next corner; rep from * around, join with sl st in first sc.

RND 2: With RS facing, join C in any corner ch-1 sp, ch 1, *(sc, ch 1) twice in corner sp, [sc, ch 1] in each ch-1 sp across to next corner; rep from * around, sl st in first sc to join.

RND 3: With E, rep Rnd 2.

RND 4: With RS facing, join B in any corner of afghan, ch 2 (counts as hdc), 2 hdc in corner sp, *2 hdc in each ch-1 sp to next corner, 3 hdc in corner sp; rep from * around, ending last rep at **, sl st in top of beg ch-2 to join, fasten off and weave in loose ends.

Wash and dry according to yarn label directions.

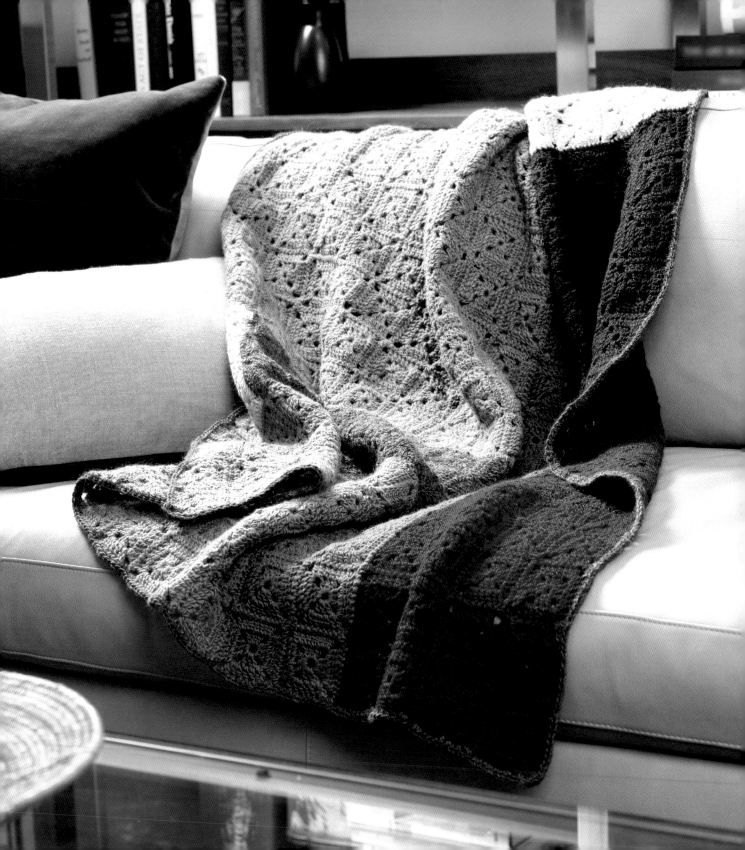

behrens color-block afghan

Combining my favorite things—celebrating color, interpreting traditional technique without compromising its simplicity, designing quick and easy projects—I was inspired to create this color-block blanket comprised of double crochet squares. Arranging the squares into a color-block pattern was the perfect way to update this time-honored stitch pattern. Follow the chart (on page 76) or be adventurous and create a color-block pattern of your own— the possibilities are endless. ● BY LEIGH RADFORD

MATERIALS
Yarn Worsted weight (#4 Medium).

Shown Brown Sheep Lamb's Pride (85% wool, 15% mohair; 190 yds [173 m]/4 oz [113 g]): M83 Raspberry (A), 3 skeins; M177 Olympic Bronze (B), 2 skeins; M18 Khaki (C), 3 skeins; M140 Aran (D), 1 skein; M171 Fresh Moss (E), 5 skeins; M04 Charcoal Heather (F), 2 skeins; M89 Roasted Coffee (G), 2 skeins.

Hook H/8 (5 mm) or size needed to obtain gauge.

Notions Tapestry needle for weaving in ends, spray bottle with water, and straight pins for blocking.

GAUGE
One square = 2½" x 2½" (6.5 x 6.5 cm)

FINISHED SIZE
45" x 60" (114.5 x 152.5 cm).

SPECIAL STITCHES
Double Crochet Square
Ch 4, sl st in first ch to form ring.

RND 1 Ch 5, (counts as dc, ch 2), [3 dc in ring, ch 2] 3 times, 2 dc in ring, sl st in 3rd ch of beg ch-5 to join—four 3-dc groups.

RND 2 Sl st in next ch, ch 6 (counts as dc, ch 3), *2 dc in same ch-sp, dc in each dc across side of square**, 2 dc in next ch-sp, ch 3; rep from * 2 times and from * to ** once more, dc in same ch-sp as t-ch, sl st in 4th ch of beg ch-6 to join, fasten off.

DC square

pattern

Make the foll number of double crochet squares (see Special Stitches) in the foll colors:

Color A 68 **Color E** 132

Color B 46 **Color F** 30

Color C 80 **Color G** 44

Color D 14

tip I crochet very loose chains. To combat this, when transitioning from one round to the next in granny squares, I use a smaller hook to work the chains to set up the next round. Once I've completed the chains, I change back to the larger hook to complete the round. If you make very tight chains, try using a larger hook. —LEIGH RADFORD

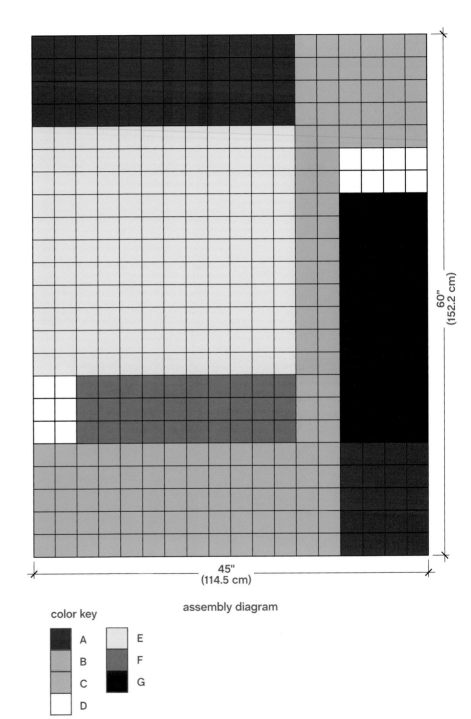

60" (152.2 cm)

45" (114.5 cm)

assembly diagram

color key

A

B

C

D

E

F

G

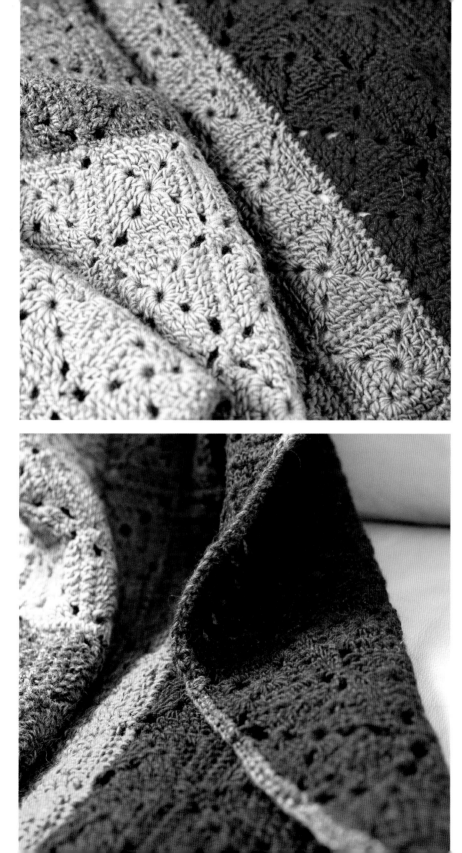

> " Color adds an extra flair to any project. I especially like to play with color in toys. You can see how colors will go together without investing a huge amount of time just to realize later that your choice was not your favorite. But in toys, it hardly matters at all; dogs and babies are just happy to have something fun to play with."

—ROBYN CHACHULA

finishing

BLOCKING AND SEAMING

Following Assembly Diagram, assemble 1 row of squares at a time, as foll: With WS tog and using tapestry needle and yarn color of your choice, whipstitch squares tog. Once all squares are sewn into rows, with WS tog, whipstitch rows tog.

EDGING

With RS facing, join F in first st to the left of any corner ch-sp, ch 1, *sc in each st across to next corner, working 2 sc in each ch-sp, 5 sc in corner sp; rep from * around, sl st in first sc to join, fasten off.

Weave in loose ends and block to measurements.

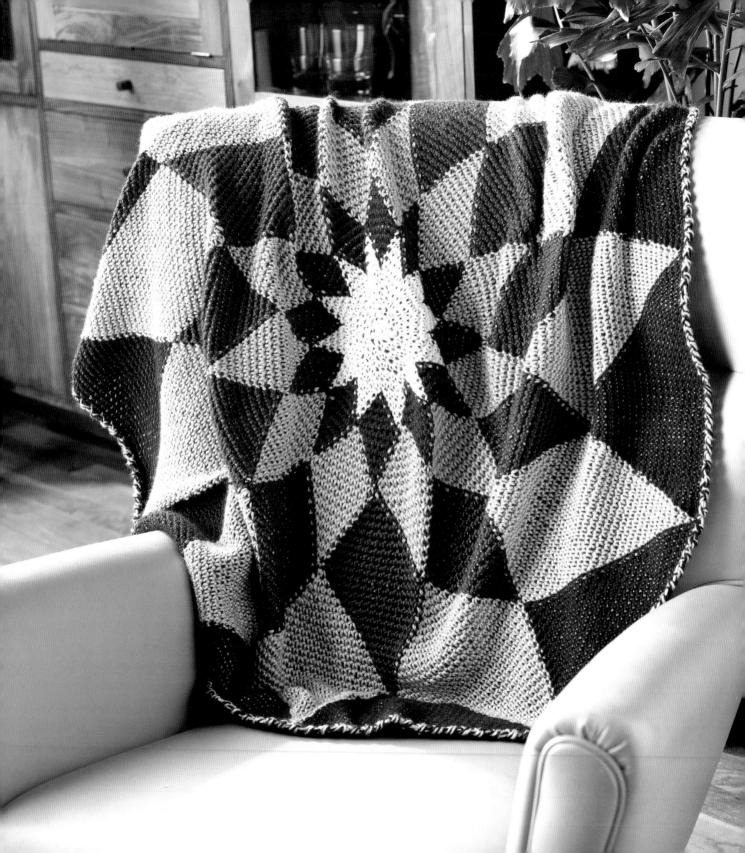

desert sunrise

Colorful yarns and loose single crochet stitches come together to create a patterned afghan that feels supple and looks good on both sides and from every angle. When working the color pattern, only one color is carried while the other is crocheted because each new diamond motif begins where another one ends. The carried yarn helps create a substantially warm, cozy fabric. ● BY CAROL VENTURA

MATERIALS
Yarn Worsted weight (#4 Medium).

Shown Caron Yarns Simply Soft (100% acrylic; 315 yd [288 m]/6 oz [170 g]): #9726 soft yellow (MC), 1 ball; #9723 raspberry (A), 1 ball; #0016 melon (B), 1 ball; #0014 pagoda (C), 1 ball; #0008 autumn maize (D), 2 balls; #0009 garnet (E), 2 balls.

Hook P (10 mm) or size needed to obtain gauge.

Notions Stitch marker.

GAUGE
11 sts and 12 rows = 4" x 4" (10 x 10 cm). First 4 rnds = 4" (10 cm) in diameter.

FINISHED SIZE
50" (127 cm) in diameter.

NOTES
Afghan is worked in the round as a spiral, not in concentric rings, so do not join rounds. To mark the end of the round, insert a stitch marker into the top of the last stitch of the first round and move it up at the end of each round.

With tapestry crochet colorwork, one yarn color is worked in single crochet while another color is carried.

To change color Work first st of first color until 2 lps rem on hook, yo with the new color and pull it through both loops.

To carry a yarn Lay the yarn over top of sts being worked into, then sc across as usual, encasing carried yarn in sts. If done correctly, carried yarn will only be slightly visible from front and back of work.

pattern

With MC and leaving an 8" (20.5 cm) tail, ch 4, sl st in first ch to form a ring.

NOTE: Carry the initial yarn tail both to achieve the same thickness of fabric you'll achieve when you begin to carry contrast-color yarn and to effectively weave in the tail.

RND 1: 6 sc in ring, carrying the tail (see Note), do not join—6 sc.

Pull tail to tighten ring, carry tail and start to carry A.

RND 2: 2 MC sc in each of next 6 sc—12 sc.

RND 3: Cut MC tail, carry A, 2 MC sc in each of next 12 sc—24 sc.

RND 4: Carry A, [1 MC sc in next sc, 2 MC sc in next sc] 12 times—36 sc.

RND 5: Carry A, [1 MC sc in each of next 2 sc, 2 MC sc in next sc] 12 times—48 sc.

RND 6: Carry A, [1 MC sc in each of next 3 sc, 2 MC sc in next sc] 12 times—60 sc.

NOTE: Rnds 7 through 69 correspond to the color chart.

beginning circle motif

color key

$+$ A
B
$-$ C
D
E
$+$ MC

color chart

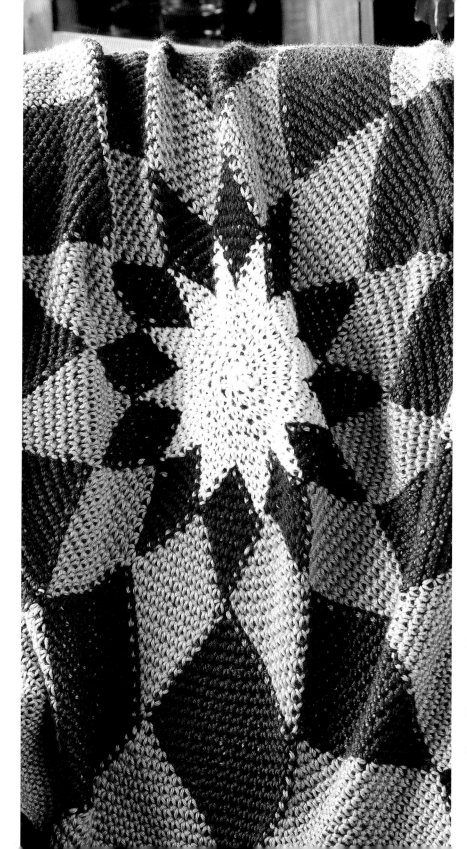

RND 7: [1 A sc in next sc, 1 MC sc in each of next 4 sc] 12 times.

RND 8: [2 A sc in next sc, 1 A sc in next sc, 1 MC sc in each of next 3 sc] 12 times—72 sc.

RND 9: [1 A sc in each of next 4 sc, 1 MC sc in each of next 2 sc] 12 times.

RND 10: [2 A sc in next sc, 1 A sc in each of next 4 sc, 1 MC sc in next sc] 12 times—84 sc.

RND 11: Carry MC, 1 A sc in each of next 70 sc, cut MC, beg to carry B, 1 A sc in each of next 14 sc.

RND 12: [2 B sc in next sc, 1 A sc in each of next 6 sc] 12 times—96 sc.

RND 13: [1 B sc in each of next 3 sc, 1 A sc in each of next 5 sc.

RND 14: [2 B sc in next sc, 1 B sc in each of next 3 sc, 1 A sc in each of next 4 sc] 12 times—108 sc.

RND 15: [1 B sc in each of next 6 sc, 1 A sc in each of next 3 sc.

RND 16: [2 B sc in next sc, 1 B sc in each of next 6 sc, 1 A sc in each of next 2 sc] 12 times—120 sc.

RND 17: [1 B sc in each of next 9 sc, 1 A sc in next sc.

RND 18: [2 B sc in next sc, 1 B sc in each of next 9 sc] 11 times, cut A and beg to carry C; 2 B sc in next sc, 1 B sc in each of next 10 sc—132 sc.

RND 19: [1 C sc in next sc, 1 B sc in each of next 10 sc] 12 times.

RND 20: [2 C sc in next sc, 1 C sc in next sc, 1 B sc in each of next 9 sc] 12 times—144 sc.

RND 21: [1 C sc in each of next 4 sc, 1 B sc in each of next 8 sc] 12 times.

RND 22: [2 C sc in next sc, 1 C sc in each of next 4 sc, 1 B sc in each of next 7 sc] 12 times—156 sc.

RND 23: [1 C sc in each of next 7 sc, 1 B in each of next 6 sc] 12 times.

RND 24: [2 C sc in next sc, 1 C sc in each of next 7 sc, 1 B sc in each of next 5 sc] 12 times—168 sc.

RND 25: [1 C sc in each of next 10 sc, 1 B sc in each of next 4 sc] 12 times.

RND 26: [2 C sc in next sc, 1 C sc in each of next 10 sc, 1 B sc in each of next 3 sc] 12 times—180 sc.

RND 27: [1 C sc in each of next 13 sc, 1 B sc in each of next 2 sc] 12 times.

RND 28: [2 C sc in next sc, 1 C sc in each of next 13 sc, 1 B sc in next sc] 12 times—192 sc.

RND 29: Carrying B, 1 C sc in each of next 176 sc, cut B, beg to carry D, 1 C sc in each of next 16 sc.

RND 30: [2 D sc in next sc, 1 C sc in each of next 15 sc] 12 times—204 sc.

RND 31: [1 D sc in each of next 3 sc, 1 C sc in each of next 14 sc] 12 times.

RND 32: [2 D sc in next sc, 1 D in each of next 3 sc, 1 C sc in each of next 13 sc] 12 times—216 sc.

RND 33: [1 D sc in each of next 6 sc, 1 C sc in each of next 12 sc] 12 times.

RND 34: [2 D sc in next sc, 1 D in each of next 6 sc, 1 C sc in each of next 11 sc] 12 times—228 sc.

RND 35: [1 D sc in each of next 9 sc, 1 C sc in each of next 10 sc] 12 times.

RND 36: [2 D sc in next sc, 1 D sc in each of next 9 sc, 1 C sc in each of next 9 sc] 12 times—240 sc.

RND 37: [1 D sc in each of next 12 sc, 1 C sc in each of next 8 sc] 12 times.

RND 38: [2 D sc in next sc, 1 D sc in each of next 12 sc, 1 C sc in each of next 7 sc] 12 times—252 sc.

RND 39: [1 D sc in each of next 15 sc, 1 C sc in each of next 6 sc] 12 times.

RND 40: [2 D sc in next sc, 1 D sc in each of next 15 sc, 1 C sc in each of next 5 sc] 12 times—264 sc.

RND 41: [1 D sc in each of next 18 sc, 1 C sc in each of next 4 sc] 12 times.

RND 42: [2 D sc in next sc, 1 D sc in each of next 18 sc, 1 C sc in each of next 3 sc] 12 times—276 sc.

RND 43: [1 D sc in each of next 21 sc, 1 C sc in each of next 2 sc] 12 times.

RND 44: [2 D sc in next sc, 1 D sc in each of next 21 sc, 1 C sc in next sc] 12 times—288 sc.

RND 45: 1 D sc in each of next 276 sc, cut C, beg to carry E, 1 D sc in each of next 12 sc.

RND 46: [2 E sc in next sc, 1 D sc in each of next 23 sc] 12 times—300 sc.

RND 47: [1 E sc in each of next 3 sc, 1 D sc in each of next 22 sc] 12 times.

RND 48: [2 E sc in next sc, 1 E sc in each of next 3 sc, 1 D sc in each of next 21 sc] 12 times—312 sc.

RND 49: [1 E sc in each of next 6 sc, 1 D sc in each of next 20 sc] 12 times.

RND 50: [2 E sc in next sc, 1 E sc in each of next 6 sc, 1 D sc in each of next 19 sc] 12 times—324 sc.

RND 51: [1 E sc in each of next 9 sc, 1 D sc in each of next 18 sc] 12 times.

RND 52: [2 E sc in next sc, 1 E sc in each of next 9 sc, 1 D sc in each of next 17 sc] 12 times—336 sc.

RND 53: [1 E sc in each of next 12 sc, 1 D sc in each of next 16 sc] 12 times.

RND 54: [2 E sc in next sc, 1 E sc in each of next 12 sc, 1 D sc in each of next 15 sc] 12 times—348 sc.

RND 55: [1 E sc in each of next 15 sc, 1 D sc in each of next 14 sc] 12 times.

RND 56: [2 E sc in next sc, 1 E sc in each of next 15 sc, 1 D sc in each of next 13 sc] 12 times—360 sc.

RND 57: [1 E sc in each of next 18 sc, 1 D sc in each of next 12 sc] 12 times.

RND 58: [2 E sc in next sc, 1 E sc in each of next 18 sc, 1 D sc in each of next 11 sc] 12 times—372 sc.

RND 59: [1 E sc in each of next 21 sc, 1 D sc in each of next 10 sc] 12 times.

RND 60: [2 E sc in next sc, 1 E sc in each of next 21 sc, 1 D sc in each of next 9 sc] 12 times—384 sc.

RND 61: [1 E sc in each of next 24 sc, 1 D sc in each of next 8 sc] 12 times.

RND 62: [2 E sc in next sc, 1 E sc in each of next 24 sc, 1 D sc in each of next 7 sc] 12 times—396 sc.

RND 63: [1 E sc in each of next 27 sc, 1 D sc in each of next 6 sc] 12 times.

RND 64: [2 E sc in next sc, 1 E sc in each of next 27 sc, 1 D sc in each of next 5 sc] 12 times—408 sc.

RND 65: [1 E sc in each of next 30 sc, 1 D sc in each of next 4 sc] 12 times.

RND 66: [2 E sc in next sc, 1 E sc in each of next 30 sc, 1 D sc in each of next 3 sc] 12 times—420 sc.

RND 67: [1 E sc in each of next 33 sc, 1 D sc in each of next 2 sc] 12 times.

RND 68: [2 E sc in next sc, 1 E sc in each of next 33 sc, 1 D sc in next sc] 12 times—432 sc.

RND 69: 1 E sc in each sc around. Do not fasten off.

finishing

BORDER

With WS of afghan facing and holding D and E tog, [rev sc in next st, sk 1 st] 216 times, turn over afghan so RS is facing, sl st in first st, cut D and E leaving 8" (20.5 cm) tails and fasten off.

Weave in the ends of D and E separately for 6" (15 cm) each, then trim them off.

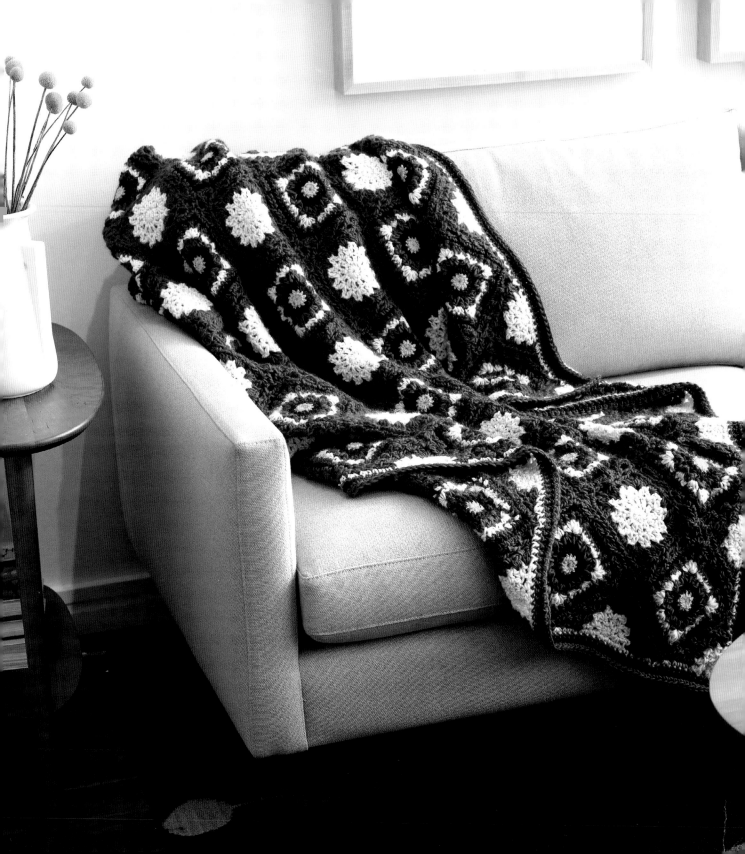

moroccan circles

Designing this afghan made me fall in love with join-as-you-go motifs and the secondary pattern that emerges from the filler motifs. I loved the portability of each motif as much as I loved snuggling up in my studio to join them to the larger afghan. ● BY KIMBERLY McALINDIN

MATERIALS

Yarn Aran weight (#4 Medium).

Shown Stitch Nation by Debbie Stoller (100% Peruvian wool; 155 yd [142 m]/3.5 oz [100 g]): #2529 Mediterranean (MC), 8 balls; #2605 Honeycomb (CC1), 1 ball; #2820 Ocean (CC2), 3 balls; #2205 Little Lamb (CC3), 5 balls; #2260 Clementine (CC4), 3 balls.

Hook J/10 (6 mm) or size needed to obtain gauge.

Notions Tapestry needle for weaving in ends, spray bottle with water, and straight pins for blocking.

GAUGE

Rnds 1–4 of Full Motif A = 4" x 4" (10 x 10 cm). Complete Full Motif = 6" x 6" (15 x 15 cm).

FINISHED SIZE

52" x 61" (132 x 155 cm).

NOTES

Join motifs as you go, according to instructions. To save time, work all 42 Full Motifs through Rnd 6, then work Rnd 7 to join 4 motifs tog at a time, then work and join a filler motif, then proceed from there.

To change color Work last st of first color until 2 lps rem on hook, yo with the new color and pull it through both lps.

SPECIAL STITCHES

Shell (sh) (3 dc, ch 2, 3 dc) in indicated st.

Front post half double crochet (fphdc) Yo, insert hook around next st from front to back to front, yo and pull up a lp, yo and draw through all 3 lps on hook.

V-stitch (V-st) (Hdc, ch 2, hdc) in indicated st.

Corner Shell (csh) ([Hdc, ch 1] 4 times, hdc) in indicated sp.

Spike sc (spike sc) Working over ch-1 sp in previous row, sc in next corresponding ch-1 sp 2 rows below.

Joining corner (jcnr) (Sc, [ch 3, sc] 3 times) in same st.

motif A

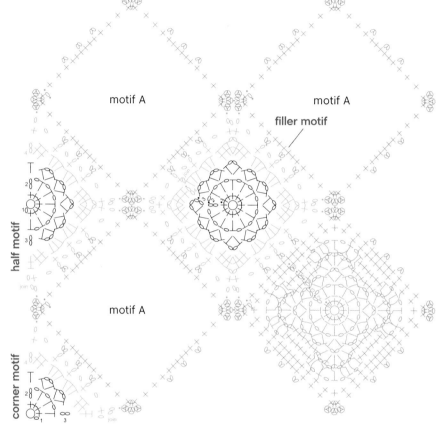

motif A

motif A

filler motif

half motif

corner motif

motif A

pattern

FIRST MOTIF A

With CC1 and using the adjustable ring method (see Glossary) make a lp.

RND 1 (RS): 12 sc in lp, sl st in first sc to join, change to CC2—12 sc.

RND 2: With CC2, ch 3 (counts as hdc, ch 1),* hdc in next sc inserting hook in blp and in horizontal strand in back of sc, ch 1; rep from * around, sl st in 2nd ch of beg-ch-3 to join, change to MC—12 hdc; 12 ch-1 sps.

RND 3: With MC, ch 4 (counts as hdc, ch 2), hdc in same ch as join (counts as V-st), V-st (see Special Stitches) in each hdc around, sl st in 2nd ch of beg ch-4 to join, change to CC3—12 V-sts.

RND 4: With CC3, ch 1, *3 sc in next ch-2 sp, csh (see Special Stitches) in next ch-2 sp, 3 sc in next ch-2 sp; rep from * around, sl st in first sc to join, change to CC4—4 csh; 24 sc.

RND 5: With CC4, ch 1, sc in same st as join, sc in next 2 sc, *[fphdc (see Special Stitches) around next hdc, ch 1] 4 times, fphdc around next hdc**, sc in next 6 sc; rep from * around, ending last rep at **, sc in last 3 sc, sl st in first sc to join, change to CC2—16 ch-1 sps; 16 fphdc; 24 sc.

RND 6: With CC2, ch 1, sc in same sp as join, sc in next 2 sc, *[sk next fphdc, spike sc (see Special Stitches) in next corresponding ch-1 sp 2 rows below] twice, 3 sc in next fphdc (corner made), [sk next fphdc, spike sc in next corresponding ch-1 sp 2 rows below] twice, sk next fphdc**, sc in next 6 sc; rep from *, ending last rep at **, sc in each of last 3 sc, sl st in first sc to join, fasten off—36 sc; 16 spike sc.

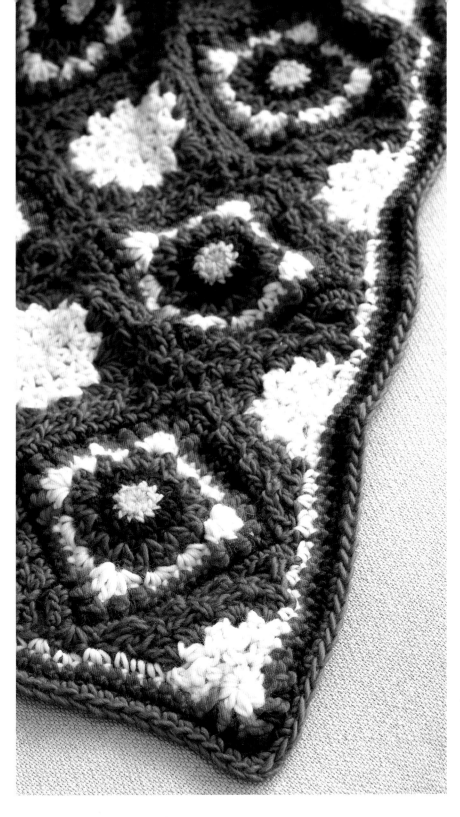

filler motif before joining

RND 7: With RS facing, join MC in any corner sc, ch 1, *jcnr (see Special Stitches) in corner sc, sc in next 3 sc, [ch 2, sc in next 3 sc] 3 times; rep from * around, sl st in first sc to join, fasten off.

SECOND AND SUCCESSIVE MOTIFS A

(make and join 41 foll assembly diagram on page 88 for placement)

Join 4 Motifs A tog at the center ch-3 of jcnr as foll:

RND 7: With RS facing, join MC in any corner sc, ch 1, drop lp from hook, insert hook in corresponding ch-3 of previous Motif A, pick up dropped lp and draw through, ch 1 (ch-3 join worked), (sc, ch 3, sc) in same corner sc on current Motif A, *sc in next 3 sc, [ch 2, sc in next 3 sc] 3 times**, jcnr in corner st; rep from * around, ending last rep at **, sl st in first sc to join, fasten off.

NOTE: Filler Motifs can be worked and joined to Motifs A as you go. When 4 Motifs A have been joined tog forming a diamond-shaped opening bet them, join a Filler Motif in the opening, beg with the first ch-3 join in the 3rd ch-2 sp on one side of the opening.

FILLER MOTIF

(make and join 30 foll assembly diagram for placement)

With CC3 and using the adjustable ring method, make a lp.

RND 1 (RS): 12 sc in lp, sl st in first sc to join—12 sc.

RND 2: Ch 3 (counts as hdc, ch 1), *hdc in next sc, ch 1, rep from * around, sl st in 2nd ch of beg ch-3 to join—12 hdc; 12 ch-1 sps.

RND 3: Ch 4 (counts as hdc, ch 2), hdc in same ch as join (counts as V-st), V-st in each hdc around, sl st in 2nd ch of beg ch-4 to join, change to MC—12 V-sts.

RND 4: Ch 2 (does not count as a st), *sh in next ch-2 sp, 3 hdc in next 2 ch-2 sps; rep from * around, sl st in 2nd ch of beg ch-2 to join—4 sh; 24 hdc.

ROW 5 (joining row): Ch 1, sc in sp bet 3-hdc and 3-dc group, work ch-3 join in corresponding 3rd ch-2 lp of adjacent Motif A, sc in ch-2 sp of next sh on current Filler Motif, ch-3 join in ch-3 lp of jcnr on adjacent Motif A, sc in ch-2 sp of same sh on current motif, ch-3 join in ch-3 lp of next Motif A, sc in ch-2 sp of same sh on current motif, *ch-3 join in next ch-2 sp on Motif A, sc in sp bet sh and 3 hdc on current motif, ch-3 join in next ch-2 sp of Motif A, sc in sp bet the next 2 hdc groups on current motif, ch-3 join in next ch-2 sp on Motif A**, sc in sp bet 3-hdc group and sh on current motif, ch-3 join in ch-3 sp of next jcnr on Motif A, sc in ch-2 sp of next sh of current motif, ch-3 join in next ch-3 sp of next Motif A, sc in ch-2 sp of same sh on current motif; rep from * around,

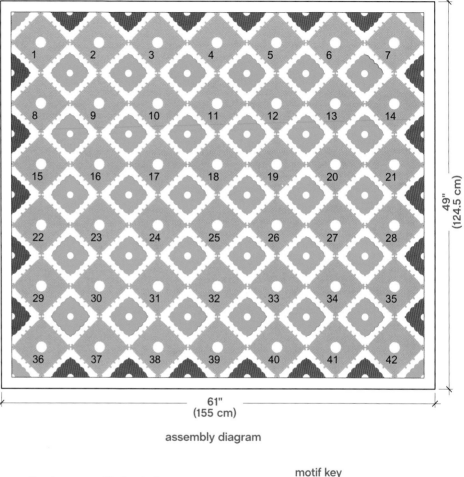

49"
(124.5 cm)

61"
(155 cm)

assembly diagram

ending last rep at **, sl st in first sc to join, fasten off.

HALF MOTIF

(make and join 22 foll assembly diagram for placement)

With CC3 and using the adjustable ring method, make a lp.

RND 1 (RS): 7 sc in lp, turn—7 sc.

RND 2: Ch 3 (counts as hdc, ch 1), *hdc in next sc, ch 1; rep from * across, hdc in last sc, turn—7 hdc; 6 ch-1 sps.

motif key

motif A

filler motif

half motif

corner motif

ROW 3: Ch 2 (counts as hdc), sk first hdc, V-st in each hdc across, hdc in 2nd ch of beg ch-3, change to MC, turn—5 V-sts; 2 hdc.

ROW 4: Ch 2 (counts as dc), 2 dc in first hdc, *(3 hdc in next ch-2 sp) 2 times*, sh in next ch-2 sp, rep from * to * once, 3 dc in 2nd ch of beg ch-2, turn—12 hdc; 6 dc; 1 sh.

ROW 5 (joining row): Ch 1, ch-3 join in first corresponding ch-3 sp of jcnr of adjacent Motif A, sc in first dc of current Half Motif, *ch-3 join in next ch-2 sp on Motif A, sc in sp bet 3 dc and 3 hdc on current motif, ch-3 join in next ch-2 sp of Motif A, sc in sp bet the next 2 hdc groups on current motif, ch-3 join in next ch-2 sp on Motif A, sc in sp bet 3-hdc group and 3-dc group on current motif, ch-3 join in ch-3 sp of next jcnr on Motif A*, sc in ch-2 sp of next sh of current motif, ch-3 join in next ch-3 sp of next Motif A, sc in ch-2 sp of same sh on current motif work, rep from * to * once, sc in top of last dc, fasten off.

CORNER MOTIF
(make and join 4 foll assembly diagram for placement)
With CC3, ch 2.

ROW 1 (RS): 4 sc in 2nd ch from hook, turn.

RND 2: Ch 3 (counts as hdc, ch 1), *hdc in next sc, ch 1; rep from * across, hdc in last sc, turn—4 hdc; 3 ch-1 sps.

ROW 3: Ch 2 (counts as hdc), sk first hdc, V-st in each hdc across, hdc in 2nd ch of beg ch-3, change to MC, turn—2 V-sts; 2 hdc.

ROW 4: Ch 2 (counts as dc), 2 dc in first hdc, 3 hdc in each of next 2 ch-2 sps, 3 dc in 2nd ch of beg ch-2, turn—6 hdc; 6 dc.

ROW 5 (joining row): Ch 1, ch-3 join in first corresponding ch-3 sp of jcnr of adjacent Motif A, sc in first dc of current Corner Motif, ch-3 join in next ch-2 sp on Motif A, sc in sp bet 3 dc and 3 hdc on current motif, ch-3 join in next ch-2 sp of Motif A, sc in sp bet the next 2 hdc groups on current motif, ch-3 join in next ch-2 sp on Motif A, sc in sp bet 3-hdc group and 3-dc group on current motif, ch-3 join in ch-3 sp of next jcnr on Motif A, sc in top of ch-2 t-ch, fasten off.

finishing
EDGING

RND 1: With RS facing, join CC3 in any corner, ch 1 (does not count as a st), *work csh in corner sp, sc evenly across to next corner; rep from * around, sl st in first hdc to join, change to CC4.

RND 2: With CC4, ch 1, *[fphdc around next hdc, ch 1] 4 times, fphdc around next hdc, sc in each sc across to next csh; rep from * around, sl st in first fphdc to join, change to CC2.

RND 3: With CC2, ch 1, *[sk next fphdc, spike sc in next corresponding ch-1 sp 2 rows below] twice, 3 sc in next fphdc (corner made), [sk next fphdc, spike sc in next corresponding ch-1 sp 2 rows below] twice, sk next fphdc, sc in each sc across to next corner; rep from * around, sl st in first sc to join, change to MC.

RND 4: With MC, ch 1, sc in each sc around, working 3 sc in each corner, sl st in first sc to join, fasten off.

BLOCKING
Lay afghan on a flat surface, steam- or spray-block to measurements (see Glossary).

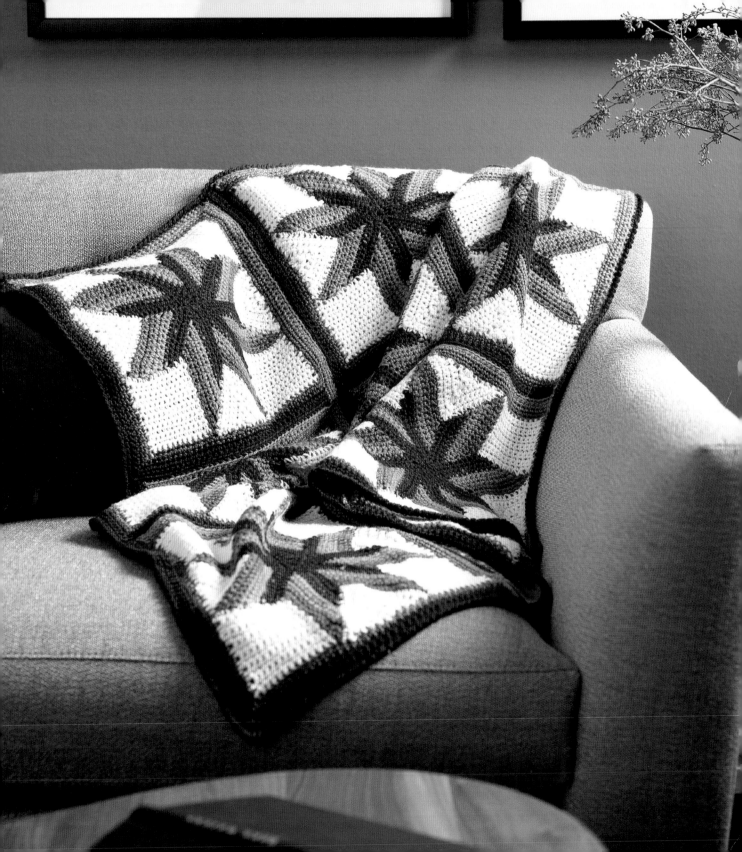

bethlehem star

This throw was inspired by a traditional patchwork quilt pattern called Bethlehem Star. The "rays" of each star are made separately and stitched together, but the block background and sashing is worked right onto the star to cut down on stitching at the end. This is a very portable project right up until the final assembly. ● BY MARY BETH TEMPLE

MATERIALS

Yarn Sportweight (#3 Light).

Shown Brown Sheep Lamb's Pride Superwash Sport (100% washable wool; 180 yd [165 m]/1.75 oz [50 g]): #SW10 Alabaster (MC), 4 balls; #SW160 Prairie Sage (CC1), 3 balls; #SW34 Rose Quartz (CC2), 3 balls; #SW43 Romantic Ruby (CC3), 3 balls.

Hook F/5 (3.75 mm) or size needed to obtain gauge.

Notions Stitch marker, tapestry needle for weaving in ends, spray bottle with water, and straight pins for blocking.

GAUGE

14 sts and 18 rows = 4" x 4" (10 x 10 cm) in sc.

FINISHED SIZE

37" x 37" (94 x 94 cm).

NOTES

Afghan is constructed similarly to a sewn quilt. Each star is constructed ray motif by ray motif. Then every corner and valley is filled in around the star to form a block. Each block is then edged in multiple colors. Only after the blocks are edged are they finally seamed together.

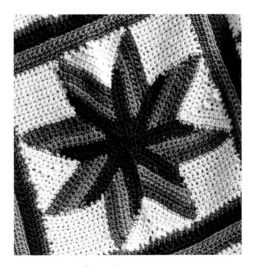

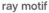

ray motif

pattern

RAY MOTIF
(make 72)

With CC1, ch 13.

ROW 1: Sc in 2nd ch from hook and in each ch across, turn—12 sc.

ROW 2: Ch 1, sc2tog over first 2 sc, sc in next 9 sc, 2 sc in last sc, turn.

ROW 3: Ch 1, 2 sc in first sc, sc in next 9 sc, sc2tog over last 2 sc, change to CC2, turn.

ROWS 4–6: With CC2, rep Rows 2–3, then rep Row 2 once more, change to CC3 at end of Row 6.

ROWS 7–9: With CC3, rep Row 3, then rep Rows 2–3, fasten off after Row 9 leaving a 10" (25.5 cm) tail for motif assembly.

ASSEMBLE STARS

Arrange 8 motifs with the CC3 point of each toward the center; using the 10" (25.5 cm) tails, whipstitch each motif to the next one as shown in Star Motif assembly diagram. Diagram shows motif from WS.

TOP-RIGHT AND BOTTOM-LEFT CORNER BLOCKS

Attach MC in st marked on assembly diagram at outside corner of ray.

ROW 1: Ch 1, 12 sc across, sl st in corresponding st of adjacent vertical ray, turn.

ROW 2: Ch 1, sc in each sc across, turn.

ROW 3: Ch 1, sc in each sc across, sl st in corresponding st of adjacent vertical ray, turn.

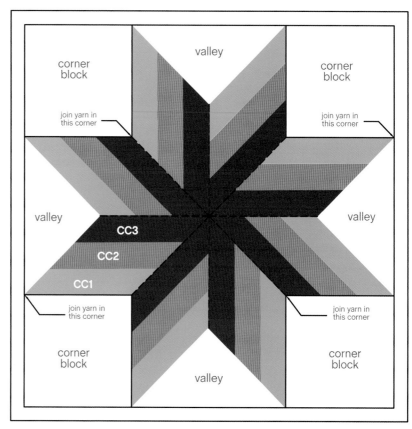

star motif assembly diagram

Rep Rows 2–3 five times, rep Row 2, fasten off.

TOP-LEFT AND BOTTOM-RIGHT CORNER BLOCKS

Attach MC in st marked on assembly diagram at inside corner between rays.

ROW 1: Ch 1, 12 sc across, turn.

ROW 2: Ch 1, sc in each sc across, sl st in corresponding st of adjacent vertical ray, turn.

ROW 3: Ch 1, sc in each sc across, ch 1, turn.

Rep Rows 2–3 five times, rep Row 2, fasten off.

FILL IN VALLEYS
(work 4)

Attach MC in st marked on diagram.

ROW 1: Work 25 sc evenly spaced along the V shape, place marker in center sc, turn.

ROW 2: Ch 1, sc2tog over first 2 sts, sc across to 1 st before marked st, sc3tog over next 3 sts, sc across to last 2 sts, sc2tog over last 2 sts, turn—21 sc.

ROWS 3–5: Rep Row 2—9 sc after completing Row 5.

ROW 6: Ch 1, sc2tog over first 2 sts, sc in next st, sc3tog over next 3 sts, sc in

valley stitch motif

next st, sc2tog over last 2 sts, ch 1, turn—5 sc.

ROW 7: Ch 1, sc in first st, sc3tog over next 3 sts, sc in last st, turn—3 sc.

ROW 8: Ch 1, sc3tog over next 3 sts. Fasten off.

FIRST EDGING

Attach CC1 in any corner.

RND 1 (RS): Ch 1, *3 sc in corner st, work 36 sc evenly spaced across to next corner; rep from * around, sl st in first sc to join—156 sc.

RND 2: Ch 1, sc in first sc, *3 sc in next sc (corner st), sc in each sc across to next corner; rep from * around, sl st in first sc to join, fasten off.

SASHING

With RS facing, attach CC3 in top right corner, ch 4.

ROW 1: Sc in 2nd ch from hook and in next 2 ch, sc in next 41 sc to next corner, 3 sc in corner st, sc in next 41 sc to next corner, turn.

ROW 2: Ch 1, sc in first 42 sc, 3 sc in next sc (corner st), sc in each sc across, turn.

ROW 3: Ch 1, sc in first 46 sc, 3 sc in next sc (corner st), sc in next 43 sc, change to CC2, do not turn.

ROW 4: With CC2, ch 1, work 3 sc evenly spaced across side of 3 rows just worked, sc in next 41 sc along next side of block, 3 sc in next sc (corner st), sc in next 41 sc, sl st in next corresponding st of Row 1, turn.

ROW 5: Ch 1, sc in first 42 sc, 3 sc in next sc (corner st), sc in each st across, turn.

ROW 6: Ch 1, sc in first 46 sc, 3 sc in next sc (corner st), sc in next 43 sc, sl st in corresponding st of Row 3, fasten off.

finishing

BLOCKING AND SEAMING

Weave in loose ends, block each square.

Align blocks in 3 rows of 3 squares each. With RS facing, sc squares tog inserting hook through front lp of front st and back lp of back st only.

EDGING

With RS facing, attach CC3 in any corner of the blanket.

RND 1: Ch 1, sc in each sc around blanket, working 3 sc in each of the four corners, sl st in first sc to join.

RND 2: Ch 1, working from left to right, rev sc in each sc around. Fasten off.

Weave in loose ends. Reblock if needed.

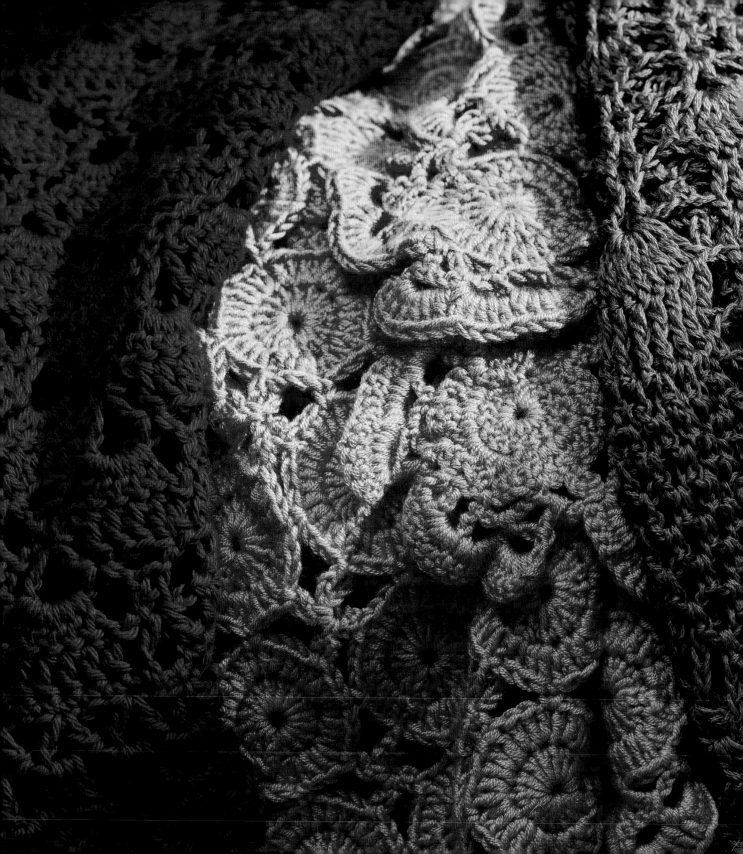

lace

Lace crochet is a magical technique.

There is a reason the classic doily has been inspiring generations of families, and I can tell you it is not just to cover the stain on the coffee table. No more explanation is needed after you take a look at Doris Chan's Exploded Pineapple Afghan (page 114). Whether on a bed or a porch swing, that masterpiece will add beauty to anyone's home. That is what crochet lace does—adds a bit of romance to any room.

Lace crochet has one simple rule: BLOCK IT. Whether worked in rows or in the round, each of these projects comes alive when you block it. Its look will change if you stretch it very taut or keep it loose. Either way, you will be rewarded in kind when you take the time to block lace.

LACE LOVE

For me, lace could cover everything in my house and I would think it is cool. Actually, I have been known to frame swatches I think are neat and hang them all over my house.

> "I love to crochet lace because it's so dimensional and sculptural. Openwork is especially pleasing to me in crochet, especially when using thicker yarn for what may be generally considered a fine-thread project."
> —ANNIE MODESITT

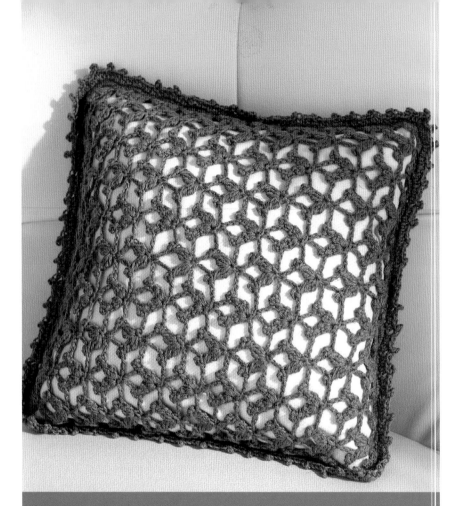

MATERIALS

Yarn DK weight (#3 Light).

Shown Classic Elite Soft Linen (35% linen, 35% wool, 30% baby alpaca; 137 yd [125 m]/1.75 oz [50g]): #2206 Thistle, 2 balls.

Hook G/6 (4 mm) or size needed to obtain gauge.

Notions Tapestry needle for weaving in ends, spray bottle with water and straight pins for blocking, 11" (28 cm) square pillow form.

GAUGE

2 shells and 8 rows = 4.5" (11.5 cm) in stitch pattern.

FINISHED SIZE

11.5" x 11.5" (29 x 29 cm) finished pillow cover front or back panel. Finished pillow is 12" x 12" (30.5 x 30.5 cm).

SPECIAL STITCHES

Picot Ch 3, sl st in 3rd ch from hook.

3 Double Crochet Cluster (3 dc-cl) [Yo, insert hook in indicated st, yo and pull up a lp, yo and draw through 2 lps on hook] 3 times, yo and draw through rem 4 lps on hook.

Shell (sh) [3 dc-cl (see above), picot, ch 5, 3 dc-cl, picot] in indicated sp.

pattern

PANELS
(make 2)

Ch 66.

ROW 1 (RS): Sc in 8th ch from hook, picot (see Special Stitches), ch 3, sk 3 ch, sc in next sc, *picot, ch 3, sk 3 ch, sc in next ch, picot, ch 5, sk 3 ch, sc in next ch, picot, ch 3, sk 3 ch, sc in next ch; rep

vigne pillow

Lace, so often associated with delicate thread projects, is often overlooked when planning a pillow or afghan. But lace is the perfect technique for adding a touch of romance to any room, even on a grand scale. This pretty lace pattern can look equally lovely as pillow covers, curtains, or even lamp shades.

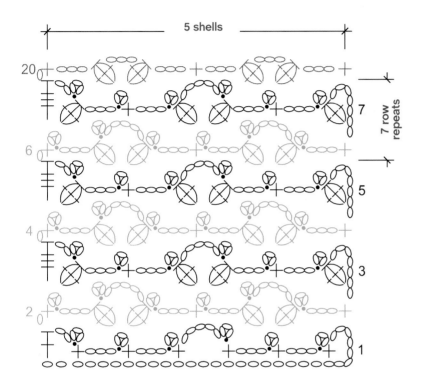

5 shells

20

7 row repeats

7

6

5

4

3

2

1

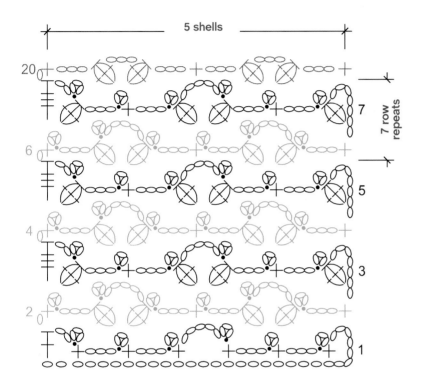

tip To let the lace fabric shine, choose a pillow-form cover in muted tones and patterns. Do not feel like you can only have a solid color as a background. Mixing and matching fabrics is a lot of fun; just remember that you want your lace to be the star of the project, not the pillow form. —ROBYN CHACHULA

from * to last 6 ch, picot, ch 3, sk 3 ch, sc in next ch, picot, ch 2, sk 1 ch, dc in last ch, turn—15 picots.

ROW 2: Ch 1, sc in first st, *picot, ch 3, sk 1 picot, sh (see Special Stitches) in next picot ch-3 sp, ch 3, sc in next ch-5 sp; rep from * to t-ch, sc in t-ch sp, turn—5 sh.

ROW 3: Ch 7 (counts as dtr, ch 2), 3 dc-cl (see Special Stitches) in sc, picot, *ch 3, sc in next ch-5 sp, picot, ch 3, sk 1 picot, sh in next picot ch-3 sp; rep from * to last sh, ch 3, sc in ch-5 sp, picot, ch 3, sk 1 picot, 3 dc-cl in last picot ch-3 sp, picot, ch 2, dtr in last sc, turn.

ROWS 4–19: Rep Rows 2–3 eight times.

ROW 20: Ch 1, sc in dtr, *ch 3, sk 1 picot, (3 dc-cl, ch 3, 3 dc-cl) in next picot ch-3 sp, ch 3, sc in next ch-5 sp; rep from * to t-ch, sc in t-ch sp—5 sh. Fasten off.

finishing

BLOCKING

Pin front and back panel to size and spray with water to block. Allow to dry.

SEAMING AND EDGING

Place pillow form between front and back panels so RS of each panel is facing out, and pin panels tog at edges.

Join yarn to edge of pillow.

RND 1: Working through front and back panels at once, sc 48 times evenly across edge, 3 sc in corner; rep from * around, sl st in first sc to join, do not turn.

RND 2: Ch 2 (counts as hdc), hdc in next 2 sc, *picot, hdc in next 3 sc; rep from * to corner, picot, hdc in next sc, (2 hdc, picot, 2 hdc) in next sc, hdc in next sc; rep from * to t-ch, picot, sl st in top of t-ch to join. Fasten off and weave in loose ends.

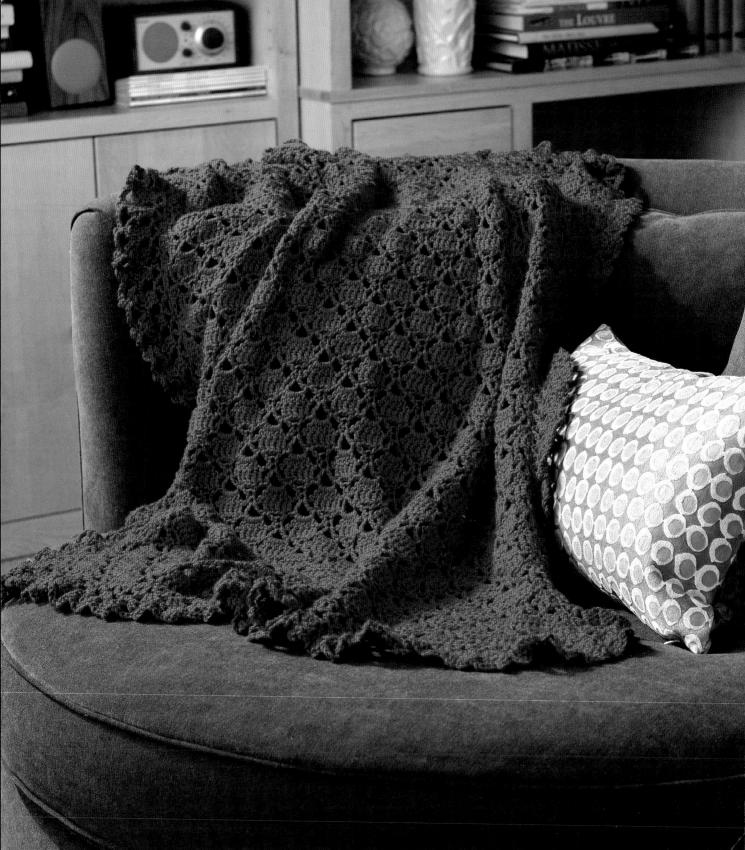

amada
baby blanket

Inspired by heirloom baby blankets made in thread, I wanted to design a baby blanket every crocheter could make quickly and easily. The cotton yarn is soft and easy to care for, and the four-row repeat combined with the heavier gauge make it quick to crochet. ● BY TRACIE BARRETT

MATERIALS

Yarn Worsted weight (#4 Medium).

Shown Universal Yarn Inc., Cotton Supreme (100% cotton; 180 yd [165 m]/3.5 oz [100 g]): #510 Magenta, 5 balls.

Hook J/10 (6 mm) or size needed to obtain gauge.

Notions Tapestry needle for weaving in ends.

GAUGE

2 patt reps = 6" (15 cm); 4 rows = 2½" (6.5 cm) in pattern.

FINISHED SIZE

39" x 39" (99 x 99 cm).

SPECIAL STITCHES

Double crochet 5 together (dc5tog) [Yo, insert hook in indicated st, yo and pull up a lp, yo and draw through 2 lps] 5 times, yo and draw through rem 6 lps on hook—4 decs made.

Double crochet 3 together (dc3tog) [Yo, insert hook in indicated st, yo and pull up a lp, yo and draw through 2 lps] 3 times, yo and draw through rem 4 lps on hook—2 decs made.

V-stitch (V-st) (Dc, ch 2, dc) in indicated st or sp.

pattern

BLANKET

Ch 113.

ROW 1 (RS): Dc in 4th ch from hook, dc in next ch, *sk 2 ch, (dc, ch 3, dc) in next ch, sk 2 ch**, dc in next 5 ch; rep from * across, ending last rep at **, dc in each of last 3 ch, turn—78 dc, 11 ch-3 sps.

ROW 2: Ch 2 (counts as dc here and throughout), sk first 2 dc, dc in next dc, *ch 2, 5 dc in next ch-3 sp, ch 2, sk next dc**, dc2tog over first and 5th dc of next dc-grp, ch 2; rep from * across, ending last rep at **, dc2tog over next dc and t-ch, turn.

ROW 3: Ch 4 (counts as dc, ch 1), dc in first st, *sk next ch-2 sp, dc in next 5 dc, sk next ch-2 sp**, (dc, ch 3, dc) in next dc2tog; rep from * across, ending last rep at **, sk next dc, (dc, ch 1, dc) in top of t-ch, turn.

ROW 4: Ch 3, 2 dc in next ch-1 sp, *ch 2, sk next dc, dc2tog over first and 5th dc of next dc-grp, ch 2**, 5 dc in next ch-3 sp; rep from * across, ending last rep at **, 2 dc in sp created by t-ch, dc in top of t-ch, turn.

ROW 5: Ch 3, dc in next 2 sts, *sk next ch-2 sp, (dc, ch 3, dc) in next dc2tog, sk next ch-2 sp**, dc in next 5 dc; rep from * across, ending last rep at **, dc in next 2 dc and top of t-ch, turn.

ROWS 6–53: Rep Rows 2–5, do not turn at end of last row.

EDGING

RND 1: Ch 1, turn work 90 degrees, working in the row ends, work 133 sc evenly

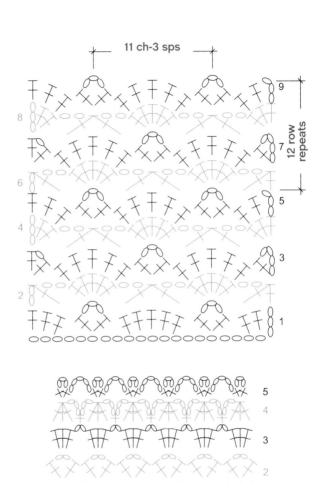

edging

spaced down side edge of blanket, 3 sc in corner (first st of foundation ch), turn work 90 degrees, work 109 sc evenly spaced across bottom edge, 3 sc in corner (last st), turn work 90 degrees, work 133 sc evenly spaced up side edge of blanket, 3 sc in corner (first

st of last row), turn work 90 degrees, work 109 sc evenly space across last row, 3 sc in last st, sl st in first sc to join, fasten off—(496 sc).

RND 2: Join yarn with sl st in 2nd sc to the left of any corner sc, ch 5 (counts as dc, ch 2), dc in same sc, *sk 2 sc, V-st in

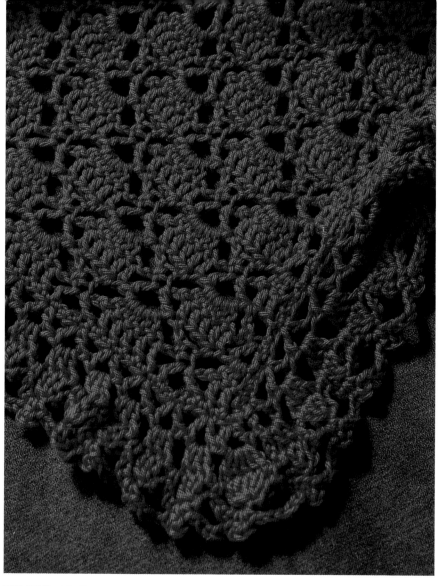

lace

> **tip** Crocheted lace always needs to be blocked to show its true beauty. No matter the fiber, no matter the size, always block. —TRACIE BARRETT

next sc; rep from * across to 1 st before next corner, sk next st, V-st in next corner st**, V-st in next st; rep from * around, ending last rep at **, sl st in top of tch to join—168 V-sts.

RND 3: Sl st in first ch-2 sp, ch 3, 2 dc in same sp, ch 2, *3 dc in next ch-2 sp, ch 2; rep from * around, working 5 dc in each corner ch-2 sp, sl st in top of t-ch to join.

RND 4: Ch 2, dc2tog over next 2 dc, ch 3, sc in next ch-2 sp, *dc3tog over next 3 dc, ch 3, sc in next ch-2 sp; rep from * around, working dc5tog over 5 dc in each corner, sl st in first dc2tog to join.

RND 5: Ch 1, (sc, ch 3, sc) in same st as join, ch 5, *(sc, ch 3, sc) in next dc3tog, ch 5; rep from * around, working (sc, ch 3, sc) in dc5tog of each corner, sl st in first sc to join. Fasten off and weave in loose ends.

finishing

BLOCKING AND SEAMING

Dampen piece, lay out on towels, pin to final measurements to open up lace pattern. Let dry.

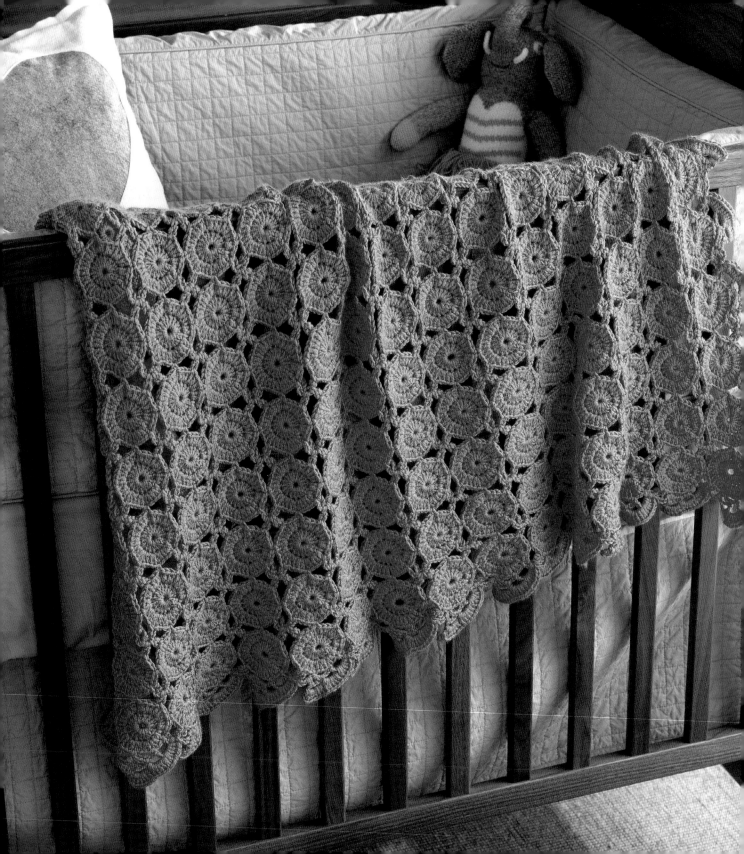

sunken treasure

A sunken treasure is the inspiration for this afghan: the crochet stitches represent a blanket of ancient medallion coins framed by the lapping waves of the ocean. The crochet motifs are simple to make and easy to join as you go. The edging is worked in one row that meanders back and forth on itself for every swirling wave repeat. You start at the end of the last motif and work your way around the entire rectangular afghan and slip-stitch to join. ● BY KRISTIN OMDAHL

MATERIALS
Yarn Worsted weight (#4 Medium).

Shown Lion Brand Microspun (100% microfiber acrylic; 168 yd [154 m]/2.5oz [70g]): #103 Coral, 8 balls.

Hook H/8 (5 mm) or size needed to obtain gauge.

Notions Tapestry needle for weaving in ends.

GAUGE
1 medallion motif = 2½" (6.5 cm) in diameter.

FINISHED SIZE
33" x 43" (84 x 109 cm).

tip Because this is a machine-washable yarn, I machine washed it and laid it flat to dry, giving it a little stretch to finished measurements but not pinning it hard because I wanted to make sure it was going to be a practical and easy-care item for regular household use. —KRISTIN OMDAHL

pattern

MEDALLION MOTIF
(make 1, join 191)

Ch 5, sl st in first ch to form ring.

RND 1 (RS): Ch 3 (counts as dc), 15 dc in
ring, sl st in top of t-ch to join, do not
turn—16 dc.

RND 2: Ch 3 (counts as dc), dc in same ch
as join, 2 dc in next 3 dc, *ch 7, sl st in
last dc made, 2 dc in each of next 4 dc;
rep from * 2 more times, ch 7, sl st in
last dc made, sl st in top of t-ch to join,
fasten off—32 dc.

MOTIFS 2–17, 33, 49, 65, 81, 97, 113, 129, 145, 161, 177
(Joining one side)

RND 1: Rep Rnd 1 of first motif.

RND 2: Ch 3 (counts as dc), dc in same ch as
join, 2 dc in each of next 3 dc, ch 3, sl st
in ch-7 sp on adjacent motif, ch 3, sl st
in last dc made, 2 dc in each of next 2
dc, sl st in sp bet 4th and 5th of 8 dc on
adjacent motif, 2 dc in next 2 dc, ch 3, sl
st in adjacent motif's ch-7 sp, ch 3, sl st
in last dc made, [2 dc in each of next 4
dc, ch 7, sl st in first ch] twice, sl st in
top of t-ch to join, fasten off.

REMAINING MOTIFS
(Joining two sides)

RND 1: Rep Rnd 1 of first motif.

RND 2: Ch 3 (counts as dc), dc in same ch
as join, 2 dc in next 3 dc, ch 3, sl st in
ch-7 sp on adjacent motif, ch 3, sl st in
last dc made, *2 dc in next 2 dc, sl st in
sp bet 2nd and 3rd of 4 dc on adjacent
motif, 2 dc in next 2 dc, ch 3, sl st in ad-
jacent motif's ch-7 sp, ch 3, sl st in last
dc made; rep from * once more, 2 dc in
next 4 dc, ch 7, sl st in last dc made,
sl st in top of t-ch to join, fasten off.

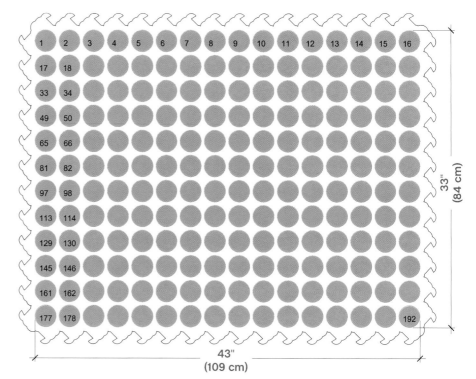

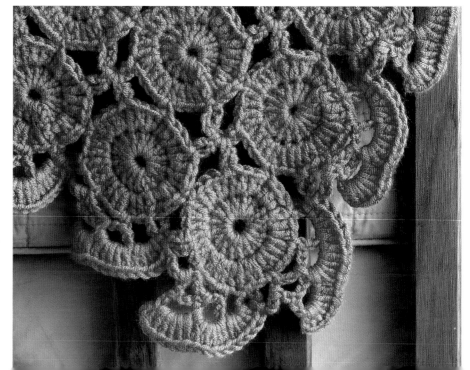

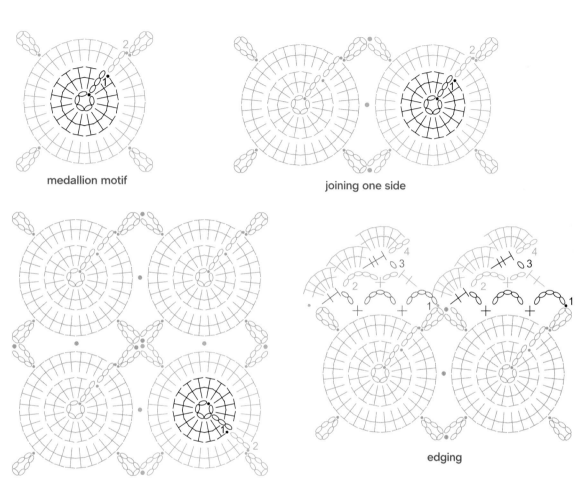

medallion motif

joining one side

joining two sides

edging

finishing

EDGING

NOTE: One rep of edging is worked for every motif edge.

Join yarn with sl st in any corner ch-7 sp.

ROW 1: Ch 5, sk next 2 dc, sc in sp before next dc, ch 5, sk 4 dc, sc in sp before next dc, ch 2, sk next 2 dc, dc in join bet next 2 ch-7 sps (counts as ch-5 sp), turn—3 ch-5 sps.

ROW 2: Ch 5, sc in next ch-5 sp, ch 2, dc in next ch-5 sp (counts as ch-5 sp), turn—2 ch-5 sps.

ROW 3: Ch 1, tr in next ch-5 sp (counts as ch-5 sp), do not turn.

ROW 4: Ch 3 (counts as dc), 6 dc in same ch-5 sp (around post of tr), [5 dc in next ch-5 sp] 2 times, sl st in same join bet next 2 ch-7 sps—17 dc.

Rep Rows 1–4 of edging around perimeter of afghan, fasten off. Weave in loose ends.

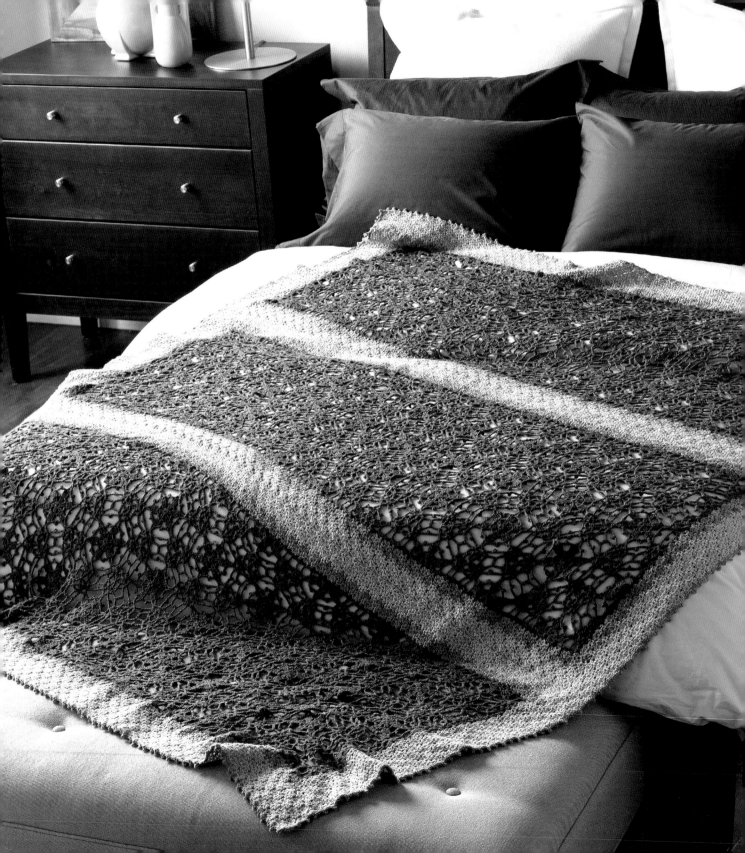

damask afghan

Inspired by the beautiful damask drapes in my mom's home, I designed this lacy afghan with join-as-you-go motifs coupled with a solid stitch border, as that is really *my* style—a little something lacy with a solid edge to it. But the yarn is the star here, the yak and bamboo combination is amazingly soft and a dream to crochet. ● BY MARLY BIRD

MATERIALS

Yarn Sportweight (#2 Fine).

Shown Bijou Basin Ranch, Lhasa Wilderness (75% yak, 25% bamboo; 180 yd [165 m]/2 oz [56 g]): #01 natural brown (MC), 14 hanks; #12 sky (CC1), 5 hanks; #13 steel (CC2), 2 hanks.

Hook F/5 (3.75 mm) or size needed to obtain gauge.

Notions Tapestry needle.

GAUGE

Damask Motif = 6½" (16.5 cm) diameter between widest points; 5½" (14 cm) from side to side; 3½" (9 cm) between ch-5 picot and ch-5 picot of outside edge.

FINISHED SIZE

62" x 77" (157.5 x 195.5 cm).

NOTE

Join all motifs with RS facing.

SPECIAL STITCHES

Picot Ch 3, sl st in 3rd ch from hook.

Beginning crossed stitch (beg x-st) Ch 3, sk next 2 dc, dc in next dc, ch 6, dc in last dc made.

Crossed stitch (x-st) Yo 3 times, insert hook in first dc, yo and pull up a lp, [yo and draw through 2 lps on hook] 2 times (2 lps rem on hook), sk next 2 dc, dc in next dc, [yo and draw through 2 lps on hook] 2 times, ch 3, dc in dc just made.

Dc cluster (2 dc-cl) Ch 2, [yo, insert hook in specified st or sp, yo and pull up a lp, yo and draw through 2 lps on hook] 2 times in same st or sp; yo and draw through all 3 lps on hook.

Cluster (3 dc-cl) [Yo, insert hook in specified st or sp, yo and pull up a lp, yo and draw through 2 lps on hook] 3 times in same st or sp, yo and draw through all 4 lps on hook.

Ch-3 join Ch 1, sl st in corresponding ch-3 sp on Rnd/Row 4 of adjacent motif, ch 1.

Ch-5 join Ch 2, sl st in corresponding ch-5 sp on Rnd/Row 4 of adjacent motif, ch 2.

Picot join Ch 1, sl st in ch-3 sp of picot on Rnd/Row 4 of adjacent motif, ch 1, sl st in first ch.

Half Double Crochet Cluster (2 hdc-cl) [Yo, insert hook in indicated st, yo and pull up a lp] 2 times in same st or sp, yo and draw through all lps on hook.

Floret [Ch 1, 2 hdc-cl (see above)] 3 times in same st or sp, ch 1.

Half floret [Ch 1, 2 hdc-cl] 2 times in same st or sp.

Border

(multiple of 6 + 8 foundation chains)

Row 1 Sc in second ch from hook, *sk 2 ch, floret (see Special Stitches) in next ch, sk 2 ch, sc in next ch; rep from * across, turn.

Row 2 Ch 2, dc in first ch-1 of floret, *ch 1, sc in 2nd ch-1 of floret, ch 3, sc in 3rd ch-1 of floret, ch 1**, dc2tog over 4th ch-1 of previous floret and first ch-1 of next floret; rep from * across, ending last rep at **, dc2tog over 4th ch-1 of floret and last sc, turn.

Row 3 Ch 2, [hdc, ch 1, hdc-cl, ch 1] in first st, *sc in next ch-3 sp, floret in next dc2tog; rep from * to last ch-3 sp, half floret (see Special Stitches) in tch, turn.

Row 4 Ch 1, sc in first st and ch-1, *ch 1, dc2tog over next 2 ch-1 sps, ch-1, sc in next ch-1**, ch 3, sc in next ch-1; rep from * across, ending last rep at **, sc in last st, turn.

Row 5 Ch 1, sc in first st, *floret, sc in next ch-3 sp; rep from * to end, turn.

Rep Rows 2–5 for patt.

MOTIFS
Damask Motif
(Make 3, join 81 to form 3 panels)
Ch 6, sl st in first ch to form a ring.

Rnd 1 (RS) Ch 3 (counts as dc here and throughout), dc in ring, ch 3, [2 dc in ring, ch 3] 5 times, sl st in 3rd ch of beg ch-3 to join—12 dc and 6 ch-3 sps.

Rnd 2 Ch 3, dc in same ch as join, 2 dc in next dc, ch 1, picot (see Special Stitches), ch 1, sk next ch-3 sp, [2 dc in each of next 2 dc, ch 1, picot, ch 1, sk next ch-3 sp] 5 times, sl st in 3rd ch of beg ch-3 to join—24 dc and 6 picots.

Rnd 3 Beg x-st (see Special Stitches), ch 3, picot, ch 3, sk next picot, [x-st (see Special Stitches) over next 4 dc, ch 3, picot, ch 3, sk

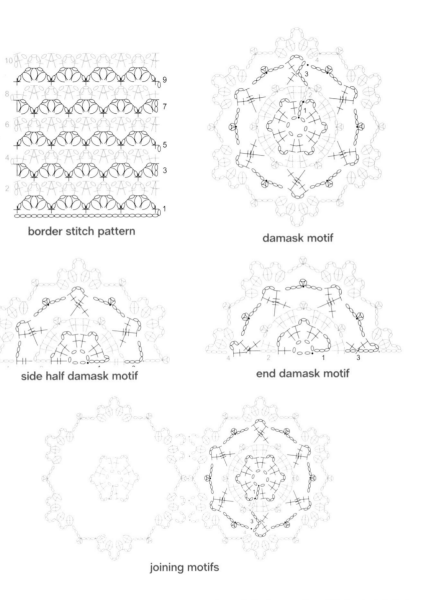

border stitch pattern

damask motif

side half damask motif

end damask motif

joining motifs

next picot] 5 times, sl st in 3rd ch of ch-6 sp on beg x-st to join—6 x-sts and 6 picots.

Rnd 4 Ch 2, (2 dc-cl [see Special Stitches], ch 3, 3 dc-cl [see Special Stitches] in ch-3 sp of beg x-st, ch 3, in ch-3 sp of beg x-st, ch 3, in ch-3 sp of beg x-st, ch 3,

picot, ch 3, sk next picot, *(3 dc-cl, ch 3, 3 dc-cl, ch 5, 3 dc-cl, ch 3, 3 dc-cl) in ch-3 sp of next x-st, ch 3, picot, ch 3, sk next picot; rep from * 4 times, sl st in top of beg dc-cl to join—24 cl and 6 picots. Fasten off.

5" (13 cm) 5" (13 cm)

62" (157.5 cm)

5" (13 cm)

77" (195.5 cm)

Side Damask Motifs

Ch 6, sl st in first ch to form a ring.

Row 1 (WS) Ch 5 (counts as tr, ch-1), [2 dc in ring, ch 3] 2 times, (2 dc, ch 1, tr) in ring, turn—2 tr, 6 dc, 2 ch-3 sps and 2 ch-1 sps.

Row 2 Ch 5, [2 dc in each of next 2 dc, ch 1, picot, ch 1, sk next ch-3 sp] 2 times; 2 dc in each of next 2 dc, ch 1, tr in 4th ch of beg ch-5, turn—2 tr, 12 dc, 2 picots and 2 ch-1 sps.

Row 3 Ch 7 (counts as tr, ch 3), sk next ch-

sp, [x-st over next 4 dc, ch 3, picot, ch 3, sk next picot] 2 times; x-st over next 4 dc, ch 3, tr in 4th ch of beg ch-5, turn—2 picots and 6 ch-3 sps.

Row 4 (joining row) Ch 3, picot, ch 3, sk next ch-sp, *(3 dc-cl, ch 3, 3 dc-cl, ch 5, 3 dc-cl, ch 3, 3 dc-cl) in ch-3 sp of next x-st**, ch 3, picot, ch 3, sk next picot; rep from * once; rep from * to ** once; ch 3, picot, ch 3, sl st in 4th ch of ch-7 to join—12 cl and 4 picots. Fasten off.

End Damask Motifs

Ch 6, sl st in first ch to form a ring.

Row 1 (WS) Ch 6 (counts as dc, ch 3), [2 dc in ring, ch 3] 2 times, dc in ring—6 dc and 3 ch-3 sps.

Row 2 Ch 3 (counts as dc), dc in first dc, ch 1, picot, ch 1, sk next ch-3 sp, [2 dc in each of next 2 dc, ch 1, picot, ch 1, sk next ch-3 sp] 2 times, 2 dc in 3rd ch of beg ch-3—12 dc and 3 picots.

Row 3 Ch 2, dc in next dc, ch 6, dc in top of last dc made (beg x-st made), ch 3, picot, ch 3, [sk next picot, x-st over next 4 dc, ch 3, picot, ch 3] 2 times; sk next picot, x-st over last 2 dc—4 x-sts and 3 picots.

Row 4 (joining row) Ch 6 (counts as ch-5 sp), (3 dc-cl, ch 3, 3 dc-cl) in ch-3 sp of first x-st, ch 3, picot, ch 3, sk next picot *(3 dc-cl, ch 3, 3 dc-cl, ch 5, 3 dc-cl, ch 3, 3 dc-cl) in ch-3 sp of next x-st, ch 3, picot, ch 3, sk next picot; rep from * once more; (3 dc-cl, ch 3, 3 dc-cl) in last ch-3 sp, ch 6, sl st in 3rd ch of beg ch-6 to join—12 cl and 3 picots. Fasten off.

> tip
>
> Motifs can be overwhelming if you don't give yourself sense-of-accomplishment goals. I like to work one panel of motifs at a time and allow for a certain amount of time to complete that one piece—that way I don't look at the overall project and get discouraged. Instead, I have a sense of accomplishment when that one panel is done. Before you know it, all the panels are complete, and you're almost there!
>
> —MARLY BIRD

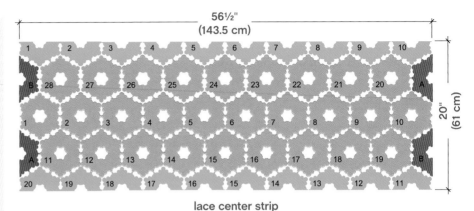

lace center strip

damask motif

side damask motif

end damask motif

pattern

LACE CENTER STRIPS
(make 3)

With MC, work one Damask Motif (see Motifs) (labeled 1 on layout diagram, above) then join opposite edges of Damask Motifs into a long strip of 10. This will be the middle of the lace portion.

2nd–10th Damask Motifs

RND 1–3: Work same as Rnds 1–3 on Damask Motif.

RND 4 (joining rnd): Ch 2, (2 dc-cl, ch 3, 3 dc-cl, ch 5, 3 dc-cl, ch 3, 3 dc-cl) in ch-3 sp of beg x-st, ch 3, picot, ch 3, sk next picot, [(3 dc-cl, ch 3, 3 dc-cl, ch 5, 3 dc-cl, ch 3, 3 dc-cl) in ch-3 sp of next x-st, ch 3, picot, ch 3, sk next picot] 3 times; (3 dc-cl, ch 3, 3 dc-cl, ch-5 join, 3 dc-cl, ch-3 join, 3 dc-cl) in ch-3 sp of next x-st; ch 3, picot join, ch 3, sk next picot; (3 dc-cl, ch-3 join, 3 dc-cl, ch-5 join, 3 dc-cl, ch 3, 3 dc-cl) in ch-3 sp of next x-st; ch 3, picot, ch 3, sk next picots, sl st in top of beg dc-cl to join—24 cl and 6 picots. Fasten off.

Beg at the bottom of the first strip, work an End Damask Motif (see Motifs) (labeled A on layout diagram) at the bottom edge, as foll:

A End Damask Motif

Rep directions for Rnds 1–3 of End Damask Motif.

RND 4: Ch 4, sl st in adjoining motif's ch-5 sp, ch 1, (3 dc-cl, ch-3 join, 3 dc-cl) in ch-3 sp of first x-st, ch 3, picot join, ch 3, sk next picot, (3 dc-cl, ch-3 join, 3 dc-cl, ch-5 join, 3 dc-cl, ch 3, 3 dc-cl) in ch-3 sp of next x-st, ch 3, picot, ch 3, sk next picot; (3 dc-cl, ch 3, 3 dc-cl, ch 5, 3 dc-cl, ch 3, 3 dc-cl) in ch-3 sp of next x-st, ch 3, picot, ch 3, sk next picot, (3 dc-cl, ch 3, 3 dc-cl), ch 6, sl st in 3rd ch of beg ch-6 to join—12 cl and 3 picots. Fasten off.

Join next 9 Damask Motifs as foll, then an End Motif B.

11–19 Damask Motifs

Rep directions for Rnds 1–3 of Damask Motif.

RND 4 (joining rnd): Ch 2, (2 dc-cl, ch 3, 3 dc-cl, ch 5, 3 dc-cl, ch 3, 3 dc-cl) in ch-3 sp of beg x-st, ch 3, picot, ch 3, sk next picot, (3 dc-cl, ch 3, 3 dc-cl, ch 5, 3 dc-cl, ch 3, 3 dc-cl) in ch-3 sp of next x-st, ch 3, picot, ch 3, sk next picot, (3 dc-cl, ch 3, 3 dc-cl, ch-5 join, 3 dc-cl, ch-3 join, 3 dc-cl) in ch-3 sp of

next x-st; ch 3, picot join, ch 3, sk next picot, [(3 dc-cl, ch-3 join, 3 dc-cl, ch-5 join, 3 dc-cl, ch-3 join, 3 dc-cl) in ch-3 sp of next x-st; ch 3, picot join, ch 3, sk next picot] twice, (3 dc-cl, ch-3 join, 3 dc-cl, ch-5 join, 3 dc-cl, ch 3, 3 dc-cl) in ch-3 sp of next x-st; ch 3, picot, ch 3, sk next picots, sl st in top of beg dc-cl to join—24 cl and 6 picots. Fasten off.

B End Damask Motif

Rep directions for Rnds 1–3 of End Damask Motif.

RND 4: Ch 6, (3 dc-cl, ch 3, 3 dc-cl) in ch-3 sp of first x-st, ch 3, picot, ch 3, sk next picot, (3 dc-cl, ch 3, 3 dc-cl, ch-5 join, 3 dc-cl, ch-3 join, 3 dc-cl) in ch-3 sp of next x-st, ch 3, picot join, ch 3, sk next picot; (3 dc-cl, ch-3 join, 3 dc-cl, ch-5 join, 3 dc-cl, ch-3 join, 3 dc-cl) in ch-3 sp of next x-st, ch 3, picot join, ch 3, sk next picot, (3 dc-cl, ch-3 join, 3 dc-cl), ch 1, sl st to adjoining motif, ch 4, sl st in 3rd ch of beg ch-6 to join—12 cl and 3 picots. Fasten off.

Rep directions for A End Motif at top left corner of strip, rep directions for Damask Motifs 11–19 for motifs 20–28, rep Directions for B End Motif.

Join Side Damask Motifs (see Motifs) to the outside edge of the large strip—28 Damask Motifs, 4 End Damask Motifs, 20 Side Damask Motifs.

1, 11 Side Damask Motifs

Join Motif 1 to the upper right corner and Motif 11 to the lower left corner.

Rep Rnds 1–3 of Side Motif.

ROW 4 (joining row): Ch 3, picot, ch 3, sk next ch-sp, (3 dc-cl, ch 3, 3 dc-cl, ch-5 join, 3 dc-cl, ch-3 join, 3 dc-cl) in ch-3 sp of next x-st, ch 3, picot join, ch 3, sk next picot, (3 dc-cl, ch-3 join, 3 dc-cl, ch-5 join, 3 dc-cl, ch-3 join, 3 dc-cl) in ch-3 sp of next x-st, ch 3, picot join, ch 3, sk next picot, (3 dc-cl, ch-3 join, 3 dc-cl, ch-5 join, 3 dc-cl, ch 3, 3 dc-cl) in ch-3 sp of next x-st, ch 3, picot, ch 3, sl st in 4th ch of ch-7 to join—12 cl and 4 picots. Fasten off.

2–10, 12–20 Side Damask Motifs

Work 2–10 Motifs on upper edge and 12–20 on lower edge.

Rep Rnds 1–3 of Side Motif.

ROW 4 (joining row): Ch 3, picot, ch 3, sk next ch-sp, (3 dc-cl, ch 3, 3 dc-cl, ch-5 join, 3 dc-cl, ch-3 join, 3 dc-cl) in ch-3 sp of next x-st, ch 3, picot join, ch 3, sk next picot, (3 dc-cl, ch-3 join, 3 dc-cl, ch-5 join, 3 dc-cl, ch-3 join, 3 dc-cl) in ch-3 sp of next x-st, ch 3, picot join, ch 3, sk next picot, (3 dc-cl, ch-3 join, 3 dc-cl, ch-5 join, 3 dc-cl, ch-3 join, 3 dc-cl) in ch-3 sp of next x-st, ch 3, picot join, ch 3, sl st in 4th ch of ch-7 to join—12 cl and 4 picots. Fasten off.

NOTE: Wet-block (see Glossary) strips at this point to make it easier to work the border.

border

CENTER STRIP BORDERS

With RS facing, join MC with sl st in short edge corner of center strip, ch 1, sc evenly around, working a multiple of 6 sts, sl st in first sc to join, changing to CC2.

NOTE: From here on work each side border in rows from corner to corner.

FIRST SHORT SIDE EDGING: Treating each sc as a base ch-sp, work Row 1 of Border Patt (see Motifs) along the short edge only, ending with sc in corner st, turn. Work Rows 2–3 of Border patt across short edge. At end of last row, fasten off.

SECOND SHORT SIDE EDGING: With RS facing, join CC2 with sl st in right corner on opposite short edge; rep First Short Side Edging across 2nd side edge.

FIRST LONG SIDE EDGING: With RS of center strip facing, join CC2 with sl st in corner st on one long edge, treating each sc as a base ch work Row 1 of Border patt to corner, ending with sc in corner st, turn. Work in Border patt for 2 more rows**, then change to CC1 and work in Border patt for 5 rows. At end of last row, fasten off.

SECOND LONG SIDE EDGING: With RS facing and on Side Damask Motifs of 1 lace center strip, rep First Long Side Edging.

END STRIP BORDERS
End Strips have 5 extra rows on outside edge of long side edging.

Work same as Center Strip borders through ** on Second Long Side Edging, then change to CC1 and work in Border patt for 10 rows. At end of last row, fasten off.

ASSEMBLE STRIPS
SEAMING ROW: With RS tog, matching the narrow border of one end strip (with only 5 rows of CC1) to one long side of center strip, join CC1 at right end of long edge, ch 1, working through double thickness, sc in each st across. Rep seaming row across other end strip and other side of center strip.

NOTE: This should place the 2 borders with 10 rows of CC1 on the outer edges of the blanket.

FINAL BORDER
Working across all three strips, join CC1 with sl st to right corner of one long edge, work Row 1 of Border patt, ending with sc in corner st, turn. Work Border Patt for 9 more rows. At end of last row, fasten off.

Rep final Border across opposite long side edge of afghan.

PICOT EDGING
RND 1: With RS facing, join CC2 with sl st in any corner, ch 1, *sc in each of next 3 sts, picot; rep from * around, sl st in first sc to join. Fasten off.

finishing

Weave in loose ends. Spray block (see Glossary).

> " I love to make shells because I can start them with the double crochet eyelets, as in the Eloise Baby Blanket (page 14). If I plan the row so that the shells are at the ends, it's easy to make a border at the same time. Less finishing! Shells can be varied easily so that no two are alike, and with these shells I make scarves, afghans, dishcloths, and much more." —MARTY MILLER

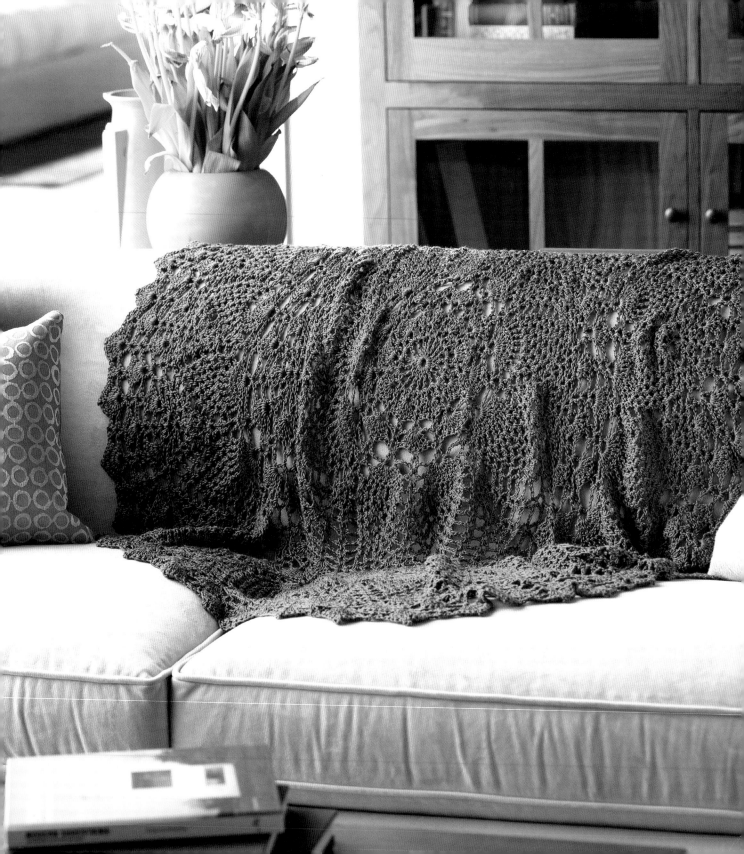

exploded pineapple afghan

In American Colonial times, pineapples were so exotic, costly, and hard to get that they became a fashionable luxury. Later, as a decorative motif in wood carvings and needlework, they became a symbol of welcome and hospitality. In this design, the iconic crocheted pineapple assumes another aspect, one of breezy, exploded gauge, afghan style. It also makes a sweet lightweight shawl. ● **BY DORIS CHAN**

MATERIALS

Yarn Sportweight (#3 Light).

Shown Naturally Caron .com Spa (75% microfiber acrylic, 25% rayon from bamboo; 251 yd [230 m]/3 oz [85 g]): #0010 Stormy Blue, 5 balls.

Hook H/8 (5 mm) or size needed to obtain gauge.

Notions Tapestry needle for weaving in ends.

GAUGE

Rnds 1–2 = 4" (10 cm) in diameter; Rnds 1–4 = 6½" (16.5 cm) as crocheted before blocking.

FINISHED SIZE

50" (127 cm) in diameter before blocking. 52" (132 cm) in diameter blocked.

NOTES

Afghan is crocheted from the center outward in joined rounds, with RS of stitches always facing as in traditional doily crochet (do not turn after each round).

Each round is different. Please check your work frequently, especially during the outer rounds that are quite long.

SPECIAL STITCHES

V-stitch (V-st) (Dc, ch 2, dc) in indicated st or sp.

Picot Ch 4, sl st in flp of tr just worked (see tip on page 117).

pattern

Ch 8, sl st in first ch to form a ring.

RND 1: Ch 6 (counts as dtr, ch 1), [dtr in ring, ch 1] 17 times, sc in 5th ch of beg ch-6 for last ch-sp and join—18 dtr, 18 ch-1 sps.

RND 2: Ch 3 (counts as dc), [sk next dtr, V-st (see Special Stitches) in next ch-1 sp] 17 times, dc in same sp as beg, hdc in 3rd ch of beg ch-3 to complete last V-st and join—18 V-sts.

RND 3: Ch 3, [5 tr for sh in ch-2 sp of next V-st, V-st in ch-2 sp of next V-st] 8 times, 5 tr in ch-2 sp of next V-st, dc in same sp as beg, hdc in 3rd ch of beg ch-3 to join—9 sh, 9 V-sts.

RND 4: Ch 5 (counts as dc, ch 2), [V-st in 3rd tr at center of next sh, ch 2, V-st in ch-2 sp of next V-st, ch 2] 8 times, V-st in 3rd tr at center of next sh, ch 2, dc in same sp as beg, hdc in 3rd ch of beg ch-5 to join—18 V-sts.

RND 5: Ch 4 (counts as tr), 3 tr in beg sp, [V-st in ch-2 sp of next V-st, 7 tr for sh in ch-2 sp of next V-st] 8 times, V-st in ch-2 sp of next V-st, 3 tr in same sp as beg, sl st in 4th ch of beg ch-4 to join.

RND 6: Ch 7 (counts as dc, ch 4), [V-st in ch-2 sp of next V-st, ch 4, V-st in 4th tr at center of next sh, ch 4] 8 times, V-st in ch-2 sp of next V-st, dc in same tr as beg, hdc in 3rd ch of beg ch-7 to join—18 V-sts.

RND 7: Ch 4 (counts as dc, ch 1), [9 tr for pineapple base in ch-2 sp of next V-st, ch 1, V-st in ch-2 sp of next V-st, ch 1] 9 times, omitting last (V-st, ch 1), end

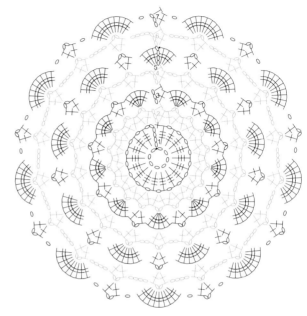

center of afghan

with dc in same sp as beg, hdc in 3rd ch of beg ch-4 to join—9 pineapple bases.

RND 8: Ch 4, *[tr in next tr, ch 1] 9 times, V-st in ch-2 sp of next V-st, ch 1; rep from * 8 more times, omitting last (V-st, ch 1), end with dc in same sp as beg, hdc in 3rd ch of beg ch-4 to join.

RND 9: Ch 6 (counts as dc, ch 3), *[sk next tr, sc in next ch-1 sp, ch 3] 8 times, V-st in ch-2 sp of next V-st, ch 3; rep from * 8 more times, omitting last (V-st, ch 3), end with dc in same sp as beg, hdc in 3rd ch of beg ch-6 to join.

RND 10: Ch 5, dc in beg sp for V-st, *[ch 3, sk next sc, sc in next ch-3 sp] 7 times, ch 3, (V-st, ch 2, V-st) in ch-2 sp of next V-st; rep from * 8 more times, omitting

last (V-st, ch 2, V-st), end with V-st in same sp as beg, hdc in 3rd ch of beg ch-5 to join.

RND 11: Ch 3, *V-st in ch-2 sp of next V-st, [ch 3, sk next sc, sc in next ch-3 sp] 6 times, ch 3, V-st in ch-2 sp of next V-st, V-st in next ch-2 sp (bet V-sts); rep from * 8 more times, omitting last V-st, end with dc in same sp as beg, hdc in 3rd ch of beg ch-3 to join.

RND 12: Ch 5, *V-st in ch-2 sp of next V-st, [ch 3, sk next sc, sc in next ch-3 sp] 5 times, ch 3, [V-st in ch-2 sp of next V-st, ch 2] 2 times; rep from * 8 more times, omitting last (V-st, ch 2), end with dc in same sp as beg, hdc in 3rd ch of beg ch-5 to join.

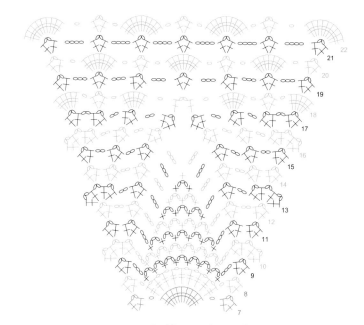

segment of lower pineapple

RND 13: Ch 5, dc in beg sp for V-st, *ch 2, V-st in ch-2 sp of next V-st, [ch 3, sk next sc, sc in next ch-3 sp] 4 times, ch 3, V-st in ch-2 sp of next V-st, ch 2**, (V-st, ch 2, V-st) in ch-2 sp of next V-st*; rep from * to * 7 more times; rep from * to ** once, end with V-st in same sp as beg, hdc in 3rd ch of beg ch-5 to join.

RND 14: Ch 3, *V-st in ch-2 sp of next V-st, ch 2, V-st in ch-2 sp of next V-st, [ch 3, sk next sc, sc in next ch-3 sp] 3 times, ch 3, V-st in ch-2 sp of next V-st, ch 2, V-st in ch-2 sp of next V-st, V-st in next ch-2 sp (bet V-sts); rep from * 8 more times, omitting last V-st, end with dc in same sp as beg, hdc in 3rd ch of beg ch-3 to join.

RND 15: Ch 5, *V-st in ch-2 sp of next V-st, ch 2, V-st in ch-2 sp of next V-st,

[ch 3, sk next sc, sc in next ch-3 sp] 2 times, ch 3, [V-st in ch-2 sp of next V-st, ch 2] 3 times; rep from * 8 more times, omitting last (V-st, ch 2), end with dc in same sp as beg, hdc in 3rd ch of beg ch-5 to join.

RND 16: Ch 5, dc in beg sp, *[ch 2, V-st in ch-2 sp of next V-st] 2 times, ch 3, sk next sc, sc in next ch-3 sp, ch 3, [V-st in ch-2 sp of next V-st, ch 2] 2 times**, (V-st, ch 2, V-st) in ch-2 sp of next V-st*; rep from * to * 7 more times, rep from * to ** once, end with V-st in same sp as beg, hdc in 3rd ch of beg ch-5 to join.

RND 17: Ch 5, *[V-st in ch-2 sp of next V-st, ch 2] 2 times, V-st in ch-2 sp of next V-st, sk next 2 ch-3 sps (do not ch as you sk pineapple point), [V-st in ch-2 sp of next V-st, ch 2] 3 times, V-st in next

ch-2 sp (bet V-sts), ch 2; rep from * 8 more times, omitting last (V-st, ch 2), end with dc in same sp as beg, hdc in 3rd ch of beg ch-5 to join.

RND 18: Ch 4, 2 tr in beg sp, *ch 1, V-st in ch-2 sp of next V-st, ch 1, 5 tr for sh in ch-2 sp of next V-st, ch 1, (dc in ch-2 sp of next V-st, ch 2, dc in ch-2 sp of next V-st) across pineapple point (counts as V-st), ch 1, 5 tr in ch-2 sp of next V-st, ch 1, V-st in ch-2 sp of next V-st, ch 1, 5 tr in ch-2 sp of next V-st; rep from * 8 more times, omitting last 5 tr, end with 2 tr in same sp as beg, sl st in 4th ch of beg ch-4 to join—27 sh.

tip To encourage the picot to stay on top of a particular st, after completing a tr as indicated, ch 4, then moving hook forward from the ch just made, insert hook from top to bottom in front lp of tr just made AND in one forward strand of the stem of the tr (just below the top lp), going under 2 strands, yo and draw a lp through the tr and through the lp on hook to sl st closed. In other words, insert the hook so that it back-traces the last step of making the tr, back through the stitch. —DORIS CHAN

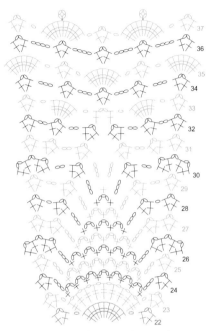

segment of upper pineapple

RND 19: Ch 6, [V-st in ch-2 sp of next V-st, ch 3, V-st in 3rd tr at center of next sh, ch 3] 27 times, omitting last (V-st, ch 3), end with dc in same st as beg, hdc in 3rd ch of beg ch-6 to join—54 V-sts.

RND 20: Ch 4 (counts as dc, ch 1), [7 tr for sh in ch-2 sp of next V-st, ch 1, V-st in ch-2 sp of next V-st, ch 1] 27 times, omitting last (V-st, ch 1), end with dc in same sp as beg, hdc in 3rd ch of beg ch-4 to join—27 sh.

RND 21: Ch 7 (counts as dc, ch 4), [V-st in 4th tr at center of next sh, ch 4, V-st in ch-2 sp of next V-st, ch 4] 27 times, omitting last (V-st, ch 4), end with dc in same sp as beg, ch 2, sl st in 3rd ch of beg ch-7, fasten off and cut yarn—54 V-sts.

Shift the joining of rnds, as foll: sk beg V-st, join new yarn with sl st in ch-2 sp of next V-st (or in any V-st worked into the center of a sh). Be careful, as the V-sts in the wedges bet the next 27 pineapples do not inc the same way as in previous rounds.

RND 22: Ch 4, [9 tr for pineapple base in ch-2 sp of next V-st, ch 1, V-st in ch-2 sp of next V-st, ch 1] 27 times, omitting last (V-st, ch 1), end with dc in same sp as beg, hdc in 3rd ch of beg ch-4 to join—27 pineapple bases.

RND 23: Ch 4, *[tr in next tr, ch 1] 9 times, V-st in ch-2 sp of next V-st, ch 1; rep from * 26 more times, omitting last (V-st, ch 1), end with dc in same sp as beg, hdc in 3rd ch of beg ch-4 to join.

RND 24: Ch 6 (counts as dc, ch 3), *[sk next tr, sc in next ch-1 sp, ch 3] 8 times, V-st in ch-2 sp of next V-st, ch 3; rep from * 26 more times, omitting last (V-st, ch 3), end with dc in same sp as beg, hdc in 3rd ch of beg ch-6 to join.

RND 25: Ch 6, *[sk next sc, sc in next ch-3 sp, ch 3] 7 times, V-st in ch-2 sp of next V-st, ch 3; rep from * 26 more times, omitting last (V-st, ch 3), end with dc in same sp as beg, hdc in 3rd ch of beg ch-6 to join.

RND 26: Ch 5, dc in beg sp for V-st, *[ch 3, sk next sc, sc in next ch-3 sp] 6 times, ch 3, (V-st, ch 2, V-st) in ch-2 sp of next V-st; rep from * 26 more times, omitting last (V-st, ch 2, V-st), end with V-st in same sp as beg, hdc in 3rd ch of beg ch-5 to join.

RND 27: Ch 3, *V-st in ch-2 sp of next V-st, [ch 3, sk next sc, sc in next ch-3 sp] 5 times, ch 3, V-st in ch-2 sp of next V-st, V-st in next ch-2 sp (bet V-sts); rep from * 26 more times, omitting last V-st, end with dc in same sp as beg, hdc in 3rd ch of beg ch-3 to join.

RND 28: Ch 4, *V-st in ch-2 sp of next V-st, [ch 3, sk next sc, sc in next ch-3 sp] 4 times, ch 3, [V-st in ch-2 sp of next

tip An exploded-gauge doily such as this afghan, made from the center out in rounds where you are always looking at the right side of the stitches, presents one big problem—a really, really big problem. The outer rounds are huge. If you come upon a mistake in the round below and want to go back and fix it, that means ripping back the entire circumference of the afghan. Been there, done that more times than I want to talk about. So please check your work carefully and often. The best way to keep up with it is to glance back each time you complete a bite—for example, a pineapple repeat. —DORIS CHAN

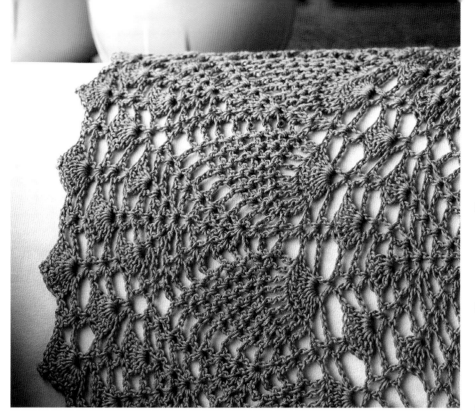

V-st, ch 1] 2 times; rep from * 26 more times, omitting last (V-st, ch 1), end with dc in same sp as beg, hdc in 3rd ch of beg ch-4 to join.

RND 29: Ch 5, *V-st in ch-2 sp of next V-st, [ch 3, sk next sc, sc in next ch-3 sp] 3 times, ch 3, [V-st in ch-2 sp of next V-st, ch 2] 2 times; rep from * 26 more times, omitting last (V-st, ch 2), end with dc in same sp as beg, hdc in 3rd ch of beg ch-5 to join.

RND 30: Ch 5, dc in beg sp for V-st, *ch 2, V-st in ch-2 sp of next V-st, [ch 3, sk next sc, sc in next ch-3 sp] 2 times, ch 3, V-st in ch-2 sp of next V-st, ch 2**, (V-st, ch 2, V-st) in ch-2 sp of next V-st*; rep from * to * 25 times; rep from * to ** once, end with V-st in same sp as beg, hdc in 3rd ch of beg ch-5 to join.

RND 31: Ch 3, *V-st in ch-2 sp of next V-st, ch 2, V-st in ch-2 sp of next V-st, ch 3, sk next sc, sc in next ch-3 sp, ch 3, V-st in ch-2 sp of next V-st, ch 2, V-st in ch-2 sp of next V-st, V-st in next ch-2 sp (bet V-sts); rep from * 26 more times, omitting last V-st, end with dc in same sp as beg, hdc in 3rd ch of beg ch-3 to join.

RND 32: Ch 5, *V-st in ch-2 sp of next V-st, ch 2, V-st in ch-2 sp of next V-st, sk next 2 ch-3 sps (do not ch as you sk pineapple point), [V-st in ch-2 sp of next V-st, ch 2] 3 times; rep from * 26 more times, omitting last (V-st, ch 2), end with dc in same sp as beg, hdc in 3rd ch of beg ch-5 to join.

RND 33: Ch 4, *5 tr for sh in ch-2 sp of next V-st, ch 1, (dc in ch-2 sp of next V-st, ch 2, dc in ch-2 sp of next V-st) across pineapple point (counts as V-st), ch 1, 5 tr in ch-2 sp of next V-st, ch 1, V-st in ch-2 sp of next V-st, ch 1; rep from * 26

more times, omitting last 5 tr, end with 2 tr in same sp as beg, sl st in 4th ch of beg ch-4 to join—54 sh.

RND 34: Ch 6, [V-st in 3rd tr at center of next sh, ch 3, V-st in ch-2 sp of next V-st, ch 3] 54 times, omitting last (V-st, ch 3), end with dc in same st as beg, hdc in 3rd ch of beg ch-6 to join—108 V-sts.

RND 35: Ch 4, 3 tr in beg sp, [ch 1, V-st in ch-2 sp of next V-st, ch 1, 7 tr for sh in ch-2 sp of next V-st] 54 times, omitting last 7 tr, end with 3 tr in same sp as beg, sl st in 4th ch of beg ch-4 to join—54 sh.

RND 36: Ch 7 (counts as dc, ch 4), [V-st in ch-2 sp of next V-st, ch 4, V-st in 4th tr at center of next sh, ch 4] 54 times, omitting last (V-st, ch 4), end with dc in same sp as beg, hdc in 3rd ch of beg ch-7 to join—108 V-sts.

RND 37: Ch 4, [(5 tr, picot, 4 tr) in ch-2 sp of next V-st, ch 1, V-st in ch-2 sp of next V-st, ch 1] 54 times, omitting last (V-st, ch 1), end with dc in same sp as beg, ch 2, sl st in 3rd ch of beg ch-4 to join, fasten off.

finishing

Weave in loose ends. Wet-block afghan by submerging project in cold water and gently rolling out the excess water in towels. Lay afghan down and pin to a 52" (132 cm) diameter, smoothing out the slight ruffling that occurs in outer rounds. Allow to dry.

Many people see Tunisian crochet and think it is anything but crochet.

This is why I love this technique. It can yield results that are unlike anything a regular hook can produce. Tunisian crochet is worked on a long crochet hook with a uniform-diameter shaft. Instead of finishing off each stitch as in regular crochet, you pick up and keep the last loop of each stitch on the hook (as in knitting). Again as in knitting, you can work either into the front or back of the loops, with the yarn held to the back (as in knit stitches) or to the front (as in purl stitches). Each project featured in this chapter demonstrates a classic technique, from lace in the Nauha Pillow (page 122), to entrelac shaping in the Starburst Entrelac Afghan (page 144), to crossing stitches in the Mission Cabled Afghan (page 128), to purling in the Smocked Elegance Baby Afghan (page 124), to post stitches in the Ariannah Sampler (page 132), and waves in the Van Gogh Waves afghan (page 138). Each one shows clearly that Tunisian crochet is a medium that screams to be tried.

TUNISIAN CROCHET LOVE

To me, Tunisian crochet looks like weaving. I love when one color is used on the forward pass and another is used on the return pass, giving a tonal fabric mash-up. Since it looks like weaving to me, I like to use Tunisian crochet in sari shawls, giving both sides of the fabric unique and beautiful results.

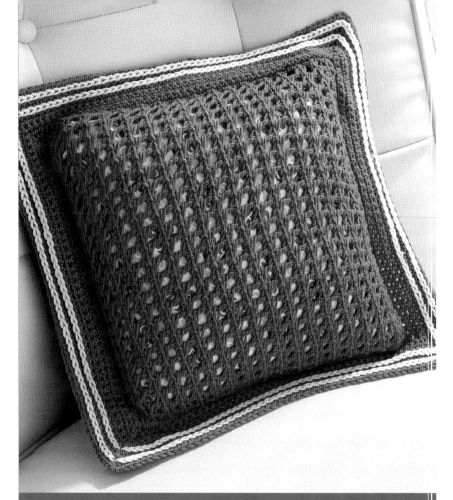

MATERIALS

Yarn DK weight (#3 Light).

Shown Filatura di Crosa Zara (100% extrafine merino superwash wool; 136.5 yd [125 m]/1.75 oz [50 g]): #1794 Coral (MC), 2 balls; #1925 Pale Spring Green (CC), 1 ball.

Hooks L/11 (8 mm) 12" (30.5 cm) Tunisian hook and H/8 (5 mm) standard hook or sizes needed to obtain gauge.

Notions Tapestry needle for weaving in ends, five ⅝" (15 mm) buttons, spray bottle with water and straight pins for blocking, 12" (30.5 cm) pillow form.

GAUGE

14 sts and 8 rows = 4" (10 cm) in stitch pattern.

FINISHED SIZE

16" x 16" (40.5 x 40.5 cm).

NOTES

Always skip first vertical bar of the row (it is already on your hook from the return pass of previous row).

For final st of row, remember to insert hook under both strands of stitch.

SPECIAL STITCHES

Tunisian Extended Stitch Decrease (Tes dec) Insert hook into vertical bar of each of next 2 sts and pull up a lp, ch 1.

pattern

With MC and Tunisian hook, ch 36.

ROW 1 (RS): *Fwd:* Pull up a lp in 2nd ch from hook and in each ch across. *Rtn:* Yo, pull through 1 lp on hook, *yo, pull through 2 lps on hook; rep from * to end—36 sts.

nauha pillow

Tunisian crochet can make so many different fabric textures, from those mimicking knitting to ones that look woven. It also makes for a really therapeutic crafting session, because its rhythmic movements repeat over and over. This pillow adds a pop of color and warms, as well as calms, your senses. What could be better?

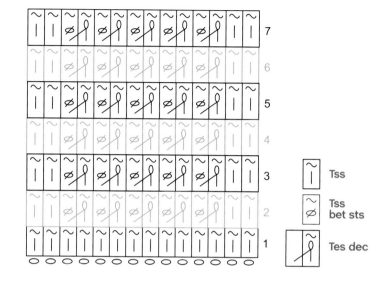

~ \|	Tss
~ ∅	Tss bet sts
~ ʅ	Tes dec

ROW 2: *Fwd:* (Lp on hk counts as first st here and throughout), Tss in next st, *Tes dec (see Special Stitches) in next 2 sts, insert hook bet previous and next sts and pull up a lp; rep from * to last 2 sts, Tss in last 2 sts. *Rtn:* Yo, pull through 1 lp on hook, *yo, pull through 2 lps on hook; rep from * to end.

ROWS 3–52: Rep Row 2.

ROW 53 (BIND-OFF ROW): Insert hook in next st and pull up a lp, pull through lp on hook, *insert hook in next 2 sts and pull up a lp, pull through lp on hook, insert hook bet previous and next st and pull up a lp, pull through lp on hook; rep from * to last 2 sts, (insert hook in next st and pull up a lp, pull through lp on hook) 2 times, fasten off.

finishing

BLOCKING AND SEAMING
Pin pillow cover to 12" × 26" (30.5 × 66 cm) and spray with water to block. Allow to dry. Fold pillow panel so top edge overlaps bottom by 2" (5 cm), pin open sides. Flap will fold to the back of pillow.

BORDER
RND 1: With front facing, using standard hook, join MC to top of left side edge of pillow cover, at the base of the flap, working through double thickness, ch 1, *sc evenly down side edge of pillow to bottom fold, rotate 90 degrees, sc evenly across folded edge fabric; rep from * once, sl st in first sc to join, turn.

RNDS 2–9: Ch 1, sc in each sc around, working 3 sc in each corner sc, sl st in first sc to join, turn. Fasten off MC.

RND 10: With front facing, using standard hook, join CC with sl st in 8th round of sc on border, surface crochet sl st in each st around. Fasten off.

RND 11: With front facing, using standard hook, join CC with sl st in 6th round of sc on border, surface crochet sl st in each st around. Fasten off.

Using spaces bet sts on flap for buttonholes, using MC, sew buttons to back of pillow evenly spaced across, opposite buttonhole spaces on flap. Stuff pillow with 12" (30.5 cm) pillow form.

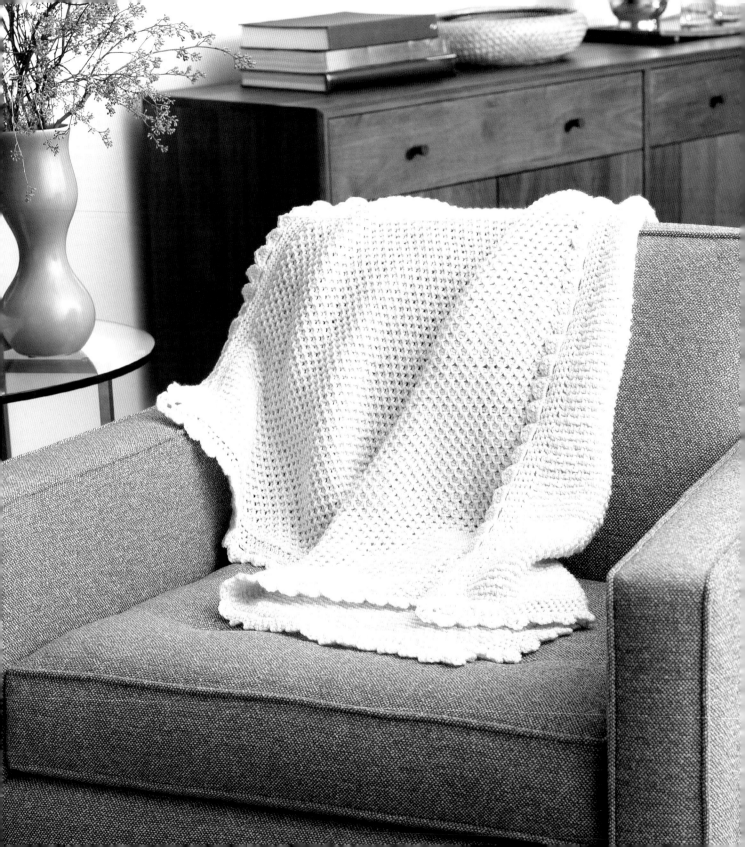

smocked elegance baby blanket

In my opinion, the key to treasured, well-used baby blankets is cuddliness. This afghan mimics the look of hand-smocked fabric using just a Tunisian crochet hook. The recessed diamonds and purl bumps create a richly textured fabric that is super cuddly and sure to please parents and babies alike. ● BY DARLA FANTON

MATERIALS

Yarn Worsted weight (#4 Medium).

Shown Premier Yarns, Deborah Norville Collection Everyday Soft Worsted (100% acrylic; 203 yd [186 m]/4 oz [113 g]): #02 Cream, 6 balls

Hooks L/11 (8 mm) 14" (35.5 cm) or cabled Tunisian hook and J/10 (6 mm) standard hook or sizes needed to obtain gauge.

Notions Stitch marker, tapestry needle for weaving in ends, steam iron, and straight pins for blocking.

GAUGE

14 sts and 11 rows = 4" (10 cm) in stitch pattern.

FINISHED SIZE

41" x 41" (104 x 104 cm).

NOTES

Always skip first vertical bar of the row (it is already on your hook from the return pass of previous row).

For final st of row, remember to insert hook under both strands of stitch.

When working yarn over from front to back, remember to bring yarn to the front before working the next purl-two-together or purl st as needed.

SPECIAL STITCHES

shell (sh) (Sc, hdc, dc, ch 2, dc, hdc, sc) in same st.

pattern

With Tunisian hook, loosely ch 132.

ROW 1 (RS): *Fwd:* Working in bumps on wrong side of ch, pull up a lp in 2nd ch from hook and in each ch across—132 sts. *Rtn:* Yo, pull through 1 lp on hook, *yo, pull through 2 lps on hook; rep from * to end—1 lp on hook.

ROW 2: *Fwd:* Tps next 2 sts tog, *yo from front to back, Tps next 2 sts tog; rep from * until 1 st rem, yo from back to front, pull up lp in final st working under both strands. *Rtn:* Yo, pull through 1 lp on hook, *yo, pull through 2 lps on hook; rep from * to end.

ROW 3: *Fwd:* Sk next st, *yo from front to back, Tps next 2 sts tog (this will include one st from each of the 2 pairs from previous row); rep from * until 2 sts remain, yo from front to back, Tps in next st, pull up lp in final st working under both strands. *Rtn:* Yo, pull through 1 lp on hook, *yo, pull through 2 lps on hook; rep from * to end.

ROWS 4–101: Rep Rows 2–3, ending after a Row 3 Rtn.

BIND-OFF: Bind off in sl st as if to Tss leaving final st unworked, switch to standard hook, cont with edging.

finishing

EDGING

Mark first st of each rnd.

Do not join rnds unless instructed.

RND 1: With standard hook, (sc, hdc, sc) in end of final row, *working in ends of rows, sc2tog over first 2 rows, sc in each of next 96 rows, sc2tog over next 2 rows*, (sc, hdc, sc) in end of Row 1, working in under side of foundation ch, sc2tog over first 2 sts, [sc in each of next 4 sts, sc2tog over next 2 sts] 21 times, sc2tog over next 2 sts, (sc, hdc, sc) in end of Row 1; rep from * to * once, (sc, hdc, sc) in end of Row 101, working in bind-off sl sts, sc2tog over

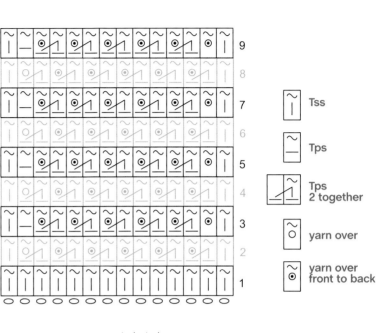

	Tss
	Tps
	Tps 2 together
	yarn over
	yarn over front to back

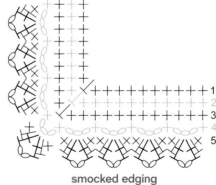

smocked edging

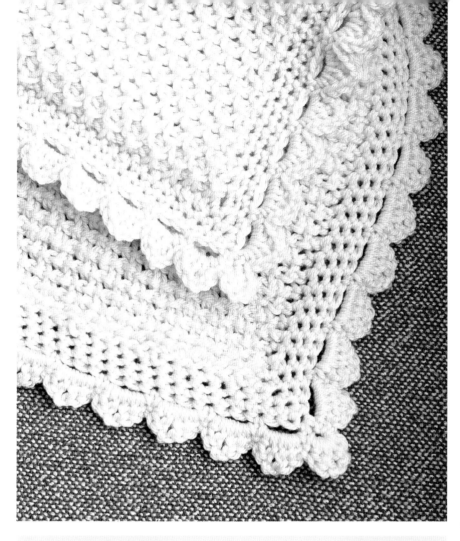

first 2 sts, [sc in each of next 4 sts, sc2tog over next 2 sts] 21 times, sc2tog over final 2 sts—100 sc bet hdc on each side edge, 115 sc bet hdc on top and bottom edges.

RNDS 2–3: Sc in each sc around, working (sc, hdc, sc) in each corner hdc—104 sc bet hdc on each side edge, 119 sc bet hdc on top and bottom edges at end of Rnd 3.

RND 4: Sc in first st, ch 3, sk next 2 sts, * (sc, ch 3, sc) in next hdc, [ch 3, sk next 2 sts, sc in next st] across to next corner, ch 3, sk next 2 sts; rep from * around, sl st in first sc to join—150 ch-3 sps.

RND 5: Sh (see Special Stitches) in each ch-3 sp around, sl st in first sc to join. Fasten off.

Weave in loose ends. Pin afghan to size and steam by holding the iron 1"–2" (2.5–5 cm) above the surface. Allow to dry before removing pins.

tip
Paying attention to the appearance of each of the four edges of your Tunisian projects will increase your overall satisfaction with the project. You want to achieve an even chain-link appearance on each of the four edges. This will serve as a good foundation for working the edging. For the lower edge, this means picking up in the bump on the wrong side of the foundation chain. For the right edge, this means making sure the loop on the hook at the beginning of the pick-up portion of a row is not too loose. For the left edge, it requires going under both strands of the final stitch. And finally for the top edge, remember to bind off. **—DARLA FANTON**

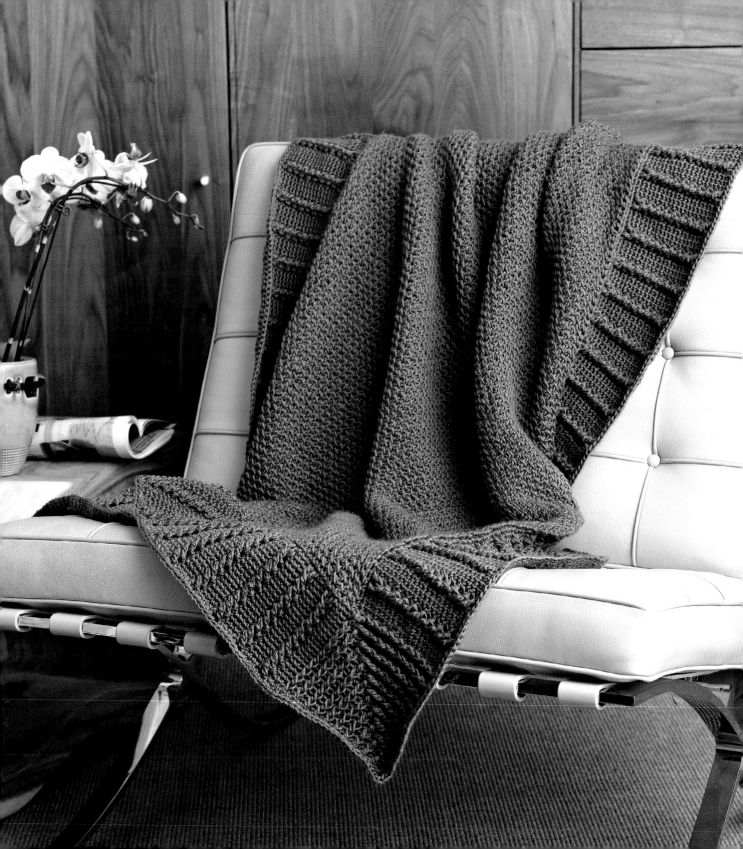

mission cabled afghan

Living with men who have definite opinions on crochet, I decided to design an afghan with my guy in mind. He'll like it because there are no ruffles, lace, or fringe. You'll enjoy the Tunisian twisted stitch, the wide modern cabled border and unusual post stitch corner, as well as the sophisticated color. He'll think it doesn't show the dirt, and he'll enjoy the sumptuous feel. ● BY DIANE HALPERN

MATERIALS

Yarn Worsted weight (#4 Medium).

Shown Naturally Caron Country (75% microdenier acrylic, 25% merino wool; 185 yd [170 m]/3 oz [85 g]): #0015 Deep Taupe, 15 balls.

Hook K/10½ (6.5 mm) Tunisian hook with 30" (76 cm) cord, H/8 (5 mm) standard hook or sizes needed to obtain gauge.

Notions Stitch markers, scissors, tapestry needle for weaving in ends, pins, and steamer or steam iron.

GAUGE

18 sts and 11 rows = 4" (10 cm) in Tunisian twisted stitch pattern; 18 sts and 16 rows = 4" (10 cm) in border pattern.

FINISHED SIZE

38" x 64" (96.5 x 162.5 cm).

NOTES

Always skip first vertical bar of the row (it is already on your hook from the return portion of previous row).

For final st of row, remember to insert hook under both strands of stitch.

Use stitch marker to mark the beginning of each round on the border.

Because of the cable border, stitch and row counts are more important than gauge.

SPECIAL STITCHES

Front post treble crochet (fptr) Yo 2 times, insert hook from front to back to front around indicated st, yo and pull up a lp, [yo and pull through 2 lps on hook] 3 times.

pattern

TUNISIAN TWISTED STITCH PANEL

(Ch must be a multiple of 6 + 3 + 1.)

Ch 124.

ROW 1: *Fwd:* Pull up a lp in 2nd ch from hook and in each ch across. *Rtn:* Yo, pull through 1 lp on hook, *yo, pull through 2 lps on hook; rep from * to end—124 lps on hook.

Pm around lps at each end of this row to mark placement of corner stitches.

ROW 2: *Fwd:* Sk first vertical bar, *insert hook under next 2 vertical bars at the same time, yo, pull up a lp, insert hook under first vertical bar of 2-lp group just formed, yo, pull through 1 lp on hook (twisted st formed) (3 lps on hook); rep from * across to last st (each twisted st adds 2 lps to the hook), Tss in last lp—124 lps on hook; 62 twisted sts. *Rtn:* Yo, pull through 1 lp on hook, *yo, pull through 2 lps on hook; rep from * to end—124 sts.

ROW 3: *Fwd:* Sk first vertical bar, Tss in next vertical bar, *work twisted st in next 2 sts; rep from * across to last 2 sts, Tss in next vertical bar, Tss in last vertical bar—124 lps on hook; 61 twisted sts. *Rtn:* Yo, pull through 1 lp on hook, *yo, pull through 2 lps on hook; rep from * to end—124 sts.

ROWS 4–147: Rep Rows 2–3.

NOTE: You will need a row count that is a multiple of 4 + 3 rows, ending with a Row 3 of pattern.

BIND-OFF ROW: Ch 1, pm in the ch-sp to mark corner st, *insert hook under next

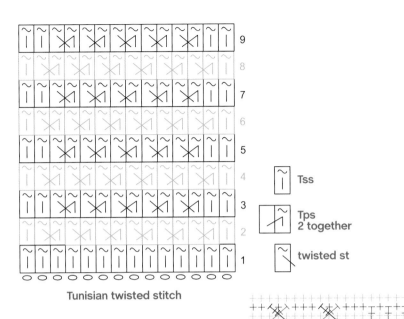

Tunisian twisted stitch

~ Tss

Tps 2 together

~ twisted st

2 vertical bars, yo and pull through 3 lps on hook (first sl st made), insert hook in first vertical bar of 2 bars just worked, yo and pull through 2 lps on hook (2nd sl st formed); rep from * to last st, insert hook as for Tss and pull through 2 lps on hook for last sl st, pm in last st for corner st—123 sl sts and a marker at each end of this row. Fasten off.

Weave in loose ends. Panel should have 123 ch at bottom, 123 sl sts at top, 146 unmarked rows on each side, and 4 markers for corner sts on top and bottom rows. Panel should measure about 27" (69 cm) wide and 53" (134.5 cm) long.

BORDER

RND 1: With RS facing and standard hook, join yarn with sc in first ch after bottom corner, working under both lps, pm for beg of rnd, sc under both lps of each ch to next marker, 3 sc in marked sp, move up marker to center sc, *sc in end of

mission cabled edging

next row working under both lps, 2 sc in end of next row working under both lps; rep from * up the ends of rows to next marker, 3 sc in marked corner sp, move up marker to center sc, sc under both lps of each sl st across to next marker, 3 sc in marked corner sp, move up marker to center sc, **sc in the end of the next row working under both lps, 2 sc in next end of row working under both lps; rep from ** down the ends of the rows to next marker, 3 sc in marked corner, move marker up to center sc, sl

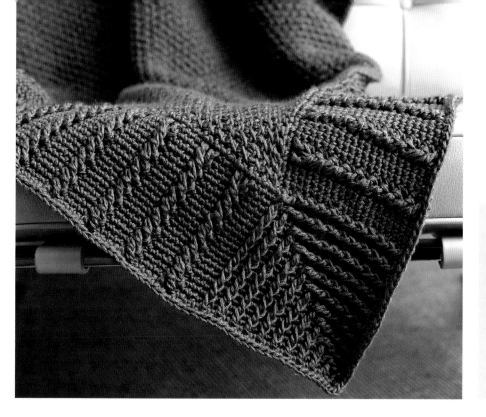

st in first sc to join—123 sc in top and bottom of panel, 219 sc on each side, four 3-sc corners.

NOTE: When working 3 sc in a corner for all foll rnds, move marker up to center sc.

RND 2: Ch 1, starting in same st as join, *sc in each sc to marker, 3 sc in marked center sc, pm in center sc; rep from * to last sc, sc in last sc, sl st in first sc to join—125 sc top and bottom, 221 sc on the sides, four 3-sc corners.

RND 3 (CABLE SET-UP ROW):
NOTE Do not work sc behind any post sts. See stitch diagrams for assistance.

Ch 1, sc in same st as join, sc in next 2 sc, ** *fpdc around post of sc 2 rows below, sc in next sc in current rnd, fpdc around post of next sc 2 rows below, sc in next 3 sc in current rnd; rep from * to 2 sts before marker, sk next 2 sc 2 rows below, fpdc around post of next sc of 3-sc corner 2 rows below, sc in next sc in current row, 3

sc in marked corner sc, sc in next sc, working over last fpdc made, fptr (see Special Stitches) around post of first skipped sc 2 rows below, sc in next 3 sc in current rnd; rep from ** around, sl st in first sc to join—20 post st pairs for cable top and bottom, 36 post st pairs on sides.

RND 4: Ch 1, sc in each sc and post st around, working 3 sc in each marked corner st and moving up markers, sl st in first sc to join.

RND 5: Ch 1, starting in first st, *sc in next 3 sc, [sk next 2 sts, fpdc around next post st 2 rows below, sc in next sc in current row, working over last fpdc made, fptr around post of last skipped post st 2 rows below, sc in next 3 sc in current rnd] across to first post st of next corner, [fpdc around next post st 2 rows below, sc in next sc] across to 2 sc before marker, fpdc around 3rd sc of 3-sc corner 2 rows below, sc in next

sc, 3 sc in marked st, pm in center sc, sc in next sc, working over fpdc already made, fptr around first sc of 3-sc corner 2 rows below, [sc in next sc, fpdc around post st 2 rows below] through last corner post st; rep from * around, sl st in first sc to join—20 cables top and bottom, 36 cables on sides (number of cable sts is constant); corner pattern continues to grow by 2 sts each rnd.

RNDS 6–22: Rep Rnds 4–5 eight times; then rep Rnd 4. Fasten off and weave in loose ends.

finishing
BLOCKING
Lay afghan flat and pin in place. Lightly steam. Allow afghan to dry before removing pins.

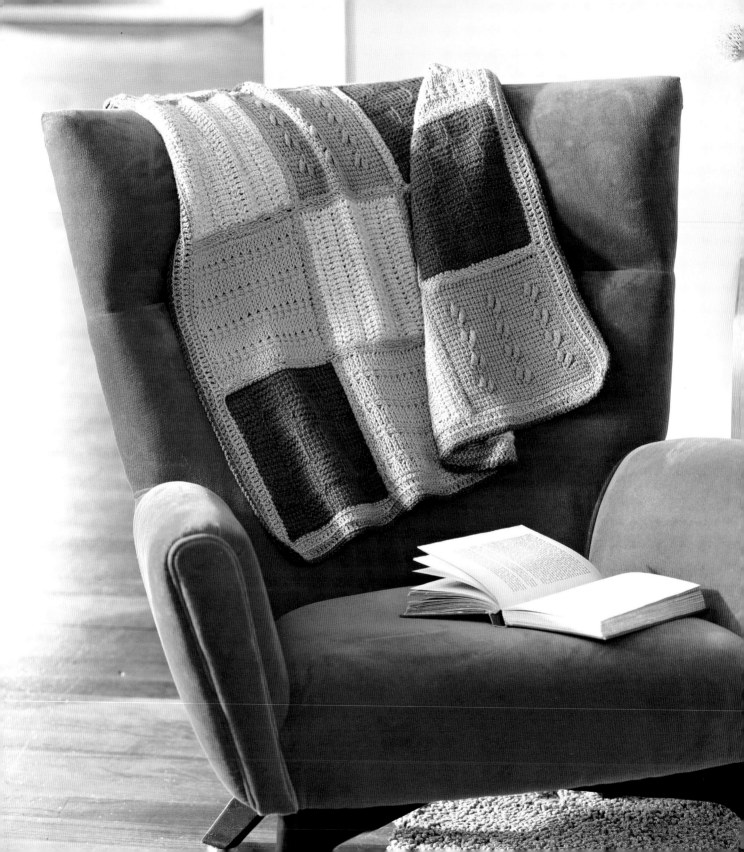

ariannah sampler

For me, Tunisian crochet opens up a world of possibilities that includes a variety of textures and surfaces. All four Tunisian stitch patterns used in this afghan are lovely and quite easy, and they blend beautifully together. When you're done, you can use any of them for a scarf or other Tunisian project. ● BY DORA OHRENSTEIN

MATERIALS
Yarn Sportweight (#2 Light).

Shown Blue Sky Alpacas Sport Weight (100% baby alpaca, 100 yd [100 m]/1.7 oz [50 g]): #502 Copper (A), 2 balls; #505 Taupe (B), 2 balls; #520 Avocado (C), 2 balls; #524 Nickel (D), 3 balls.

Hooks Standard crochet hook sizes: G/6 (4 mm), H/8 (5 mm), and I/9 (5.5 mm); Tunisian hooks in sizes: J/10 (6 mm) and K/10½ (6.5 mm).

Notions Tapestry needle.

GAUGE
Each square measures 8" x 8" (20.5 x 20.5 cm) after blocking.

Basketweave Square 12 sts and 12 rows = 3" (7.5 cm) in patt, before blocking, using J/10 (6 mm) Tunisian hook.

Gobelin Square 18 sts and 14 rows = 4" (10 cm) in patt, before blocking, using J/10 (6 mm) Tunisian hook.

Leafy Vine Square 15 sts and 15 rows = 4" (10 cm) in patt, before blocking, using I/9 (5.5 mm) Tunisian hook.

Knit and Crossed Square 14 sts and 16 rows = 4" (10 cm) in Tks using K/10½ (6.5 mm) Tunisian hook.

FINISHED SIZE
35" x 35" (89 x 89 cm)

NOTES
Always skip first vertical bar of the row (it is already on your hook from the return pass of previous row).

For final st of row, remember to insert hook under both strands of stitch.

Work border with standard crochet hook in the size that allows the work to stay flat.

SPECIAL STITCHES
Spike-dc two together (spikedc2tog) Working loosely, yo, [insert hook in indicated st 3 rows below, yo, pull up a lp, yo, draw through 2 lps] 2 times, yo, draw through 2 lps on hook.

pattern

BASKETWEAVE SQUARES

(make 4)

With I/9 (5.5 mm) standard crochet hook and A, ch 31, change to J/10 (6 mm) Tunisian hook.

ROW 1: *Fwd:* Pull up lp in 2nd ch from hook and in each ch across—31 lps on hook. *Rtn:* Yo, pull through 1 lp on hook, *yo, pull through 2 lps on hook; rep from * to end—31 sts.

ROW 2: *Fwd:* *Tss in next 6 sts, Tps in next 6 sts; rep from * once, Tss in the next 6 sts. *Rtn:* Yo, pull through 1 lp on hook, *yo, pull through 2 lps on hook; rep from * to end.

ROWS 3–7: Rep Row 2.

ROWS 8–13: *Fwd:* *Tps in next 6 sts, Tss in next 6 sts; rep from * once, Tps in next 5 sts, Tss in last st. *Rtn:* Work as for Row 2.

ROWS 14–19: Rep Row 2.

ROWS 20–25: Rep Row 8.

ROWS 26–30: Rep Row 2.

ROW 31: Bind off in sl st as if to Tss.

Fasten off.

GOBELIN SQUARES

(make 4)

Gobelin is the name given in historical sources for the upside-down shell used in this pattern.

NOTE: Work return row tightly, especially ch-1 over shells.

With I/9 (5.5 mm) standard hook and B, ch 32, change to J/10 (6 mm) Tunisian hook.

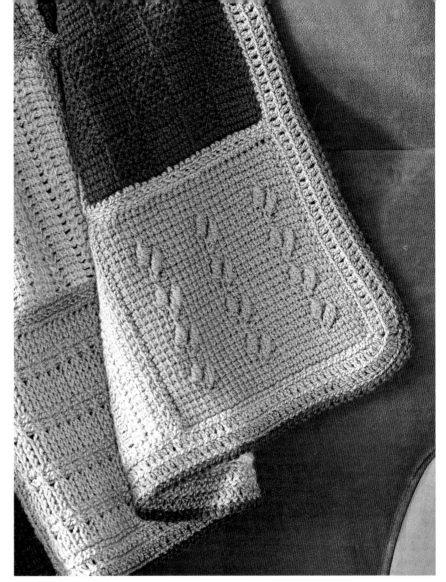

ROW 1: *Fwd:* Pull up lp in 2nd ch from hook and in each ch across—32 lps on hook. *Rtn:* Yo, pull through 1 lp on hook, *yo, pull through 2 lps on hook, rep from * to end—32 sts.

ROW 2: *Fwd:* Work in Tss across. *Rtn:* Yo, pull through 1 lp on hook, [yo, pull through 2 lps] twice, *ch 1, yo, pull through next 3 lps for shell, ch 1, [yo, pull through 2 lps] 3 times; rep from * across.

ROW 3 *Fwd:* Tss in next 2 sts, *insert hook under horizontal bar, yo, pull up a loop, insert hook in top of next shell, yo, pull up a lp, insert hook under next horizontal bar, yo, pull up lp, Tss in next 3 sts, rep from * across. Rtn as for TSS.

Rep Rows 2 and 3 until piece measures 7½" (19 cm) from beg.

BIND-OFF: Bind off in sl st as if to Tss. Fasten off.

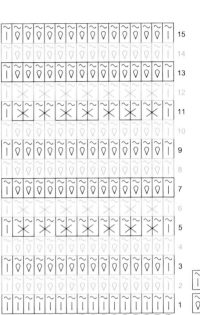

knit and crossed square

~ⅼ	Tss
~Ⅴ	Tks

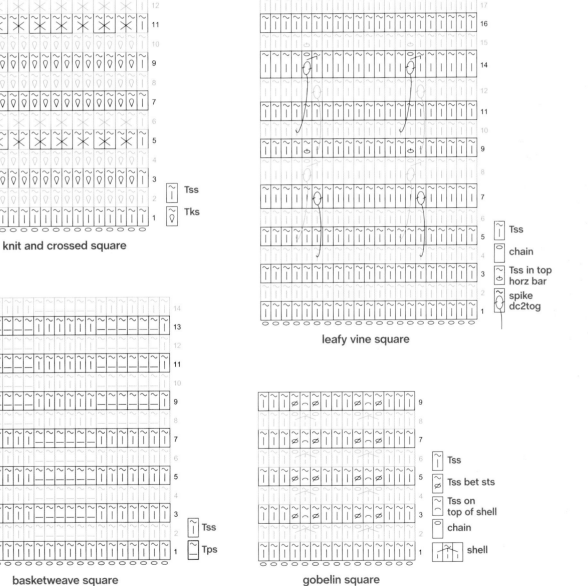

basketweave square

~ⅼ	Tss
ⅼ—	Tps

leafy vine square

ⅼ	Tss
⊘	chain
ᶜ	Tss in top horz bar
⊘	spike dc2tog

gobelin square

~	Tss
∅	Tss bet sts
~	Tss on top of shell
☐	chain
⋈	shell

For all squares, when changing stitch patterns from one row to the next, the change appears one row below the working row. For example, when you change patterns in Row 8 of the Basketweave Square, the pattern will appear to change in Row 7. Keep this mind when counting rows. —DORA OHRENSTEIN

LEAFY VINE SQUARES
(make 4)

NOTE: When working spikedc2tog in Row 8, do not work into the vertical bar below this st, work into next vertical bar. In Row 9, be sure to skip only 1 vertical bar, work next TSS in vertical bar that lines up with spikedc2tog.

With I/9 (5.5 mm) standard crochet hook and C, ch 31, change to J/10 (6 mm) Tunisian hook.

ROW 1: *Fwd:* Pull up a lp in 2nd ch from hook and in each ch across—31 lps on hook. *Rtn:* Yo, pull through 1 lp on hook, *yo, pull through 2 lps on hook; rep from * to end—31 sts.

ROWS 2–6: *Fwd:* Work in Tss across. *Rtn:* Yo, pull through 1 lp on hook, *yo, pull through 2 lps on hook; rep from * to end.

ROW 7: *Fwd:* Tss in next 4 sts, *spikedc2tog (see Special Stitches) around vertical bar 3 rows below**, Tss in next 9 sts; rep from * once, rep from * to ** once,

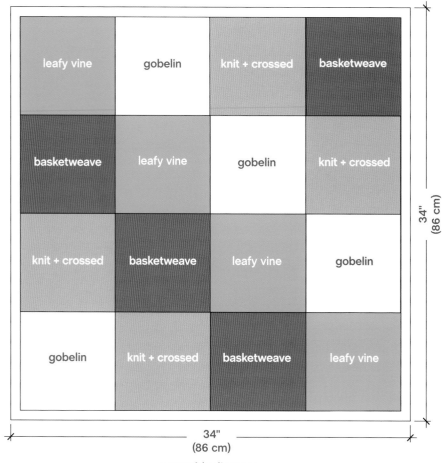

34" (86 cm)

34" (86 cm)

assembly diagram

Tss in each st to end. *Rtn:* Yo, pull through 1 lp on hook, *yo, pull through 2 lps on hook; rep from * to end.

ROW 8: *Fwd:* Tss in next 5 sts, *spikedc2tog around vertical bar 1 st to the left AND 3 rows below**, Tss in next 9 sts; rep from * once more, rep from * to ** once, Tss in each st to end. *Rtn:* Yo, pull through 1 lp on hook, [yo pull through 2 lps on hook] 3 times, *ch 1, yo, pull

through 3 lps**, [yo, pull through 2 lps on hook] 8 times; rep from * once; rep from * to ** once, [yo, pull through 2 lps on hook] 5 times.

ROW 9: *Fwd:* Tss in next 5 sts, sk 2nd vertical bar of spikedc2tog, *insert hook under "bump" of next ch, yo, draw through 1 lp on hook, Tss in next 8 sts; rep from * once, rep from * to ** once, Tss in each st to end. *Rtn.*

ROWS 10–11: Rep Row 2.

ROWS 12–26: Rep Rows 7–11 three times.

BIND-OFF: Bind off in sl st as if to Tss. Fasten off.

KNIT AND CROSSED SQUARES (make 4)

NOTE: Work Fwd passes of crossed stitches loosely.

With J/10 (6.0 mm) standard hook and D, ch 29, change to K/10½ (6.5 mm) Tunisian hook.

ROW 1: *Fwd:* Pull up a lp in 2nd ch from hook and in each ch across—29 lps on hook. *Rtn:* Yo, pull through 1 lp on hook, *yo, pull through 2 lps on hook; rep from * to end—29 sts.

ROWS 2–4: *Fwd:* Tks in each st across. *Rtn:* Yo, pull through 1 lp on hook, *yo, pull through 2 lps on hook; rep from * to end.

ROWS 5–6: *Fwd:* *Sk next vertical bar, pick up lp in next vertical bar, pick up lp in last skipped vertical bar; rep from * across, Tss in last st. *Rtn:* Yo, pull through 1 lp on hook, *yo, pull through 2 lps on hook; rep from * to end.

ROWS 7–10: Rep Row 2.

ROWS 11–22: Rep Rows 6–10 twice.

ROWS 23–24: Rep Rows 5–6.

ROWS 25–27: Rep Row 2.

BIND-OFF: Bind off in sl st as if to Tss. Fasten off.

finishing

Wet-block all squares to measure 8" × 8" (20.5 × 20.5 cm).

SQUARE EDGING

RND 1: With G-6 (4 mm) standard hook, join D in any corner of square, ch 1, *2 sc in corner st, sc in each st across to next corner; rep from * around square, sl st in first sc to join.

NOTE: The squares should have about 30 sts on each side (this may vary by one or two stitches depending on the square), not counting corner stitches.

ASSEMBLY

With tapestry needle and D, following assembly diagram, join squares from the RS with mattress stitch as foll: Leaving a 4" (10 cm) tail, insert tapestry needle through the outermost strand on one square, then into the corresponding strand on the square to be joined, *insert needle through the next outermost strand on the same side, then through the corresponding strand on opposite side; rep from * to end of squares, tug the tail to bring the edges of the square tidily together, creating a flat edge. Rep until all squares are joined. If squares do not have the exact same number of sts to be joined, ease in the extra sts by skipping a st where necessary, or joining 2 sts to 1.

BORDER

With G-6 (4 mm) standard hook, join D in any corner of afghan.

RND 1: Ch 3 (counts as dc here and throughout), dc-blo evenly around, placing one st in each sc, 2 sts in each join bet squares, and 3 sts in each corner, sl st in top of beg ch-3 to join, change to color C.

RND 2: Ch 3, dc-blo in each dc around, placing 4 sts in each corner, sl st in top of beg ch-3 to join, change to color A.

RND 3: Ch 1, sc in each dc around, sl st in first sc to join. Fasten off and weave in loose ends.

> " I love to make garments with Tunisian crochet. The fabric behaves a little differently than other techniques, so it's fun to experiment with it and figure out how to fit it to a body."
>
> —MEGAN GRANHOLM

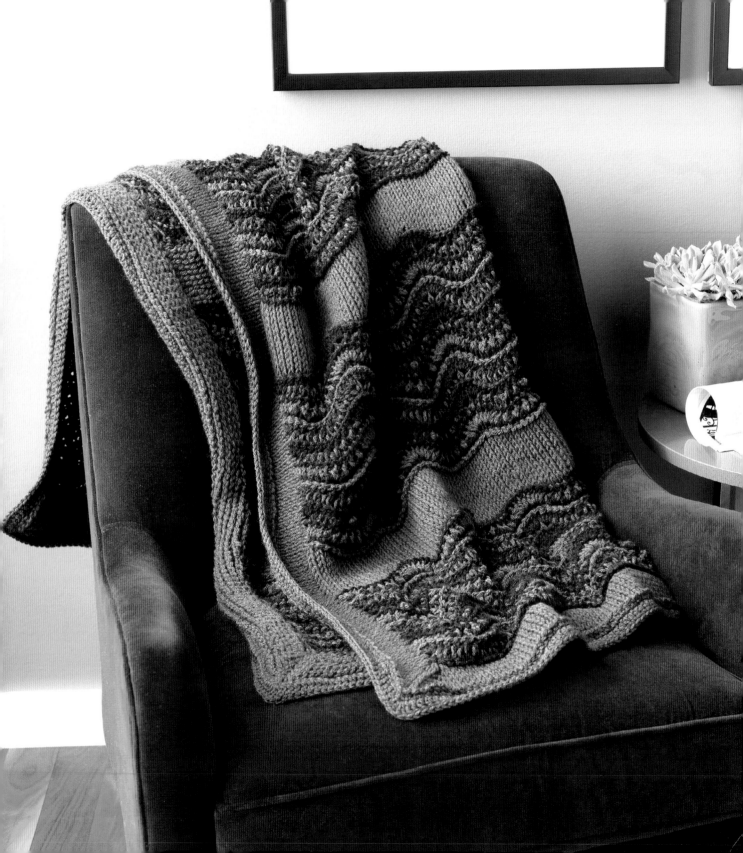

van gogh waves

Inspired by the colors of Vincent Van Gogh's *Starry Night,* I transformed the swirling sky into ocean waves. Using three colors for the waves evokes the ocean on a night of a clear moon. The waves are separated by short rows in two different colors to represent different bands of waves in the distance. The afghan is bordered with a "frame," as artwork deserves.

● BY KIM GUZMAN

MATERIALS
Yarn Worsted weight (#4 Medium).

Shown Lion Brand Wool-Ease Worsted Weight (80% acrylic/20% wool; Solids: 197 yd [180 m]/3 oz [85 g]; Prints: 162 yd [146 m]/2.5 oz [70 g]):

3 skeins each of #111 navy (A), #234 pines print (B), #115 blue mist (C), #118 indigo (D), #191 violet (E).

Hooks K/10½ (6.5 mm) Tunisian hook (minimum 14" [35.5 cm] long), K/10½ (6.5 mm) cabled Tunisian hook (minimum 44" [112 cm] long), H/8 (5 mm) standard crochet hook or sizes needed to obtain gauge.

Notions Yarn needle.

GAUGE
13 Tks and 14 rows = 4" (10 cm).

FINISHED SIZE
43" x 58" (109 x 147.5 cm).

NOTES
Always skip first vertical bar of the row unless directed otherwise (it is already on your hook from the return portion of previous row).

For final st of row, remember to insert hook under both strands of stitch.

Work all return passes as foll, unless instructed otherwise: Yo, pull through 1 lp on hook, *yo, pull through 2 lps on hook; rep from * to end.

Color sequence When working in 3-color sequence, always maintain the same sequence, working 1 fwd or rtn pass in the foll color sequence: *A, B, C; rep from * throughout 3-color sections, changing colors at end of each fwd and rtn pass.

When working in 3-color sequence, do not cut yarn; drop it to begin working with new color and carry former color alongside. Use care to not pull the yarn too tautly when changing colors.

When changing colors at the end of a return pass, work until 2 lps remain on hook (1 st remains to be bound off), drop previous color and work the final st with the new color.

When working into a yo-space, insert hook into space as instructed (example: as for Tks or as for Trs).

SPECIAL STITCHES
Tunisian Reverse Stitch (Trs) Insert hook under vertical bar on back of next st, yo, pull through st.

Tunisian Knit Stitch (Tks) Insert hook from front to back bet front and back vertical bars of next st, yo, pull through st.

Tunisian Double Crochet (Tdc) Yo, insert hook from front to back bet front and back vertical bars as for Tks, yo, pull lp through st, yo and draw through 2 lps, leaving last lp on hook.

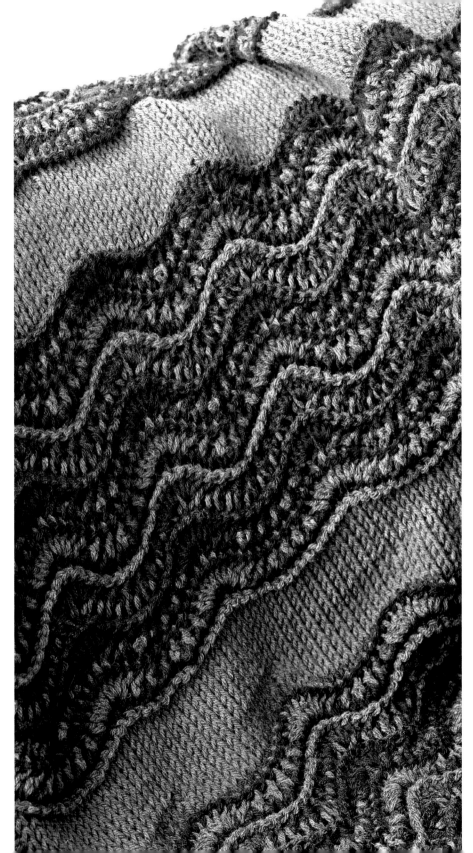

pattern

With shorter Tunisian hook and A, ch 120.

ROW 1: *Fwd:* With A, pull up a lp in 2nd ch from hook and in each ch across, drop A, join B. *Rtn:* With B, work return pass (see Notes), changing to C when working final st.

ROW 2: *Fwd:* With C, sk first st, Trs (see Special Stitches) across, drop C, pick up A. *Rtn:* With A, work return pass, changing to B when working final st.

ROW 3: *Fwd:* With B, ch 1, 3 Tdc (see Special Stitches) in first st, *Tdc in next st, [sk 1 st, Tdc in next st] 6 times, [4 Tdc in next st] 2 times; rep from * 6 times, Tdc in next st, [sk 1 st, Tdc in next st] 6 times, 4 Tdc in last st, drop A, pick up B. *Rtn:* With B, work return pass, changing to C when working final st.

ROWS 4–17: Maintaining color sequence as est, rep Rows 2–3, changing to B when working final st of Row 17.

ROW 18: *Fwd:* With B, sk first st, Tks (see Special Stitches) across. *Rtn:* With B, work return pass, changing to D when working final st. Fasten off all colors except D.

ROW 19: *Fwd:* With D, sk first st, Tks (see Special Stitches) across. *Rtn:* With D, work return pass. (Cont with D until instructed otherwise.)

ROW 20: *Fwd:* Sk first st, Tks to last 15 sts (105 lps on hook). *Rtn:* Work return pass, leaving rem sts unworked.

ROW 21: Rep Row 20—90 lps on hook.

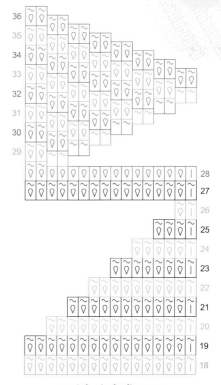

⌇Ọ	Tks
†⌇	Tdc
⌇	Tss
Ⅼ⌇	Trs

partial stitch diagram
of angled sections

ROWS 22–26: Rep Row 20—15 lps on hook after completing Row 26.

ROW 27: Sk first st, Tks across 14 sts, Tks across 15 unworked sts from each of previous 7 rows (120 lps on hook), return, changing to E when working final st. Fasten off D.

ROW 28: *Fwd:* With E, sk first st, Tks across. (Cont with E until instructed otherwise.) *Rtn:* Yo, pull through 1 lp on hook, [yo, pull through 2 lps on hook] 14 times. (Cont to next row without binding off all sts here and throughout, until instructed otherwise.)

ROW 29: *Fwd:* Sk first st, Tks across rem 14 sts. *Rtn:* Yo, pull through 1 lp on hook, [yo, pull through 2 lps on hook] 29 times.

ROW 30: *Fwd:* Sk first st, Tks across 29 sts. *Rtn:* Yo, pull through 1 lp on hook, [yo, pull through 2 lps on hook] 44 times.

ROW 31: *Fwd:* Sk first st, Tks across 44 sts. *Rtn:* Yo, pull through 1 lp on hook, [yo, pull through 2 lps on hook] 59 times.

ROW 32: *Fwd:* Sk first st, Tks across 59 sts. *Rtn:* Yo, pull through 1 lp on hook, [yo, pull through 2 lps on hook] 74 times.

ROW 33: *Fwd:* Sk first st, Tks across 74 sts. *Rtn:* Yo, pull through 1 lp on hook, [yo, pull through 2 lps on hook] 89 times.

ROW 34: *Fwd:* Sk first st, Tks across 89 sts. *Rtn:* Yo, pull through 1 lp on hook, [yo, pull through 2 lps on hook] 104 times.

ROW 35: *Fwd:* Sk first st, Tks across 104 sts. *Rtn:* Work return pass across entire row.

 tip As you will notice, to fasten off properly in Tunisian crochet, you start the row as normal but instead of leaving the loop on the hook, you bind it off. This bind-off row can turn out a bit looser than the rest, so drop a hook size for the last row only. **—KIM GUZMAN**

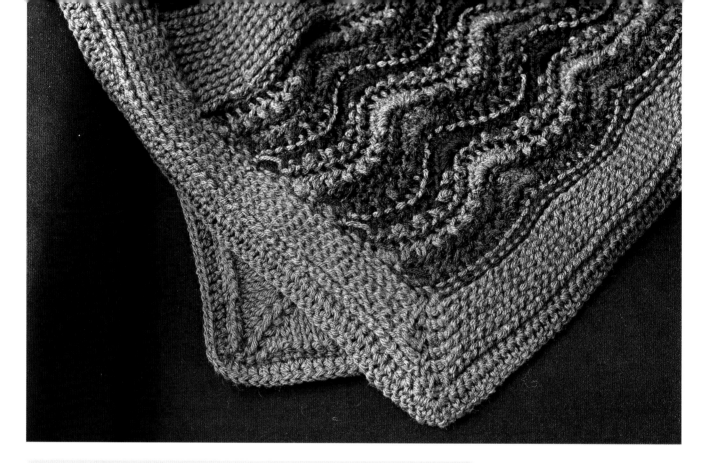

tip When I was designing this afghan, I did the border in straight Tunisian crochet, joining at the end of the round as in regular crochet. This required a very long cable to get all the way around the afghan. However, just as in knitting, this can be accomplished in other ways. The most obvious way is by working in double-ended Tunisian where the short double-ended hook can be used, picking up and working off sections at a time. Another, less common method is to use four afghan hooks, one for each side, working as you would when knitting a sock with double-pointed needles.

—KIM GUZMAN

ROW 36: *Fwd:* Sk first st, Tks across. *Rtn:* Work return pass, changing to B when working final st. Fasten off E.

ROW 37: *Fwd:* With B, Tks across, drop B. *Rtn:* With C, work return pass, changing to A when working final st.

ROWS 38–54: Rep Rows 2–18, ending with C, changing to D when working final st.

ROWS 55–63: With D, rep Rows 28–36, changing to E when working final st of final row.

ROWS 64–72: With E, rep Rows 19–27, changing to C when working final st of final row.

ROW 73: *Fwd:* With C, Tks across, drop C. *Rtn:* With A, work return pass, changing to B when working final st.

ROWS 74–89: Maintaining color sequence as est, rep Rows 2–18, ending with B.

ROWS 90–107: Rep Rows 19–36, changing to C when working final st of final row.

ROW 108: *Fwd:* With C, Tks across, drop C. *Rtn:* With A, work return pass, changing to B when working final st.

ROWS 109–123: Maintaining color sequence as est, rep Rows 2–17, changing to A when working final st of row 123.

ROW 124: *Fwd:* With A, sk first st, Trs across, drop A. *Rtn:* With B, work return pass, changing to D when working final st.

Fasten off all colors except D.

EDGING

RND 1: *Fwd:* With longer Tunisian hook and still with D, yo, pull up a lp in same st (3 lps on hook), Tks to last st, [yo, pull up a lp, yo] in last st (corner inc made), pull up lps evenly along side edge, lower edge and opposite side edge, with corner inc worked at each rem corner. *Rtn:* Work return pass. With 1 lp rem on hook, remove hook carefully and place hook in last st of round, place lp back on hook, yo, pull through 2 lps on hook to join.

RND 2: *Fwd:* Sk first st, Tks in each st and yo-space, except at Tks-corner work (yo, pull up a lp, yo) in corner st. *Rtn:* Work return pass and join as for Rnd 1.

RNDS 3–4: Rep Rnd 2, changing to E on final st of Rnd 4.

RND 5: Rep Rnd 2, changing to D on final st of rnd. Fasten off E.

RND 6: With standard crochet hook, ch 1, working as for Trs, sc in each st around, sl st in first sc to join.

RND 7: Ch 3, sk first sc, dc in each sc around, working 5 dc in each center st of each corner, sl st in top of beg ch-3 to join. Fasten off D. Weave in loose ends.

> " I love making fashion pieces with Tunisian crochet, because the drape is lovely even with heavier weight yarns. With a large hook—like an M—and worsted-weight yarn, you can make a sweater with a solid fabric that is fluid, not stiff, when worn. Another favorite thing to do with Tunisian is to work with a kooky novelty yarn, something with a lot of texture—this kind of yarn can be really hard to work in regular crochet, but with Tunisian it can become a work of art." —DORA OHRENSTEIN

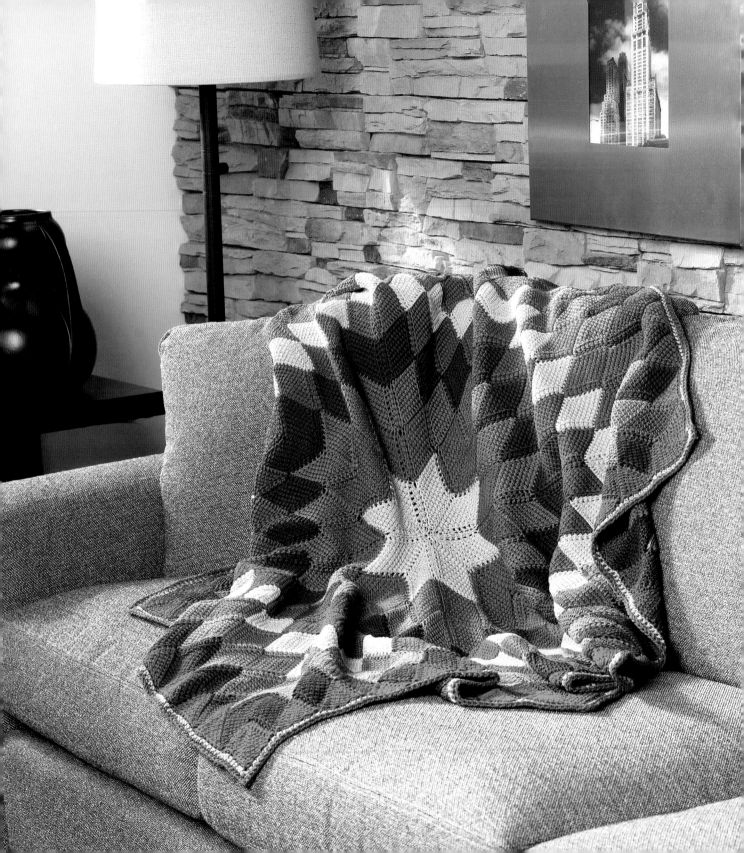

starburst entrelac afghan

Even though I can knit, I prefer to see how creative I can get in applying knitting techniques—such as entrelac—in crochet. Tunisian crochet, being somewhat similar to both crafts, is an easy way to experiment with knitting techniques using a hook. Inspired by a starburst quilt (another craft technique borrowed by a hook!), this octagonal afghan looks great hanging over a couch or crib rail. ● BY MEGAN GRANHOLM

MATERIALS

Yarn DK weight (#3 Light).

Shown Classic Elite Yarns Province (100% cotton; 205 yd [187 m]/3.5 oz [100 g]): #2683 Gimlet Green (CC1), 3 skeins; #2619 Zinnia Flower (CC2), 3 skeins; #2640 Gunmetal Grey (CC3), 3 skeins; #2624 Deep Sea (CC4), 4 skeins; #2665 Mallard (CC5), 3 skeins.

Hooks I (5.5 mm) Tunisian hook, and I (5.5 mm) standard hook or sizes needed to obtain gauge.

Notions Tapestry needle for weaving in ends, spray bottle with water and straight pins for blocking, stitch markers.

GAUGE

7 sts and 7 rows = 2" (5 cm) in Tss.

FINISHED SIZE

62" x 62" (157.5 x 157.5 cm) from point to point.

NOTES

In its finished form, entrelac looks like woven strips of fabric, but it is really just rows of diamonds building off of one another. Traditional knitted entrelac is worked in rows, topping one row of diamonds with another, but for this project it's worked in the round. Because of the unique hook-work of Tunisian crochet, which affects which corner of each diamond the hook ends on and which direction the vertical stitches slant, five slightly different diamond patterns are used to ensure that the next diamond is easily worked without fastening off beforehand. To start, you will crochet Diamond 1 on Round 1, then follow by crocheting diamonds that adjoin. Each diamond will either be worked off a foundation chain and joined at the ends of the rows to the previous diamond or worked directly onto the previous motif, picking up stitches along the edge. Be sure to follow the layout diagram for which diamond is next to crochet and in which direction it will be worked. All rounds are worked counterclockwise.

SPECIAL STITCHES

Tss increase (Tss inc) *Fwd:* Insert hook in sp before next st of previous row and pull up a lp, cont across as directed. *Rtn:* Return as normal.

Tss decrease (Tss2tog) *Fwd:* Insert hook into vertical bar of next 2 sts at the same time, yo and pull up a lp, cont across as directed. *Rtn:* Return as normal.

DIAMOND STITCH PATTERNS

After the first diamond, six Diamond variations are used to complete the afghan. See stitch diagram at right for assistance.

Diamond A

Ch 12.

Row 1 *Fwd:* Pull up a lp in 2nd ch from hook and in each ch across, insert hook in next st of previous diamond and pull up a lp—13 lps. *Rtn:* *Yo, pull through 2 lps on hook; rep from * across.

Rows 2–8 *Fwd:* Tss2tog (see Special Stitches) over next 2 sts, Tss in each st across to last st, Tss inc (see Special Stitches) in next sp, Tss in last st, Tss and in next st of previous diamond, insert hook in next st of previous diamond and pull up a lp—13 lps. *Rtn:* *Yo, pull through 2 lps on hook; rep from * across.

Diamond B

Row 1 *Fwd:* Working bet vertical bars, Tss in each st across, Tss in last st—12 lps. *Rtn:* Yo, pull through 1 lp on hook, *yo, pull through 2 lps on hook; rep from * across.

Rows 2–8 *Fwd:* Tss inc in next sp, Tss in each st across to last 3 sts, Tss2tog over next 2 sts, Tss in last st—12 lps. *Rtn:* Yo, pull through 1 loop on hook, *yo, pull through 2 lps on hook; rep from * across.

Row 9: Bind off in sl st as if to Tss.

Diamond C

Row 1 *Fwd:* Tss in each st across, Tss in last st—12 lps. *Rtn:* Yo, pull through 1 lp on hook, *yo, pull through 2 lps on hook; rep from * across.

Rows 2–8 *Fwd:* Tss inc in next sp, Tss in each st across to last 3 sts, Tss2tog over next 2 sts, Tss in last st—12 lps. *Rtn:* Yo, pull through 1 loop on hook, *yo, pull through 2 lps on hook; rep from * across.

Row 9: Bind off in sl st as if to Tss.

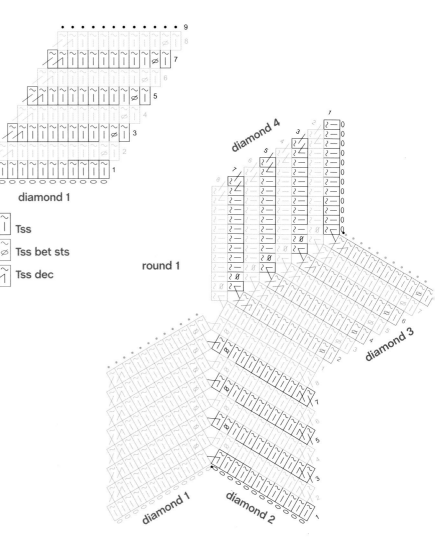

diamond 1

| Tss |
| Tss bet sts |
| Tss dec |

round 1

diamond 4
diamond 5
diamond 3
diamond 1
diamond 2

Diamond D

Ch 12.

Row 1 *Fwd:* Pull up a lp in 2nd ch from hook and in each ch across, insert hook in next st of previous diamond and pull up a lp—13 lps. *Rtn:* *Yo, pull through 2 lps on hook; rep from * across.

Rows 2–7 *Fwd:* Tss2tog over next 2 sts, Tss in each st across to last st, Tss inc in next sp, Tss in last st, insert hook in next st of previous diamond—13 lps. *Rtn:* *Yo, pull through 2 lps on hook; rep from * across.

Row 8 *Fwd:* Tss in each st across—12 lps. *Rtn:* (and join to next diamond): *Yo and pull up a lp in first st of next diamond, yo and pull through 2 sts, insert hook in next st of diamond, yo and pull through st and 2 lps, rep from * across.

color key

	CC1
	CC2
	CC3
	CC4
	CC5

layout key

◆ diamond

▲ triangle

*1 first diamond of round

A type of diamond

round 1 layout

Diamond E

Row 1 *Fwd:* Tss in each st across, Tss in last st, insert hook in next st of previous diamond and pull up a lp—13 lps. *Rtn:* *Yo, pull through 2 lps on hook; rep from * across.

Rows 2–8 *Fwd:* Tss inc in next sp, Tss in each st across to last 3 sts, Tss2tog over next 2 sts, Tss in last st, insert hook in next st of previous diamond and pull up a lp—13 lps. *Rtn:* *Yo, pull through 2 lps on hook; rep from * across.

Row 9: Bind off in sl st as if to Tss.

pattern

ROUND 1

Diamond 1: With CC1, ch 12.

ROW 1 *Fwd:* Pull up a lp in 2nd ch from hook and in each ch across. *Rtn:* Yo, pull through 1 lp on hook, *yo, pull through 2 lps on hook; rep from * across.

ROWS 2–8 *Fwd:* Tss inc (see Special Stitches) in next sp, Tss in each st across to last 3 sts, Tss2tog (see Special Stitches) over next 2 sts, Tss in last st. *Rtn:* Yo, pull through 1 lp on hook, *yo, pull through 2 lps on hook; rep from * across.

ROW 9: Bind off in sl st as if to Tss.

Fasten off.

Diamond 2: With RS facing, join CC1 in first st in Row 1 of Diamond 1, work Diamond A (see Special Stitches).

Diamond 3: Work Diamond B (see Special Stitches). Fasten off.

Diamond 4: With RS facing, join CC1 in last st of previous diamond, work Diamond A.

Diamonds 5–6: Rep Diamonds 3–4.

Diamond 7: Rep Diamond 3.

> **tip**
>
> Block your piece before you consider it finished! It can be easy to fasten off and start using an afghan immediately, but for a lot of techniques (Tunisian entrelac included), blocking transforms the fabric and can really make a plain or wonky-looking piece into a show stopper. —MEGAN GRANHOLM

Diamond 8: With RS facing, join CC1 in last st of previous diamond, work Diamond A through Row 7.

ROW 8 *Fwd:* Tss in each st across. *Rtn:* (and join to next diamond): *Yo and pull up a lp in first st of next diamond, yo and pull through 2 sts, insert hook in next st of diamond, yo and pull through st and 2 lps, rep from * across. Fasten off. Place marker in tip of last diamond of rnd.

ROUND 2

With RS facing, join CC2 with sl st in tip of Diamond 1 in Rnd 1, in the last st of the foundation ch.

Diamond 1: Work Diamond C (see Special Stitches).

Diamond 2: Work Diamond D (see Special Stitches).

Diamond 3: Work Diamond A.

Diamond 4: Work Diamond E (see Special Stitches).

Diamonds 5–16: Rep Diamonds 1–4. Fasten off. Place marker in tip of last diamond of rnd.

ROUND 3

With RS facing, join CC3 with sl st in tip of Diamond 16 in Rnd 2, in the first st on the last row.

Diamond 1: Work Diamond E.

Diamond 2: Work Diamond C.

Diamonds 3–4: Work Diamond D.

Diamond 5: Work Diamond A.

Diamond 6: Work Diamond E.

Diamonds 7–24: Rep Diamonds 1–6. Fasten off. Place marker in tip of last diamond of rnd.

ROUND 4

With RS facing, join CC4 with sl st in tip of Diamond 24 in Rnd 3, in the first st on the last row.

Diamonds 1–2: Work Diamond E.

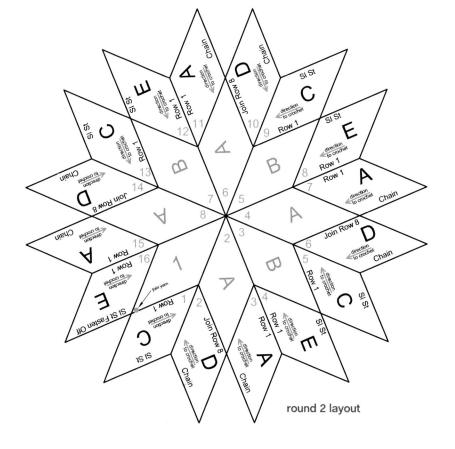

round 2 layout

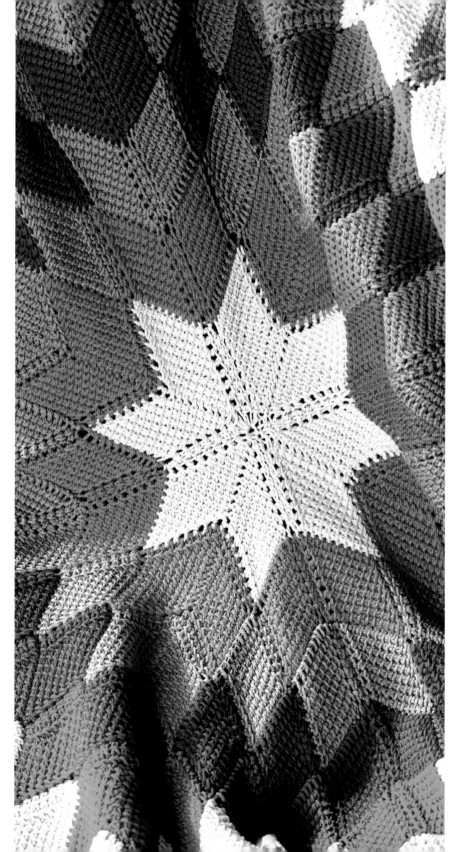

Diamond 3: Work Diamond C.

Diamonds 4–6: Work Diamond D.

Diamond 7: Work Diamond A.

Diamond 8: Work Diamond E.

Diamonds 9–32: Rep Diamonds 1–8. Fasten off. Place marker in tip of last diamond of rnd.

ROUND 5

With RS facing, join CC5 with sl st in tip of Diamond 32 in Rnd 4, in the first st on the last row.

Diamonds 1–3: Work Diamond E.

Diamond 4: Work Diamond C.

Diamonds 5–8: Work Diamond D.

Diamond 9: Work Diamond A.

Diamond 10: Work Diamond E.

Diamonds 11–40: Rep Diamonds 1–10. Fasten off. Place marker in tip of last diamond of rnd.

ROUND 6

With RS facing, join CC1 with sl st in tip of Diamond 40 in Rnd 5, in the first st on the last row.

Diamonds 1–4: Work Diamond E.

Diamond 5: Work Diamond C.

Diamonds 6–10: Work Diamond D.

Diamond 11: Work Diamond A.

Diamond 12: Work Diamond E.

Diamonds 13–48: Rep Diamonds 1–12. Fasten off. Place marker in tip of last diamond of rnd.

ROUND 7

With RS facing, join CC2 with sl st in tip of Diamond 48 in Rnd 6, in the first st on the last row.

Diamonds 1–5: Work Diamond E.

Diamond 6: Work Diamond C.

Diamonds 7–12: Work Diamond D.

Diamond 13: Work Diamond A.

Diamond 14: Work Diamond E.

Diamonds 15–56: Rep Diamonds 1–14. Fasten off. Place marker in tip of last diamond of round.

ROUND 8

With RS facing, join CC3 with sl st in tip of Diamond 56 in Rnd 7, in the first st on the last row.

Diamonds 1–6: Work Diamond E.

Diamond 7: Work Diamond C.

Diamonds 8–14: Work Diamond D.

Diamond 15: Work Diamond A.

Diamond 16: Work Diamond E.

Diamonds 17–64: Rep Diamonds 1–16. Fasten off. Place marker in tip of last diamond of round.

ROUND 9

With RS facing, join CC4 with sl st in tip of Diamond 64 in Rnd 8, in the first st on the last row.

Diamonds 1–7: Work Diamond E.

Diamond 8: Work Diamond C.

Diamonds 9–16: Work Diamond D.

Diamond 17: Work Diamond A.

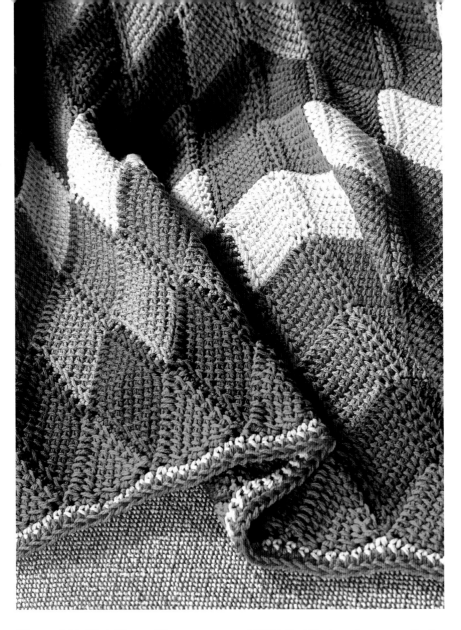

Diamond 18: Work Diamond E.

Diamonds 19–72: Rep Diamonds 1–18. Fasten off. Place marker in tip of last diamond of round.

ROUND 10
Triangle 1

With RS facing, join CC5 with sl st in tip of Diamond 72 in Rnd 9, in first st of last row.

ROW 1: *Fwd:* Tss in each st across, Tss in last st, insert hook in next st of previous diamond and pull up a lp—13 lps. *Rtn:* *Yo, pull through 2 lps on hook; rep from * across—12 sts.

ROW 2: *Fwd:* Tss2tog over next 2 sts, Tss in each st across to last 3 sts, Tss2tog over next 2 sts, Tss in last st, insert hook in next st of previous

diamond and pull up a lp—11 lps. *Rtn:* *Yo, pull through 2 lps on hook; rep from * across—10 sts.

ROW 3: *Fwd:* Tss in each st across to last 3 sts, Tss2tog over next 2 sts, Tss in last st, insert hook in next st of previous diamond and pull up a lp—10 lps. *Rtn:* *Yo, pull through 2 lps on hook; rep from * across—9 sts.

ROWS 4–7: Rep Rows 2–3 two times—3 sts at end of last row.

ROW 8: *Fwd:* Insert hook in next st, insert hook in next st of previous diamond and pull up a lp—2 sts. *Rtn:* Yo, pull through 2 lps on hook, sl st in tip of next diamond.

Triangles 2–8
Rep Triangle 1.

Triangle 9

ROW 1: *Fwd:* Tss in each st across last row of diamond—12 lps. *Rtn:* Yo, pull through 1 lp on hook, *yo, pull through 2 lps on hook; rep from * across.

ROW 2: *Fwd:* Tss2tog over next 2 sts, Tss in each st across to last 3 sts, Tss2tog over next 2 sts, Tss in last st—10 lps. *Rtn:* Yo, pull through 1 lp on hook, *yo, pull through 2 lps on hook; rep from * across.

ROW 3: *Fwd:* Tss in each st across to last 3 sts, Tss2tog over next 2 sts, Tss in last st—9 lps. *Rtn:* Yo, pull through 1 lp on hook, *yo, pull through 2 lps on hook; rep from * across.

ROWS 4–7: Rep Rows 2–3 two times—3 sts at end of last row.

ROW 8: *Fwd:* Tss2tog over next 2 sts—2 lps. *Rtn:* Yo, pull through 1 lp on hook, yo, pull through 2 lps on hook.

Triangle 10

ROW 1: *Fwd:* Ch 1, insert hook in next st of previous motif and pull up a lp—2 lps. *Rtn:* Yo, pull through 1 lp on hook, yo, pull through 2 lps on hook—1 st.

ROW 2: *Fwd:* Tss inc in next sp, Tss in last st, insert hook in next st of previous diamond and pull up a lp—3 lps. *Rtn:* *Yo, pull through 2 lps on hook; rep from * across—2 sts.

ROW 3: *Fwd:* Tss inc in next sp, Tss in next st, Tss inc in next sp, Tss in last st, insert hook in next st of previous diamond and pull up a lp—6 lps. *Rtn:* *Yo, pull through 2 lps on hook; rep from * across—5 sts.

ROW 4: *Fwd:* Tss in each st across to last st, Tss inc in next sp, Tss in last st, insert hook in next st of previous diamond and pull up a lp—7 lps. *Rtn:* *Yo, pull through 2 lps on hook; rep from * across—6 sts.

ROW 5: *Fwd:* Tss inc in next sp, Tss in each st across to last st, Tss inc in next sp, Tss in last st, insert hook in next st of previous diamond and pull up a lp—9 lps. *Rtn:* *Yo, pull through 2 lps on hook; rep from * across—8 sts.

ROW 6: Rep Row 4—9 sts.

ROW 7: Rep Row 5—11 sts.

ROW 8: *Fwd:* Tss in each st across to last st, Tss inc in next sp, Tss in last st, insert hook in next st of previous diamond and pull up a lp, return—13 lps. *Rtn* and join to next diamond: *Yo and pull up a lp in first st of next diamond, yo and pull through 2 sts, insert hook in next st of diamond, yo and pull through st and 2 lps, rep from * across—12 sts. Fasten off.

Triangles 11–18
Rep Triangle 10.

Triangle 19

ROWS 1–7: Rep Rows 1–7 of Triangle 10—11 sts at end of last row.

ROW 8: *Fwd:* Tss in each st across to last st, Tss inc in next sp, Tss in last st, insert hook in next st of previous diamond and pull up a lp—13 lps. *Rtn:* *Yo, pull through 2 lps on hook; rep from * across—12 sts.

Triangle 20
Rep Triangle 1.

Triangles 21–80
Rep Triangles 1–20 three times. Fasten off.

finishing

EDGING

RND 1: With RS facing and standard hook, join CC1 in any st, ch 1, sc evenly around, working 3 sc in each corner, sl st in first st sc to join. Fasten off.

RND 2: With RS facing, join CC2 in any st, ch 2 (counts as hdc), hdc in each sc around, working 3 hdc in each corner sc, sl st in top of beg ch-2 to join. Fasten off. Weave in loose ends.

BLOCKING
Lay afghan flat and pin to blocking board; spritz with water and allow to dry.

contributors

ABOUT THE AUTHOR A structural engineer by trade, **Robyn Chachula** uses her knowledge of building-design processes to create crochet projects in Pittsburgh, Pennsylvania. In her first crochet book, *Blueprint Crochet: Modern Designs for the Visual Crocheter* (Interweave), she used her engineering background to bring crochet to new learners with the basics of symbol crochet. In her follow-up book, *Baby Blueprint Crochet: Irresistible Projects for Little Ones*, she dove deeper into the mysteries of crochet diagrams through small, parent-friendly baby projects. You can catch Robyn as one of the crochet experts on *Knit and Crochet Now* on public television. Feel free to stop by **crochetbyfaye.com** to check up on what has inspired her lately.

CONTRIBUTORS

TRACIE BARRETT is a crochet designer living in sunny Florida. For more great designs, head to **traciebarrett.com.** You can also find her on Ravelry and Twitter as **TracieCrochets.**

MARLY BIRD is a busy wife, mother, creative director for Bijou Basin Ranch, knitting and crochet designer, teacher, and host of the Yarn Thing Podcast. But she wouldn't change it for anything. You can find more of her designs and listen to her show at **MarlyBird.com** and **thepurseworkshop.com.**

DORIS CHAN's exploded lace and seamless garment designs can be explored more in her books *Crochet Lace Innovations, Everyday Crochet,* and *Amazing Crochet Lace.* Visit her site **DorisChanCrochet.com** for more information about her work and her independently published pattern lines, DJC Designs and DJC, Too!

EDIE ECKMAN likes to crochet, knit, sew, embroider, teach, design, write, and edit, not necessarily in that order. She is the author of several best-selling books, including *Around the Corner Crochet Borders, Beyond the Square Crochet Motifs, How to Knit Socks: Three Methods Made Easy,* and *The Crochet Answer Book.* She can be found on the Web at **edieeckman.com,** on Ravelry and Twitter (edieeckman), and on Facebook (Edie Eckman).

DREW EMBORSKY, aka The Crochet Dude, has published numerous patterns in magazines and compilation books, his own full-length books, has appeared as a guest on various TV programs, and is currently one of the crochet experts on the hit PBS show *Knit and Crochet Now.* Drew has teamed up with Boye brand hooks to launch his own line of kits, hooks, tools, and accessories, called The Crochet Dude Collection, available now nationwide. See his popular blog at **TheCrochetDude.com.**

DARLA FANTON has been designing needlework professionally since 1984. In 1998, she started experimenting with a double-ended crochet hook and was instantly captivated by the "sister" techniques of double hook and Tunisian crochet. When not teaching crochet in Portland, Oregon, or developing new classes, Darla continues to design crochet projects for books, magazines, and yarn companies.

ELLEN GORMLEY is the author of *Go Crochet! Afghan Design Workbook* (F+W/Krause, 2011). She has sold more than 150 designs and has been published numerous times in many crochet magazines. You can follow Ellen on her blog at **GoCrochet.com** and as 'GoCrochet' on **Ravelry.com.** Ellen keeps an emergency bag of hooks and yarn in her car the way most people keep flares and blankets.

MEGAN GRANHOLM's clean, classic garments with a design twist have been featured in *Interweave Crochet, Inside Crochet, crochetme.com,* and in several books. Megan designs crochet patterns from her home in tiny little Adair Village, Oregon. Find her on Ravelry or at her blog, **loopdedoo.blogspot.com.**

KIM GUZMAN fills each day with creativity. Whether she's knitting or crocheting a new design or working on a new canning experiment with the fruits and vegetables she grows at home, she fulfills the dream she has always desired: one of endless creative ventures in a lovely country setting in Arkansas with her family close at hand. Kim is well known for her innovative Tunisian crochet designs. Look for her new book *Tunisian Crochet*, published by Leisure Arts.

DIANE HALPERN started crocheting during the first crochet revolution and is now heavily involved in the second. If only she'd originally had the communications technology available today. You can catch Diane and her fellow Pittsburgh, Pennsylvania, crocheters at **three riverscrochet.blogspot.com.**

TAMMY HILDEBRAND learned to crochet from her second-grade teacher. They are still in touch and Tammy says she loves to show her teacher her designs. Tammy has been designing professionally for sixteen years.

KIMBERLY MCALINDIN's first designs were published in the first

and second Tahki-Stacy Charles Inc. crochet books. Her designs have appeared in *Interweave Crochet*, *Crochet!* magazine, *Crochet World*, *Knit n' Style* magazine, Redheart.com, Caron.com, and a few self published designs on Ravelry. She lives in New Jersey with her husband, three children, and her dog, Otis. She uses knit and crochet and single malt scotch to stay sane. Catch more of Kimberly at **mybuttonjar.blogspot.com.**

SIMONA MERCHANT-DEST was born and raised in the Czech Republic; she now designs knit and crochet patterns for magazines, books, yarn companies, and her pattern collection in Maryland, where she lives with her husband and three daughters. Read more about Simona and her designs at **StylishKnits.blogspot.com** or **SimonaMerchantDest.com.**

KATHRYN MERRICK designs both knitting and crochet patterns. Her book, *Crochet In Color,* was published by Interweave in 2009. She has a website for selling finished items, **kathrynmerrick.com.**

MARTY MILLER, aka The Crochet Doctor, has been crocheting since she was five years old. A past president of the Crochet Guild of America, she teaches and tech edits, as well as designs. Check out her blogs: **notyourgranny scrochet-marty.blogspot.com** to find out about her latest designs

and crochet activities, and **the crochetdoctor.blogspot.com** to ask her questions about crochet and to read about yarns and hooks and various crochet topics.

ANNIE MODESITT is the author of eight books on knitting and crochet, including *Confessions of a Knitting Heretic.* She loves to knit and crochet, believing that they are two children of the same loopy parents. She blogs about her fiber journey (and other life events) at **modeknit.com.**

KRISTIN OMDAHL is passionate about creating with her hands. She loves coastal, tropical living and having fun outside with her son every day. Kristin is the author of *Wrapped In Crochet, Crochet So Fine, A Knitting Wrapsody* and *Seamless Crochet.* She is the crochet expert on *Knitting Daily TV* and several DVD workshops on knitting and crochet. When she isn't running, cooking, playing guitar and piano, she enjoys knitting and crocheting in her orchid garden in sunny southwest Florida. Check out what's new with Kristin at **StyledbyKristin.com.**

DORA OHRENSTEIN is founder and editor of *Crochet Insider* (**crochetinsider.com**), which has won a Flamie Award three years in a row. She is author of *Creating Crochet Fabric* and *Custom Crochet Sweaters,* both published by Lark Books.

LINDA PERMANN is the author of two acclaimed books, *Little Crochet* and *Crochet Adorned.* She teaches crochet courses online at **Craftsy.com** and locally at Yarnivore in San Antonio, Texas. When she's not designing, she's snuggling with her Chihuahua sidekick, Freddie. Read about her crafty adventures at **lindamade.com/wordpress** or say "hi" on Twitter and Ravelry **@lindamade.**

ANNETTE PETAVY is a Swedish crochet designer living in France. She publishes her own patterns and those of other independent designers on her website **annettepetavy.com**. Visit Annette's website for her free monthly newsletter with crochet tutorials and inspiration.

LEIGH RADFORD is an award-winning author, designer, and teacher. Her books include *One More Skein: 30 Quick Projects to Knit* (STC, 2009), *AlterKnits Felt: Imaginative Projects for Knitting and Felting* (STC, 2008), *Alter-Knits: Imaginative Projects and Creativity Exercises* (STC, 2005) and *One Skein: 30 Quick Projects to Knit & Crochet* (Interweave, 2006). Leigh recently launched radford+knitware, a line of hand-knit and cast porcelain ceramics. See more of her work at **leighradford.com.**

MARY BETH TEMPLE is a designer in both crochet and knit whose work appears in a variety

of books and magazines, as well as in the independent pattern line Hooked for Life **(hookedforlife publishing.com).** She is often to be found traipsing around the country teaching a variety of knit and crochet techniques.

CAROL VENTURA was initially inspired to give tapestry crochet a try in the 1970s from colorful Guatemalan shoulder bags. More than thirty years later, she's still excited about its design potential. For more about Carol's tapestry crochet books and videos, please visit **tapestrycrochet.com/blog/** and **tapestrycrochet.com.**

JILL WRIGHT adores both crochet and knitting and has been working on both crafts since she was seven years old. Check out her website, **woolcrafting.com.** Recently Jill has had designs published in the Leisure Arts *Crochet Prayer Shawls* and *Knit Prayer Shawls* books as well as the joint venture with Marlaina Bird—*Leisure Arts Curvy Crochet* booklet—in which all designs are for the curvier figure beginning with size Large.

symbol basics

The key to understanding crochet symbols is to remember that each symbol represents a crochet stitch. I like to think of them as little stick diagrams of the actual stitch—the symbols mimic the actual stitch as much as possible in a very simplified form.

Take the slip-stitch symbol, which is a filled dot. The symbol is tiny, just like the actual stitch. The symbol for single crochet is a squat cross, again similar to the stitch. The double crochet symbol is taller than the half double and has a cross in its middle. From the double crochet up, these crosses tell you how many yarn overs to make before you insert your hook.

To read granny square diagrams, you start in the center just as you do to crochet. Following the symbol key, crochet the stitches you see, reading in a counterclockwise direction. The numbers on the diagram let you know where the beginning of each round is, so you can keep track of where you are. Granny square diagrams feature each round in a new color so it's easy to keep track of the round you are on.

Stitch pattern diagrams are not much different from granny square diagrams. The key difference is that instead of crocheting in the round, you crochet back and

TOP SIX RULES OF SYMBOL CROCHET

1. Each symbol represents one stitch or cluster to crochet.

2. Each symbol is a tiny stick diagram of the stitch. The taller or fatter the symbol, the taller or fatter the stitch it represents.

3. Each row or round is a different color in the diagrams to help you keep track of your place.

4. Each row or round has a number next to the beginning turning chain, indicating the start of the row or round.

5. Granny square diagrams start in the center and increase outward, just as you crochet them.

6. Stitch pattern diagrams work rows back and forth and indicate in brackets how many stitches to repeat.

forth in turned rows. Therefore, when you are reading the diagram, you start at the foundation chain and crochet as many chains as the diagram shows. Then, following the symbol key, crochet the stitches you see for the first row, working from right to left. At the end of the row, turn, and continue crocheting the stitches you see for the second row, reading from left to right. The numbers on the diagram let you know where the beginning of each row is, so you can keep track of where you are. Each diagram has a different color for each row, so it's easy to keep track of the row you are on.

abbreviations

bpdc	back post double crochet	**fphdc**	front post half double crochet	**st(s)**	stitch(es)
beg	begin/beginning	**fptr**	front post treble crochet	**t-ch**	turning chain
bet	between	**fwd**	forward pass	**tog**	together
blo	through back loop(s) only	**g**	gram(s)	**tr**	treble crochet
blp	through back loop(s) only	**hdc**	half double crochet	**tr-cl**	treble crochet cluster
bptr	back post treble crochet	**hdc-cl**	half double crochet cluster	**Tss**	Tunisian simple stitch
CC	contrasting color	**inc**	increase/increases/increasing	**Tps**	Tunisian purl stitch
ch	chain	**lp(s)**	loop(s)	**Tdc**	Tunisian double crochet
ch-sp	chain space	**MC**	main color	**Tks**	Tunisian knit stitch
cm	centimeter(s)	**m**	marker	**WS**	wrong side
dc	double crochet	**opp**	opposite	**yd**	yard(s)
dc-cl	double crochet cluster	**pm**	place marker	**yo**	yarn over
dec	decrease/decreases/decreasing	**prev**	previous	*****	repeat instructions following asterisk as directed
dtr	double treble crochet	**rem**	remain/remaining		
edc	extended double crochet	**rep**	repeat(s)	******	repeat all instructions between asterisks as directed
est	established	**rnd(s)**	round(s)		
flo	through front loop(s) only	**rtn**	return pass	**()**	perform stitches in same indicated stitches
flp	through front loop(s) only	**RS**	right side		
foll	follow/follows/following	**sc**	single crochet	**()**	alternate instructions and/or measurements
fpdc	front post double crochet	**sh**	shell		
		sk	skip	**[]**	work bracketed instructions specified number of times
		sl st	slip stitch		

glossary

terms

GAUGE

The quickest way to check gauge is to crochet a square of fabric about 4" (10 cm) wide by 4" (10 cm) tall (or a whole motif if indicated in pattern for gauge) with the suggested hook size and in the indicated stitch pattern. If your measurements match the measurements of the pattern's gauge, congratulations! If you have too many stitches, try going up a hook size; if you have too few stitches, try going down a hook size. Crochet another swatch with the new hook until your gauge matches what is indicated in the pattern.

If the gauge has been measured after blocking, be sure to wet your swatch and block it before taking measurements to check gauge. Wet-blocking dramatically affects the gauge measurement, especially in lace work.

BLOCKING

Blocking allows the fabric to relax and ensures proper shape, measurements, and drape of the fabric. Remember to treat wool fibers carefully when wetting or washing—avoid felting by staying away from hot water and agitation (from a washing machine or water removal by hand). Also remember to keep synthetic fibers (e.g., acrylic) away from high heat.

There are three common blocking methods: spray blocking, wet-blocking, and steam blocking. In spray blocking, the project is pinned to its schematic size then sprayed with water and allowed to air-dry. Wet-blocking involves pinning a wet piece to finished measurements and allowing the piece to air-dry. Steam blocking is achieved by pinning the piece to finished measurements (dry) and then using a steamer or steam iron to gently steam the entire piece (do not touch the iron directly to the fabric), and then allowing the piece to air-dry. In many cases, a designer will recommend their preferred method of blocking for their pattern.

STITCH PATTERN REPEAT (SR)

The indicated stitches that are repeated on the same row to create the stitch pattern.

crochet stitches

CROCHET CHAIN (CH)

Make a slipknot and place it on crochet hook, *yarn over and draw through loop on hook; repeat from * for the desired number of chains.

SLIP STITCH (SL ST)

Insert hook in stitch, yarn over and draw through stitch and loop on hook.

SINGLE CROCHET (SC)

Insert hook in stitch, yarn over and pull up a loop, yarn over and draw through both loops on hook.

SINGLE CROCHET 2 TOGETHER (SC2TOG)

Insert hook in stitch, yarn over and pull up a loop, insert hook in next stitch, yarn over and pull up a loop, yarn over and draw through all 3 loops on hook—1 decrease made.

ADJUSTABLE RING

Make a large loop with the yarn, leaving a 6" (15 cm) tail. Holding the loop with your fingers, insert hook into loop and pull working yarn through loop, yarn over, draw through loop on hook. Continue to work indicated number of stitches into loop. Pull on yarn tail to close loop.

HALF DOUBLE CROCHET (HDC)

Yarn over, insert hook in stitch, yarn over and pull up a loop (3 loops on hook), yarn over and draw through all loops on hook.

2 HALF DOUBLE CROCHET CLUSTER (2HDC-CL)

[Yarn over, insert hook in stitch, yarn over, pull up a loop] 2 times, yarn over, draw through all 5 loops on hook.

FRONT POST HALF DOUBLE CROCHET (FPHDC)

Yarn over, insert hook from front to back to front around post of indicated stitch, yarn over and pull up a loop, yarn over and draw through all loops on hook.

DOUBLE CROCHET (DC)

Yarn over, insert hook in stitch, yarn over and pull up a loop (3 loops on hook), yarn over and draw through 2 loops on hook, yarn over and draw through remaining 2 loops on hook.

DOUBLE CROCHET 2 TOGETHER (DC2TOG)

Yarn over, insert hook in indicated stitch, yarn over and pull up a loop, yarn over and draw through 2 loops, yarn over, insert hook in next indicated stitch and pull up a loop, yarn over and draw yarn through 2 loops, yarn over and draw yarn through remaining 3 loops on hook—1 stitch decreased.

DOUBLE CROCHET 3 TOGETHER (DC3TOG)

[Yarn over, insert hook in indicated stitch, yarn over and pull up a loop, yarn over and draw through 2 loops] 3 times, yarn over and draw through remaining 4 loops on hook—2 stitches decreased.

2 DOUBLE CROCHET CLUSTER (2DC-CL)

[Yarn over, insert hook in indicated stitch, yarn over and pull up a loop, yarn over and draw through 2 loops on hook] 2 times, yarn over and draw through remaining 3 loops on hook.

3 DOUBLE CROCHET CLUSTER (3DC-CL)

[Yarn over, insert hook in indicated stitch, yarn over and pull up a loop, yarn over and draw through 2 loops on hook] 3 times, yarn over and draw through remaining 4 loops on hook.

FRONT POST DOUBLE CROCHET (FPDC)

Yarn over, insert hook from front to back to front around post of indicated stitch, yarn over and pull up a loop, yarn over and draw through 2 loops on hook, yarn over and draw through remaining 2 loops on hook.

BACK POST DOUBLE CROCHET (BPDC)

Yarn over, insert hook from back to front to back around post of indicated stitch, yarn over and pull up a loop, yarn over and draw through 2 loops on hook, yarn over and draw through remaining 2 loops on hook.

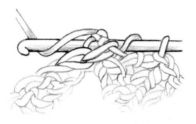

TREBLE CROCHET (TR)

Yarn over twice, insert hook in stitch, yarn over and pull up a loop (4 loops on hook), yarn over and draw through 2 loops, yarn over and draw through the next 2 loops, yarn over and draw through remaining 2 loops on hook.

4 TREBLE CROCHET CLUSTER (4TR-CL)

[Yarn over, insert hook in stitch, yarn over and pull up a loop, *yarn over and draw through 2 loops on hook; rep from * once more] 4 times, yarn over and draw through remaining 5 loops on hook.

5 TREBLE CROCHET CLUSTER (5TR-CL)

[Yarn over, insert hook in stitch, yarn over and pull up a loop, *yarn over and draw through 2 loops on hook; rep from * once more] 5 times, yarn over and draw through remaining 6 loops on hook.

FRONT POST TREBLE CROCHET (FPTR)

Yarn over twice, insert hook from front to back to front around post of indicated stitch, yarn over and pull up a loop, [yarn over, draw through 2 loops on hook] 2 times, yarn over and draw through remaining 2 loops on hook.

BACK POST TREBLE CROCHET (BPTR)

Yarn over twice, insert hook from back to front to back around post of indicated stitch, yarn over and pull up a loop, [yarn over, draw through 2 loops on hook] 2 times, yarn over and draw through remaining 2 loops on hook.

DOUBLE TREBLE CROCHET (DTR)

Yarn over 3 times, insert hook in stitch, yarn over and pull up a loop (5 loops on hook), [yarn over and draw through 2 loops] 4 times.

tunisian stitches

TUNISIAN SIMPLE STITCH (TSS)

Row 1 (RS) *Fwd:* Pull up a loop in 2nd chain from hook and in each chain across. *Rtn:* Yarn over and draw through 1 loop on hook, *yarn over and draw through 2 loops on hook; repeat from * to end.

Row 2 *Fwd:* (loop on hook counts as first st) *Insert hook in vertical bar of next stitch and pull up a loop; rep from * across. *Rtn:* Yarn over and draw through 1 loop on hook, *yarn over and draw through 2 loops on hook; repeat from * to end.

Repeat Row 2 to desired length.

TUNISIAN PURL STITCH (TPS)

Row 1 (RS) *Fwd:* Pull up a loop in 2nd chain from hook and in each chain across. *Rtn:* Yarn over and draw through 1 loop on hook, *yarn over and draw through 2 loops on hook; repeat from * to end.

Row 2 *Fwd:* (loop on hook counts as first st): *Move yarn to front of work, insert hook in vertical bar of next stitch, yarn over and pull up a loop; repeat from * across. *Rtn:* Yarn over and draw through 1 loop on hook, *yarn over and draw through 2 loops on hook; repeat from * to end.

Rep Row 2 to desired length.

TUNISIAN DOUBLE CROCHET (TDC)

Row 1 (RS) *Fwd:* Pull up a loop in 2nd chain from hook and in each chain across. *Rtn:* Yarn over and draw through 1 loop on hook, *yarn over and draw through 2 loops on hook; repeat from * to end.

Row 2 *Fwd:* (loop on hook counts as first st): *Yarn over, insert hook behind vertical bar of stitch as for Tss, yarn over and pull up a loop, yarn over and draw through 2 loops, leaving last loop on hook; repeat from * across. *Rtn:* Yarn over and draw through 1 loop on hook, *yarn over and draw through 2 loops on hook; repeat from * to end.

Rep Row 2 to desired length.

TUNISIAN KNIT STITCH (TKS)

Row 1 (RS) *Fwd:* Pull up a loop in 2nd chain from hook and in each chain across. *Rtn:* Yarn over and draw through 1 loop on hook, *yarn over and draw through 2 loops on hook; repeat from * to end.

Row 2 *Fwd:* (loop on hook counts as first st): *Insert hook from front to back between front and back vertical bars and under all horizontal loops of designated stitch, yarn over and pull up a loop; rep from * across. *Rtn:* Yarn over and draw through 1 loop on hook, *yarn over and draw through 2 loops on hook; repeat from * to end.

Rep Row 2 to desired length.

embroidery stitches

BACKSTITCH

Working from right to left, bring needle up at **1** and insert behind the starting point at **2**. Bring the needle up at **3**, repeat by inserting at **1** and bringing the needle up at a point that is a stitch length beyond **3**.

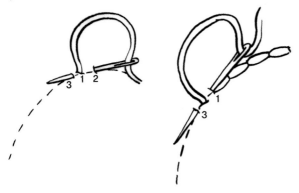

WHIPSTITCH SEAM

With right sides of work facing and working through edge stitches, bring threaded needle out from back to front, along edge of piece.

yarn resources

BIJOU BASIN RANCH
PO Box 154
Elbert, CO 80106
(303) 601-7544
bijoubasinranch.com
Lhasa Wilderness

BLUE SKY ALPACAS
PO Box 88
Cedar, MN 55011
(763) 753-5815
blueskyalpacas.com
Sportweight Alpaca; Techno;
Worsted Cotton

BROWN SHEEP COMPANY
100662 County Rd. 16
Mitchell, NE 69357
(800) 826-9136
brownsheep.com
Lamb's Pride; Lamb's Pride
Superwash; Nature Spun

CARON INTERNATIONAL
PO Box 222
Washington, NC 27889
caron.com
Naturally Caron Country;
Naturally Caron Spa; Simply
Soft; Simply Soft Eco

CASCADE YARNS
1224 Andover Park E.
Tukwila, WA 98188
cascadeyarns.com
Cascade 220; Cascade 220
Superwash

CLASSIC ELITE
122 Western Ave.
Lowell, MA 01851
(978) 453-2837
classiceliteyarns.com
Provence; Soft Linen

COATS AND CLARK
PO Box 12229
Greenville, SC 29612
(800) 648-1479
coatsandclark.com
Red Heart Eco-ways; Stitch
Nation Full O' Sheep

LION BRAND YARN
135 Kero Rd.
Carlstadt, NJ 07072
(800) 258-9276
lionbrand.com
Cotton Ease; MicroSpun;
Vanna's Choice; Wool-ease

PREMIER YARNS
284 Ann St.
Concord, NC 28025
(704) 786-1155
premieryarns.com
Dream; Deborah Norville
Collection Everyday™ Soft
Worsted

TAHKI-STACY CHARLES INC.
70-30 80th St.
Bldg. 36
Ridgewood, NY 11385
(800) 338-9276
tahkistacycharles.com
Filatura Di Crosa Zara

UNIVERSAL YARN
284 Ann St.
Concord, NC 28025
(704) 789-Yarn (9276)
universalyarn.com
Cotton Supreme; Deluxe
Worsted

index

Looking for more fresh and innovative projects from expert crocheters? Add these Interweave titles to your collection!

SIMPLY CROCHET
22 Stylish Designs for Every Day
Robyn Chachula
ISBN 978-1-59668-298-6, $22.95

**THE BEST OF
INTERWEAVE CROCHET**
A Collection of Our
Favorite Designs
Marcy Smith
ISBN 978-1-59668-302-0, $24.95

SEAMLESS CROCHET
Techniques and Motifs
for Join-As-You-Go Designs
+ DVD
Kristin Omdahl
ISBN 978-1-59668-297-9, $24.95

INTERWEAVE CROCHET

From cover to cover, *Interweave Crochet* magazine presents great projects for the beginner to the advanced crocheter. Every issue is packed full of captivating smart designs, step-by-step instructions, easy-to-understand illustrations, plus well-written, lively articles sure to inspire.
Interweavecrochet.com

fueling the crochet revolution

Want to CrochetMe?

Crochet Me is an online community that shares your passion for all things crochet. Browse through our free patterns, read our blogs, check our galleries, chat in the forums, make a few friends. Sign up at **Crochetme.com.**

crochet*me* shop
shop.crochetme.com